JAMES GRAHAM-CAMPBELL was educated at Cambridge and studied as a postgraduate in London and in Scandinavia at the Universities of Bergen and Oslo. He is Emeritus Professor of Medieval Archaeology at University College London and is a Fellow of the British Academy. His lifetime's study of the Vikings and their art has focused particularly on silver hoards and the pagan Norse burials of Scotland. His many publications on the subject include *The Viking World*, *The Vikings* (with Dafydd Kidd), *Vikings in Scotland: An Archaeological Survey* (with Colleen Batey), *The Cultural Atlas of the Viking World* (as editor) and, most recently, *The Cuerdale Hoard and Related Viking-Age Silver and Gold from Britain and Ireland in the British Museum*.

Thames & Hudson world of art

This famous series provides the widest available range of illustrated books on art in all its aspects.

To find out about all our publications, including other titles in the World of Art series, please visit **www.thamesandhudson.com**. There you can subscribe to our e-newsletter, browse or download our current catalogue, and buy any titles that are in print.

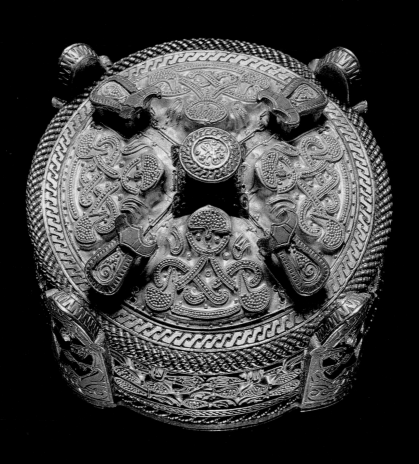

James Graham-Campbell

Viking Art

220 illustrations, 156 in colour

 Thames & Hudson world of art

For Otelo Miranda Fabião

In captions, the following abbreviations will be used:

L = Length
H = Height
W = Width
D = Diameter

1. 'Box-shaped' brooch from Mårtens, Gotland, Sweden, of gilt-bronze with panels of gold filigree and silver plates inlaid with niello (D 7.5 cm). Its eclectic ornament is in the Borre-style tradition of Viking art, but with late Ringerike-/Urnes-style elements dating its manufacture to the 11th century. This is an exceptionally fine example of a 'box-' or 'drum-shaped' type of brooch used to fasten a woman's outer garment during the Viking Age in Gotland (as ill. 23).

First published in the United Kingdom in 2013 by
Thames & Hudson Ltd, 181A High Holborn, London WC1V 7QX

www.thamesandhudson.com

Reprinted 2018

Viking Art © 2013 Thames & Hudson Ltd, London

British Library Cataloguing-in-Publication Data
A catalogue record for this book is available from the British Library

ISBN 978-0-500-20419-1

Printed and bound in Hong Kong through Asia Pacific Offset Ltd

Contents

Introduction What is Viking Art?

This book sets out to provide a general survey of the visual arts of Scandinavia during the Viking Age, covering also typical Viking Age works produced in the Scandinavian settlements overseas, from Iceland to Russia (including Britain and Ireland). Modern historians mark the beginning of this period by the commencement of regular expeditions out of Scandinavia during the late eighth century AD – undertaken by people we know as 'the Vikings' – rather than defining it by any particular political or social development in the lands of Denmark, Norway and Sweden. These foreign excursions were carried out by sea and river for the purposes of raiding and/or trading, but they also inevitably resulted in new foreign influences reaching Scandinavia, some of which are evident in the development of Viking art. The ultimate external influence on Scandinavia during the Viking Age was the introduction of Christianity, such that the full establishment of the Church can reasonably be taken as marking the end of this period, in the late eleventh century.

Viking Art covers these 300 years. Its title is, however, something of a misnomer. In the first place, the word 'art' in this context is not restricted to 'fine art' (though there are pieces created in connection with religious beliefs, both pagan and Christian, that do fall into this category): in fact the primary purpose in creating the majority of the works described here was that they should be used. Most of the material under consideration – that is to say ornamental metalwork – was both functional and decorative, however finely executed [1].

Secondly, 'viking' is the modern English form of the Old Scandinavian word *vikingr*, normally translated as 'sea warrior', with *viking* itself meaning a 'raid or military expedition (over sea)'. 'Viking' (with its capital 'V') has been converted – rather misleadingly – into an ethnic term and, as such, has come to embrace all those of Scandinavian origin and descent wherever they are found in the so-called 'Viking World' – from Newfoundland to Novgorod – during what has become known (but only since the nineteenth century) as the 'Viking Age'. This

usage is now so embedded in the popular consciousness that attempts by some academics to encourage the narrower use of the word 'viking', as a proper noun with its original meaning, have met with little success even in the limited context of specialist journals and learned tomes.

There is one respect, however, in which the modern usage of the term 'Viking' can be genuinely misleading: if it gives rise to the notion that there existed a high degree of overall unity throughout the Viking homelands. It is important, for instance, not to lose sight of the topographical diversity of Scandinavia, the length of which stretches from the rugged terrain of northern Norway, beyond the Arctic Circle, to the woodlands and cattle pastures of the Jutland peninsula in the south. Also, during the centuries discussed here, there still existed a considerable degree of political fragmentation, given that it was only during the Viking Age that there emerged the fully Christian nation-states of Denmark, Norway and Sweden, of which Denmark was the first. The growing centralization of authority was supported economically by the development of towns, the inhabitants of which engaged in manufacture and trade, although it is of course true that the Viking raids and other more overtly military expeditions, combined with foreign conquests and new overseas settlements, provided a significant boost to the economy during this period.

A certain underlying unity did exist, however, because there were shared Germanic roots – relating to the fact that the whole of Scandinavia had escaped the rule of Rome during the early centuries AD – and, of course, because of the power of the 'old religion'. Under the circumstances, it is of particular interest that Viking art does provide evidence for some degree of Scandinavian cultural uniformity, even given the periods of innovation in one region then another. There will also have been regional fashions, which, in our present state of knowledge, may be difficult to perceive, unless clearly circumscribed – as on the island of Gotland, in the Baltic Sea.

The foundations for the history of Viking art were laid in the late nineteenth century and can be said to have come of age in the early twentieth, with the detailed publication (in 1920) by the Norwegian archaeologist Haakon Shetelig of the ornate wood-carvings that had been found, in 1904, in the Oseberg ship-burial. It was, however, the English archaeologist David M. Wilson who, in the 1966 survey *Viking Art* written together with

Timeline showing approximate
duration of the Viking art styles
in Scandinavia.

a Danish colleague, Ole Klindt-Jensen, laid the foundations
for the systematic characterization of the subject, still in use
today, and who likewise refined a chronological framework.
The latter has since gained greater precision through the
modern application of dendrochronology (tree-ring dating)
of certain key sites and diagnostic finds in Scandinavia.

David Wilson has continued to publish extensively on
the subject of Viking art, most often for an English-speaking
audience, but he has been joined in recent decades by the
Norwegian art-historian Signe Horn Fuglesang with a series
of major books and papers of her own. The authority and
accessibility of the publications of these two scholars mean
that their work is that most frequently cited in what follows,
with full details provided (together with other sources)
in the Select Bibliography (pp. 200–3). Also provided are a
timeline (opposite) and maps of places mentioned in the text
(pp. 196–99).

In this book, Old Norse names have been rendered into
their modern English equivalents, with which most readers
will be familiar, thus without the use of inflexional endings and
accents, and with the adaptation of the unusual letter forms
used in Old Norse/Icelandic – so, for example, the god *Óðinn*
is known here simply as Odin, and the well-known Danish king
Knútr, who ruled for a period in England during the eleventh
century, becomes Cnut (he is, indeed, the same 'memorable
monarch' as the 'Canute' celebrated by W. C. Sellar and
R. J. Yeatman in *1066 and All That*). Old Norse words not
so normalized are rendered in *italics*. Overall, the aim has
been not so much to achieve complete consistency or
standardization in approach to this matter, but rather to
render both personal and place names in the forms most
likely to be encountered in the main publications suggested
for further reading.

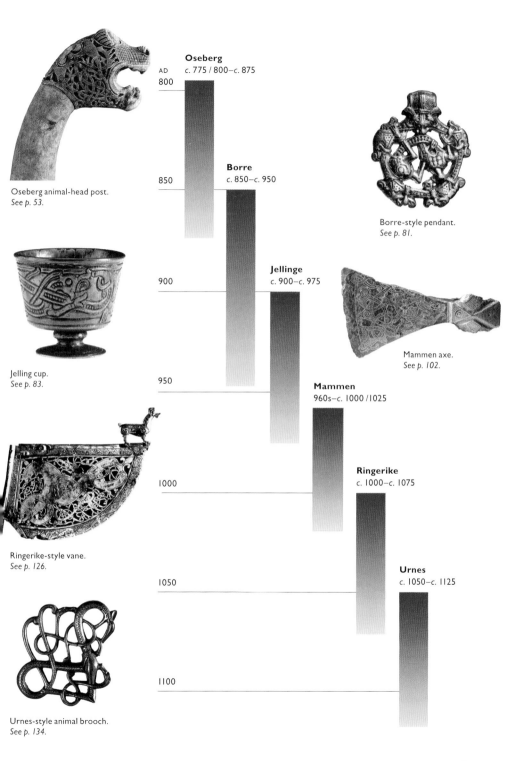

Oseberg
c. 775 / 800–c. 875

AD
800

Oseberg animal-head post.
See p. 53.

Borre
c. 850–c. 950

850

Borre-style pendant.
See p. 81.

Jellinge
c. 900–c. 975

900

Jelling cup.
See p. 83.

Mammen axe.
See p. 102.

950

Mammen
960s–c. 1000 / 1025

Ringerike-style vane.
See p. 126.

1000

Ringerike
c. 1000–c. 1075

1050

Urnes
c. 1050–c. 1125

Urnes-style animal brooch.
See p. 134.

1100

9

The World of the Vikings and the
Origins of Viking Art

The period of European history that has become known as the
Viking Age lasted some 300 years: that is from the late eighth
to the late eleventh century AD. Before discussing the art itself,
it will be helpful to outline the main areas of Viking settlement
and their development during the Viking Age in both
Scandinavia and the wider Viking world. For these purposes,
'West' is used to refer to the area west of the Scandinavian
mainland, encompassing the islands from Britain and Ireland to
Iceland and Greenland – and even the coast of North America.
The 'East' of the Viking world stretched from modern Finland,
the Baltic states and western Russia to the areas along the
great rivers Dnepr (Dnieper) and Volga.

Scandinavia and the Viking Age

The Viking Age is, as we have seen, a modern concept, but it is
the case that by about AD 1100 the Scandinavian homelands of
the Vikings had reached the end of their prehistory, entering
the European Middle Ages as Christian nation-states. That the
Viking Age in Scandinavia is to be regarded as the final phase
of the Iron Age, rather than as an integral part of the wider
medieval period, arises from the fact that it was only on
conversion to Christianity [2] that (Latin) literacy became
established in the Scandinavian countries. It is true that there
were Vikings familiar with the use of runes, but this form of
script – intended for carving on wood, bone or stone [3] – was
unsuited for lengthy inscriptions of any kind, for which pen and
ink were required in order to write upon prepared animal
skins, using the Roman alphabet.

Though the Christianization of the Vikings marks the end of
the Viking Age, the introduction of Christianity to Scandinavia
progressed slowly, with the earliest recorded missionary
activity taking place in Denmark in the eighth century. Viking
art forms reflect this process in a gradual inclusion of Christian
motifs through these centuries. Ultimately, conversion was a
top-down process, proceeding most rapidly with the growing
authority of kings and the resultant centralization of authority,

3. (opposite below) The
runic inscription on this early
11th-century memorial stone
from Yttergårde, Uppland,
Sweden, commemorates a man
called Ulf who had taken part
in three attacks on England.

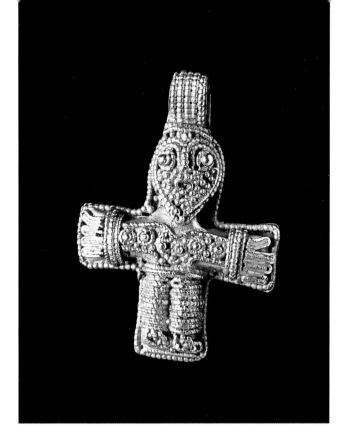

2. Gilt-silver crucifix pendant (H 3.4 cm) from Birka grave 660, Uppland, Sweden, that of a wealthy woman who was perhaps a convert to Christianity. The filigree figure of Christ, wearing trousers, is shown bound to the cross (as on ills 158–59).

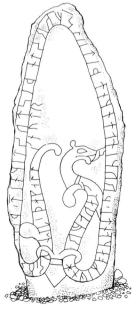

as in the case of King Harald Bluetooth who proclaimed on the runestone that he erected at Jelling, in about 965, that he had 'made the Danes Christians' [6, 105]. The development of the nation-states of Denmark, Norway and Sweden, as summarized below, was fuelled by the burgeoning economy of the Vikings – through their raiding and trading activities, combined with land-taking and the establishment of overseas settlements (see maps pp. 196–99). It is of no surprise therefore that the establishment of towns in Scandinavia presents another defining aspect of the Viking Age.

The pattern of settlement in pre-Viking Scandinavia was mainly one of dispersed farmsteads, which would have been largely self-sufficient. Wealthy chieftains operated from what have become known as 'central places': hubs for the local assembly and cult. It was these men who developed the wealth required to build ships and resource the first Viking raids. However, another more peaceful indication of growing economic complexity, especially in southern Scandinavia, was

the development of village units capable of producing agricultural surpluses for trading purposes. One response was the creation of regulated seasonal marketplaces, which also served the needs of specialized craftsmen, such as the glass-bead maker and the fine metalworker engaged in the production of jewelry. The growth of such markets (or 'proto-towns') was a step in the direction of actual urbanization, with the foundation of towns under royal control.

The Vikings who engaged in raiding and trading across much of western Europe – as also those who followed the eastern routes to the Byzantine empire and the Islamic world of the

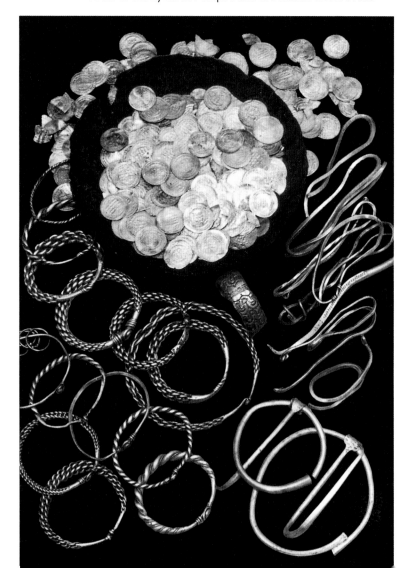

Abbasid Caliphate, with its capital at Baghdad – encountered societies with regulated coin-using economies. At the beginning of the Viking Age in Scandinavia, however, there still existed a prestige economy, with portable wealth measured in gold and silver rings [e.g. 58] and with exchange based on barter. The development of trade was facilitated by means of a bullion economy in which coins, ornaments and ingots were utilized by weight – being cut up for use as 'small change' when such was needed for minor payments [4]. Denmark's experiment with local coinage in the ninth century, notably at Hedeby [59], did not take immediate root. It was only during the late tenth and eleventh centuries that kings began to strike what can be considered the first national coinages in Scandinavia.

Before turning to summarize the major developments that took place in Denmark, Norway and Sweden during the Viking Age, it is necessary to mention the high degree of interaction that existed between the Nordic peoples and the Sámi who inhabited a large part of the Scandinavian peninsula during this period. In addition to co-existence along the north Norwegian coast, there was widespread territorial overlap across central Scandinavia. The Sámi were skilled hunters, including for walrus in the north, with access to fine furs, so that in addition to their reindeer products they had available luxury goods for the purposes of trade (in exchange for silver) or, when necessary, for the payment of tribute. Marriage partners were exchanged and the Nordic peoples seem to have held Sámi magical powers in considerable respect. Despite these extensive economic, social and religious contacts, there does not, however, seem to have been much by way of reciprocity in terms of art.

Denmark

The process of state-formation in Scandinavia was underway earliest in Denmark, the name containing the word *mark*, which may mean 'dividing forest' (in the form of its southern border), combined with the name of the inhabitants *Danir*. It has been suggested that Denmark's various territories were already unified into a single kingdom in the eighth century. Dendrochronology supports historical dating for the foundation of the proto-town of Hedeby – or Haithabu (in German) – the predecessor of medieval and modern Schleswig, for which it was abandoned in the 1060s. The earliest manufacturing and trading centre in Denmark was at Ribe, on

5. Aerial view of the Danish royal site of Jelling, in central Jutland. The North Mound (in the foreground) contained a burial-chamber, constructed in 958/59, presumably for the pagan king Gorm whose body appears to have been transferred to a grave beneath the first timber church (on the site of its medieval stone successor), in front of which King Harald (Gorm's son) erected a great runestone (ill. 6). The South Mound was also constructed during Harald's reign.

the west coast of Jutland where it was well situated for participation in the developing North Sea trade, if initially only on a seasonal basis. As Hedeby was becoming the foremost Viking Age town in Scandinavia, other towns developed in Denmark – notably Århus and Roskilde (the latter replacing the 'central place' of Lejre as a royal seat). Lund, in Skåne, was a royal foundation of the 990s, which soon overshadowed the nearby 'central place' of Uppåkra, becoming the seat of the first archbishop in Scandinavia, in 1103/04.

The Danish nation reached its greatest territorial extent during the Viking Age, when its boundaries extended well beyond those of the present-day kingdom. 'Old Denmark' included the southern provinces of modern Sweden: Skåne, Halland and Blekinge. Its sometimes contested southern boundary was marked by a multi-period frontier earthwork, known as the Danevirke (the earliest phase of which seems to have been constructed about AD 700). At the beginning of the Viking Age, the southeastern part of Norway, the coastal region of Viken (around the Vik fjord), was also under Danish

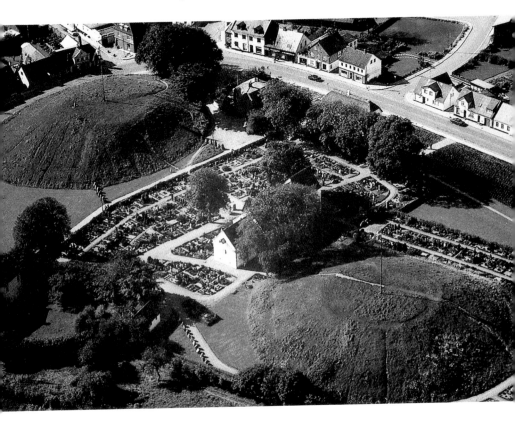

control, as was to be the case for much of the Viking Age. An important manufacturing and trading centre established at Kaupang (or *Skíringssalr*), in Vestfold, flourished during the ninth century.

In addition to the fortification of towns (such as Århus and Hedeby) and the re-organization of the Danevirke, Denmark saw other royal investment in military and administrative works, particularly during the reign of Harald Bluetooth (c. 958–87). Much of the royal necropolis and assembly site at Jelling in central Jutland [5] was planned for him, with the North Mound seemingly constructed for the pagan burial of his father, King Gorm, although his bones were later transferred to a grave beneath the first church on the site, built in wood beside his great runestone [6]. The construction projects undertaken by Harald included four circular fortresses – of unique design – at Aggersborg, Fyrkat, Nonnebakken and Trelleborg. These were all built about 980 (according to dendrochronological dating), although their use did not outlast his reign.

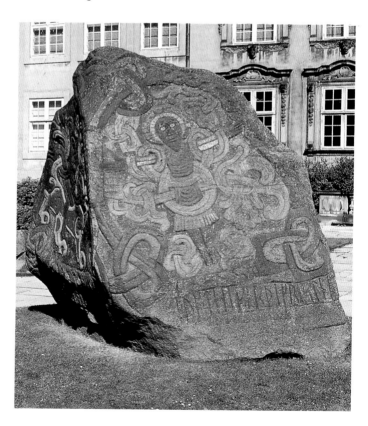

6. Replica of the three-sided runestone erected by King Harald Bluetooth at Jelling (ills 105–7), with modern paint to create an impression of how it might originally have appeared (H 2.43 m). The depiction of the Crucifixion, with the bound figure of Christ, illustrates Harald's claim to 'have made the Danes Christians', following his own conversion in about 965.

Harald issued cross-bearing coins, but there were no uniform regal coinages in Scandinavia before about 995. It was under King Cnut the Great (r. 1018–35) that the first fully nationalized coin type was struck in Scandinavia, during the 1020s or 1030s, when Lund was of particular importance among a widespread network of Danish mints. Although Scandinavian royal coinages during the late Viking Age were based on contemporary Anglo-Saxon types, one of Cnut's main designs was of a snake [7].

Norway

The name Norway derives from the Old Norse Norðvegr, meaning 'the way to the North', so the country was in origin a geographical rather than a political concept. Indeed, at the beginning of the Viking Age, Norway was divided into various territories, including Viken in the southeast, which (as already noted) was under Danish control. The most powerful family in the west was that of the earls of Lade, in Trøndelag, which archaeological evidence demonstrates was one of the two main regions in Norway involved in the earliest raids on Britain and Ireland, the other being Rogaland in the southwest.

The development of Kaupang in the southeast has already been mentioned, but its importance declined in the tenth century, with Tønsberg and Oslo developing in status. The most important urban settlement during the late Viking Age in Norway was, however, Trondheim in the west – known then as Nidaros or Nidarnes – the location of Norway's main mint when King Harald Hardrada (from harðráði, meaning 'hard

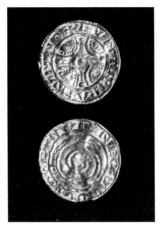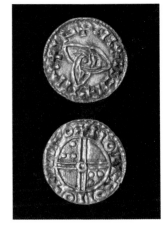

7, 8. The Danish silver penny (left), with a cross on one side and a snake on the other, was minted in the 1020s or 1030s for Cnut the Great (r. 1018–35), and is considered to be the first nationalized coin type in Scandinavia. On the right is a coin of Harald Hardrada (r. 1046–66) who established the first national coinage in Norway.

9. The 12th-century stave-church at Urnes, beside the Sognefjord in western Norway, incorporates a portal and other wood-carvings from its 11th-century predecessor, the decoration of which (ills 161–62) has given its name to the last of the Viking Age art styles.

ruler' or 'ruthless') established the first national coinage [8]. Harald had achieved the throne of Norway in 1046, after having seen international service as a mercenary for the Byzantine emperor (p. 20), but was killed invading England in 1066.

Trondheim cathedral housed the relics of the first Scandinavian saint, King Olaf Haraldsson, who had met his death in 1030, at the battle of Stiklestad. Christianity had become established in parts of Norway during the tenth century, although it was during the process of unification in the eleventh that the whole country was converted – and the Norwegian church established [9]. The last of the 'Viking' kings of Norway is considered to have been Magnus Barelegs (r. 1093–1103), because he also ruled in the West from 1098, having successfully conquered the kingdom of Man and the (Western) Isles of Scotland.

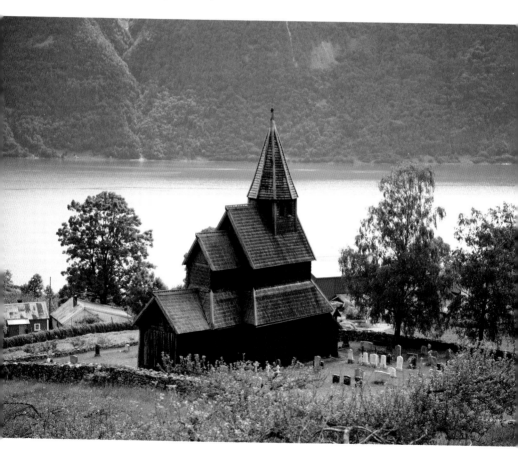

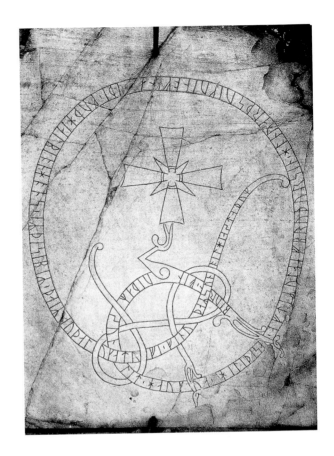

10. Sweden was the last of the Scandinavian nations to be converted to Christianity, but a central cross is commonly featured on 11th-century memorial stones with runic inscriptions. This example, with its Urnes-style decoration (as ill. 167), is carved on a rock face at Nora in Uppland.

Sweden

Given that what is now southern Sweden formed part of the Viking Age kingdom of Denmark, the royal seat of the Swedes (or *Svear*, who gave their name to Sverige in modern Swedish) was at Uppsala, in the central region. According to Adam of Bremen (writing about 1075), a major pagan cult-centre existed at Uppsala, with an elaborate temple and a sacred grove, aspects of which are discussed below in the context of art associated with paganism in Scandinavia (pp. 164–65). The conversion of Sweden to Christianity during the eleventh century was marked by a fashion for erecting runestone memorials, especially in Uppland (described in Chapter 4), with some impressive examples actually carved into the living rock, as at Nora [10], Sjusta [166] and Ramsund [195].

The most important Viking Age town in Sweden was on the small island of Birka, in Lake Mälar, located on the waterway

between Uppsala and the Baltic Sea. A proto-urban site was established there already in the mid-eighth century and excavated evidence from its earliest workshops demonstrates that (as at Ribe and Staraya Ladoga) elements of what is generally regarded as 'early Viking art' were already in use before the traditional date for the beginning of the Viking Age (in the 790s). Birka's earliest commercial links were with the southwest (Denmark and the Rhineland), but it was to flourish on eastern contacts, trading furs (in particular) for quantities of silver [4] and such luxury goods as silks. Both the settlement and its extensive cemeteries have produced much in the way of rich archaeological finds. However, its functions declined in the 970s, being taken over by Sigtuna, which was founded about 980, where a prolific mint operated from the 990s to 1020s, producing imitation Anglo-Saxon pennies (as at Lund).

Eastward expansion from central Sweden began as early as the seventh century, with the establishment of settlements across the Baltic Sea. There were Scandinavians living in the area of Lake Ladoga, in Russia, during the second half of the eighth century, as described below. During the Viking Age, the island of Gotland, at the centre of the Baltic, seems to have enjoyed an autonomous relationship with Sweden. Although most probably a tributary of the Swedish king, Gotland can be seen to have retained a considerable degree of independence, as reflected in various aspects of its cultural life, including the development of its artistic traditions, most notably its distinctive 'picture-stones' (pp. 41–45).

The Viking Expansion

The Viking Age was marked by an extraordinary Scandinavian diaspora, with journeys undertaken that expanded the horizons of the medieval European world (see map pp. 196–97). In the far West, Norsemen were the first Europeans to settle in Greenland and to set foot in North America. In the East, settlements were established along the great river routes (the Dnepr and Volga, in particular), which were navigated to access the wealth of Byzantium and the Abbasid Caliphate – and even of China, given that the 'silk route' from China reached the town of Bulgar on the Middle Volga, in the territory of the Bulgars (who thus controlled Scandinavian access to the Caliphate in the south).

The Vikings in the East

Scandinavian settlers were present on the eastern shores of the Baltic Sea from the seventh century, as at Grobiņa in Latvia, and by the second half of the eighth century there were Scandinavians living in the area of Lake Ladoga, in Russia. It was during the second half of the eighth century that they started in earnest to use the river routes to penetrate deep into eastern Europe. In this way, the Vikings or *Rus/Rhos* (as they were known in the East) were able to reach both the Caliphate, by means of the River Volga, and the Byzantine empire, down the River Dnepr and across the Black Sea.

Lake Ladoga was directly accessible from the Baltic, by way of the Gulf of Finland, and so too was the River Volkhov, on which the trading centre of Staraya Ladoga was located, with a Scandinavian presence dating already from the 750s. Other significant settlements with partly Scandinavian populations on this northern part of the route to the East, were Rjurikovo Gorodishche and its successor Novgorod.

Gnëzdovo (near modern Smolensk) was also of particular importance to the Rus. Its settlement complex, associated with several large cemeteries, was located on the right bank of the Upper Dnepr, between two of its tributaries. Further south, beside the Middle Dnepr (on its route to the Black Sea), the Vikings established themselves at Kiev, a Slavic princely stronghold. Kiev became the 'capital' of the new Russian state, which was officially converted to Orthodox Christianity at the end of the tenth century. The boats of the Rus gathered annually at Kiev to travel down the river in flotillas, for mutual assistance and protection during the dangerous portage around the Dnepr Rapids, en route to the markets of Constantinople.

In Constantinople, Viking mercenaries found employment in the emperor's Varangian Guard (the term *Rus/Rhos* being replaced with the Greek *Varangoi* during the eleventh century). The most important figure in Scandinavian history known to have been a member of the Varangian Guard was Harald Hardrada, who is said to have served in Bulgaria, Sicily and Syria, before becoming king of Norway in the mid-eleventh century.

The southernmost archaeological trace left by the Vikings (or at least until it was looted by the Venetians in the seventeenth century) is the eleventh-century Swedish runic inscription carved onto a marble lion while it stood guard at

11. Engraving of a marble lion that stood at the entrance to the Greek harbour of Piraeus until looted by the Venetians in 1687. It has a much worn runic inscription (now illegible) on its right shoulder, incised in looping bands as on the Swedish runestones – the work of an 11th-century Scandinavian traveller.

the entrance to the Greek harbour of Piraeus [11]. The easternmost Scandinavian artefact to have been discovered is a tenth-century scabbard-chape from a Viking sword found at Danilovka, near Kamyshin, on the Lower Volga, but there is a large concentration of Scandinavian material from sites in the Upper Volga area.

The Vikings in the West

One of the major achievements of the Viking Age was the Norse expansion across the North Atlantic, with permanent settlements being established in the Faroe Islands, Iceland and Greenland. Britain and Ireland were subject to land-taking and military conquest, by both Norwegians and Danes, which resulted in extensive Scandinavian settlement in parts of Scotland and across eastern and northern England, as well as on the Isle of Man (see map p. 199). The Vikings in Ireland were, however, largely confined to a number of coastal locations, including what was to become the kingdom of Dublin. On the other hand, the Scandinavian settlements established in Continental Europe were temporary in nature (because they were usually military in purpose), with the exception of that in Normandy.

Scotland, Ireland and the Isle of Man

The Viking Age in the north and west of the British Isles was clearly underway by the end of the eighth century. Iona, the most important monastery in the Western Isles of Scotland, is recorded as having been raided (for the first time) in 802. It had therefore presumably been missed as a target by the earliest Viking raiders in the region who were recorded off the coast of Ireland from 795. However, there is no historical evidence for any Scandinavian settlement in Ireland before 840, when a winter base was established on Lough Neagh. The Vikings overwintered for the first time at Dublin in 841/42, at the mouth of the River Liffey, a prime location for the development of the first town in Ireland – and the seat of later Viking kings. The Norse rulers were evicted by the Irish in 902, but after some fifteen years the Dublin dynasty was back in power.

Hiberno-Scandinavian towns likewise flourished during the tenth century, at Limerick and Cork, and in the southeast at Wexford and Waterford. After the battle of Tara, in 980, Viking

military power was at an end in Ireland, but the towns continued to play an important role in the commercial and cultural life of the island. Indeed, the first coinage to be struck in Ireland (c. 995) was for the then Viking king of Dublin.

The archaeological dating for the establishment of a permanent Norse presence in northern and western Scotland indicates that the initial land-taking there happened during the same period as in Ireland. By contrast, however, the pattern was one of dispersed rural settlement: throughout the Orkney and Shetland Islands, on the adjacent mainland (Caithness and Sutherland), and scattered down the length of the Western Isles (or Hebrides) and through the southwest of the Mainland. The main centre of Norse power (and wealth) in Scandinavian Scotland was the earldom of Orkney.

The Isle of Man was seized by Vikings around 900, some at least of whom received elaborate pagan burial in mounds and boats. However, intermarriage with the native Christian population (as elsewhere in Britain and Ireland) is implied by the fact that some of those commemorated in Norse runes on the earliest Manx cross-slabs with Viking-style decoration have Celtic names [80].

The Faroe Islands, Iceland and Greenland

The Norse settlement of the Faroe Islands presumably took place about the same time as that of the Northern Isles of Scotland, although the existing population seems to have consisted only of some Irish monks who had sought isolation there. Their name in Old Norse (*Færeyjar*) means 'sheep islands', but their limited resources meant that the Viking Age settlers never grew wealthy.

The 'historical' account given in the twelfth-century *Íslendingabók* indicates that the first settlement of Iceland took place rapidly from about 870. This has been borne out by archaeology, with some excavated sites incorporating a recent layer of volcanic ash that has been dated precisely, by reference to the Greenland ice-core, to 871±2.

The Vikings seem to have encountered only a few Irish hermits in Iceland, for there was no native population to contend with, as was the case also in southern and western Greenland where Norse settlements were established towards the end of the tenth century. On the other hand, the venture onto the continent of North America (c. 1000) proved to be a

short-lived experience, though it has been archaeologically proven through the excavation of the site of L'Anse aux Meadows, located on the northern tip of Newfoundland.

The settlers of Iceland derived not only from Norway, but also from Britain and Ireland, such that some of them were already Christian – or at least had Christian families and/or slaves. Even so, the old religion persisted at least until the official conversion at the annual meeting of the general assembly (or Althing) in 999 or 1000, with the first bishopric in Iceland being established at Skálholt in 1056 [12, 157]. As to be expected, the settlement pattern was one of dispersed, largely self-sufficient, farmsteads, with power shared between the wealthiest chieftains.

12. This cast silver pendant in the form of a cross, with a fanged animal head forming its suspension loop, is a stray find from Foss in southern Iceland (L 5.0 cm).

England

The earliest recorded Viking raid on an Anglo-Saxon monastery took place in 793, with the plundering and burning of Lindisfarne, on an island off the coast of Northumbria. Pagan pirates are known to have been operating in the Channel in the 790s, but the first serious threat for the Anglo-Saxon kingdoms was the arrival of a 'great army' in East Anglia in 865/66. This campaigned for a number of years, using a different base each winter, until 876 when one part of the army seized an area of Northumbria for permanent settlement. Similar land-taking occurred in the east Midlands in 877 and then in East Anglia in 879. A treaty between King Alfred of Wessex and the Danish military leader, Guthrum (in about 880–90), defined the existence of the Viking kingdom of East Anglia.

East Anglia was the first of the so-called 'Danelaw' territories to be repossessed by the Anglo-Saxons in 917. However, at the same time, at the beginning of the tenth century, England experienced a new wave of Scandinavian settlement with land-taking in the northwest. In the meantime, the economy of the Viking kingdom of York (which covered much of what had been the Anglo-Saxon kingdom of Northumbria) was flourishing, with a well-regulated coin economy [104]. Viking rule in York (Old Norse *Jórvík*) came to an end in 954 with the departure and death of the exiled Norwegian prince, Eric Bloodaxe.

This settlement by pagan Vikings across northern England, where there existed a well-established Anglo-Saxon tradition of carved stone Christian monuments, resulted – on their

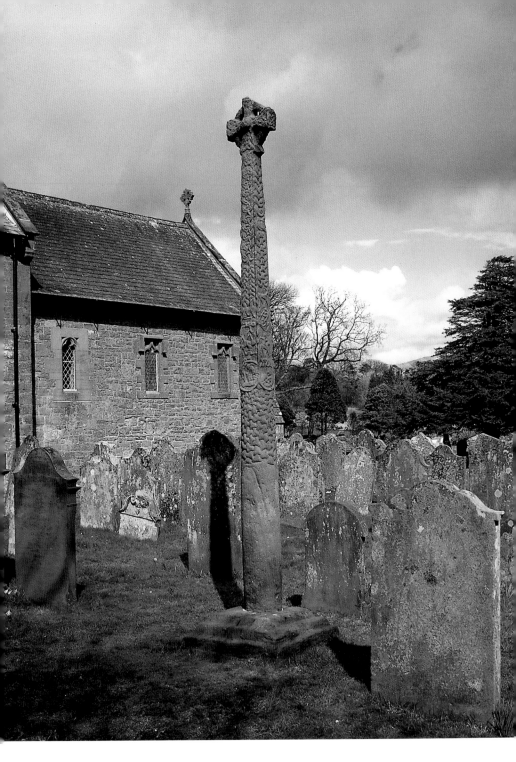

13. The 10th-century ring-headed cross (H 4.42 m) still standing in the churchyard at Gosforth in Cumbria is decorated with an elaborate iconographical scheme combining scenes from pagan Norse mythology with the Crucifixion (see ill. 200). The church contains other Viking Age sculpture, including the remains of two 'hogback' grave-markers (p. 79) and a slab depicting the pagan god Thor on a fishing expedition (ill. 186).

conversion – in the creation of a variety of Anglo-Scandinavian sculpture (p. 80). One of the finest (it is certainly the tallest) surviving examples is the cross still standing in the churchyard at Gosforth in Cumbria [13].

The conquest of England by Cnut (the Great) in 1016 resulted in the creation of a short-lived North Sea 'Viking empire' with his assumption of the Danish crown in 1018, but this was to fall apart after his death. The death of King Harald Hardrada and defeat of his Norwegian invasion force at the battle of Stamford Bridge, in 1066, marked the beginning of the end of the Viking Age for England, which was conquered by the French-speaking descendants of the 'Northmen' who had been settled in Normandy.

Normandy and Brittany

Viking activity on the River Seine, which included some settlement on the lower part of the river and around its estuary, resulted in the Frankish king, Charles the Simple, drawing up a treaty, in 911, with the Viking chieftain, Rollo (*Hrólfr*, in Old Norse). This territorial grant required the Vikings to protect their new realm and to become Christian. Further land grants enlarged what became the duchy of Normandy, but the Scandinavian settlers rapidly integrated with the local Frankish population, adopting the French language and abandoning their Scandinavian cultural heritage.

The Viking conquest of Brittany was short-lived, lasting for no more than twenty years, and they left only slight remains of their presence. It is not surprising therefore that neither of these territories feature in this survey of Viking art, except for when it is noted that these Scandinavian 'roots' loomed large in 1911, on the occasion of the millennial celebrations of the foundation of Normandy [215].

Scandinavian Art before the Vikings

The tradition of Germanic animal ornament, which was to form the basis for Viking art, appears to have been created in Denmark in the late fifth century, in response to the decoration then in use on Late Roman provincial metalwork. Modern study of the motif was pioneered back in 1904, when Bernhard Salin proposed the existence of a three-phase chronological progression within the overall development of this zoomorphic

15, 16, 17. (opposite) Strap-end from Vendel (top left), in the form of an animal head, with garnet eyes, and two rectangular harness mounts from Valsgärde (top right) and Vendel (below), both high-status cemeteries in central Sweden. In each case, the design has been created from a pair of Style II ribbon-shaped animals, with interlaced bodies depicted in profile; the heads have circular eyes and elongated open jaws. (Objects not to scale.)

art, up to and including the eighth century. His sequence of 'Styles I–III' (identified as such by the use of Roman numerals) is still in use today.

Salin's Style II experienced pan-Germanic popularity during the seventh century. Outstanding examples of the ornamental metalwork of the period from Scandinavia include splendid horse-harness mounts from the high-status cemeteries at Vendel and Valsgärde, Uppland (in Sweden) [15–17]. Style II was based on non-naturalistic ribbon-like animals used to form interlaced patterns, which are difficult for the untrained eye to decipher, although the menagerie was expanded to include such predatory creatures as the boar and raven, together with the aristocratic image of horse and rider.

The term 'Style III' is nowadays reserved for the eighth-century development of Germanic art in Scandinavia, where it has been found helpful to subdivide it into three groups labelled (Vendel) Style C, D and E. In general, the stylized animals were rendered in an even more abstract manner [14], with the predatory beasts being discontinued, although the horse motif was retained. As we shall see, 'Style III/E' – or rather just 'Style E', as it will be known here – became fashionable during the second half of the eighth century, laying the foundation for Viking art.

14. Style E ornament on a 'disc-on-bow' brooch from Othemars, Othem, Gotland. The pair of ribbon-shaped animals in profile (heads at centre), although descended from those of Style II (cf. ills 15–17), have sprouted tendril-like extensions to further complicate the interlace design.

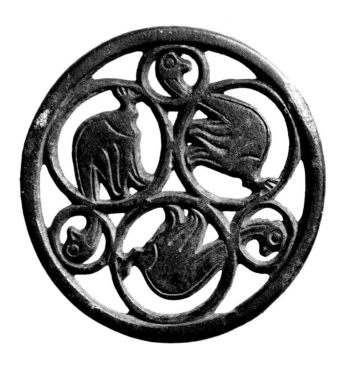

18. The circular frame of this openwork bronze mount for a purse lid (D 6.7 cm) from Othem, Gotland, contains three Style E birds, each framed by its own pair of circles.

Style E

Two pieces of ornamental metalwork from Gotland serve well to introduce one of the main zoomorphic motifs of Style E (a stylized bird/animal seen in profile): these are an openwork roundel from Othem and a sword pommel from Stora Ihre (grave 174). The Othem mount is made up from three pairs of rings in two sizes: the three small ones each encircle the head of a bird, with its body in the corresponding larger ring [18]. The small beaked head has a circular eye and the body is double-contoured; its wings are frond-like in their treatment. The central part of the Stora Ihre pommel is decorated with a quadruped, which is seen as if through a window with three openings [19, 20]. The uppermost field – or 'opening' – is heart-shaped and frames the animal's beaked head. This has a triple crest, as well as a lower lappet with a triple tendril-like terminal. The body is double-contoured, with three-toed feet. The expanded hips have openings with a tendril-like interlace, formed by the tail in the case of the hindquarters.

Both the Othem bird and the Stora Ihre animal, with its ribbon-shaped body (to be imagined between the lower two openings), are unidentifiable – if coherent – creatures. Their

19, 20. The body of the Style E quadruped at the centre of this bronze sword-pommel mount (L 9.5 cm) from Stora Ihre grave 174, Hellvi, Gotland, appears disjointed in three openings: the neck, fore- and hindquarters all have characteristic perforations with interlacing tendrils. The animals on either side are likewise broken – and have bird's heads.

flat treatment and distinctive details make them characteristic of Style E and this will be encountered again on the Broa mounts (also from Gotland), which best of all typify Style E in metalwork. In terms of overall design, the use of frameworks to isolate the creatures – and even to divide them into parts – is a characteristic feature.

Style E is, however, marked out by the introduction of a novel animal motif, which, for obvious reasons, has become known as the 'gripping-beast'. Compared with the more traditional animals, these appear to be somewhat randomly disposed, except that their legs reach out for the frames around them to grip with their feet – or else they grasp their own bodies. The heads are normally full-faced, with necks and bodies that are no more than ribbons, although the hips are emphasized to give power to their paws.

A classic example of the use of the new 'gripping-beast' motif is to be seen on the hilt of the sword from a grave at Steinsvik, Nordland (in Norway). This is inlaid with silver and copper wires, together with thirteen cast bronze panels [21, 22]. The twelve panels on the two guards each contain a single 'gripping-beast', although some are in fact anthropomorphic.

21, 22. The Steinsvik sword-hilt, from a man's grave in northern Norway, is inlaid with silver and copper wires, together with thirteen cast bronze panels, each containing a single 'gripping-beast', except for the larger U-shaped mount across the top of the pommel, which has a pair on either side (L of lower guard 8.3 cm). The drawings show the mounts on the reverse of the sword.

These humanoid figures lack the protruding ears of the 'beasts', but have a pigtail instead – and in some cases also a beard (likewise the actual 'beasts') – providing further gripping opportunities for their hands and feet.

A small 'box-shaped' brooch of gilt-bronze from Valla, Gotland, of the same type as the later and more elaborate example illustrated above [1], which is likewise from Gotland, demonstrates the combination of Style E 'ribbon-animals' [cf. 24, 25], in the four main panels around the sides, with four 'gripping-beasts', in the four oval fields on its top [23].

23. Gilt-bronze 'box-shaped' brooch (D 4.7 cm) from Valla, Gotland, decorated on top with four individual 'gripping-beasts' together with Style E animals around its sides, one in each of the four main fields.

24, 25. A classic example of the Style E 'ribbon-animal', with interlaced tendril extensions, extends across each of the two longitudinal fields on this gilt-bronze mount (L 4.9 cm) from Broa, Gotland, divided in two by the cruciform framework (see also ills 26–27).

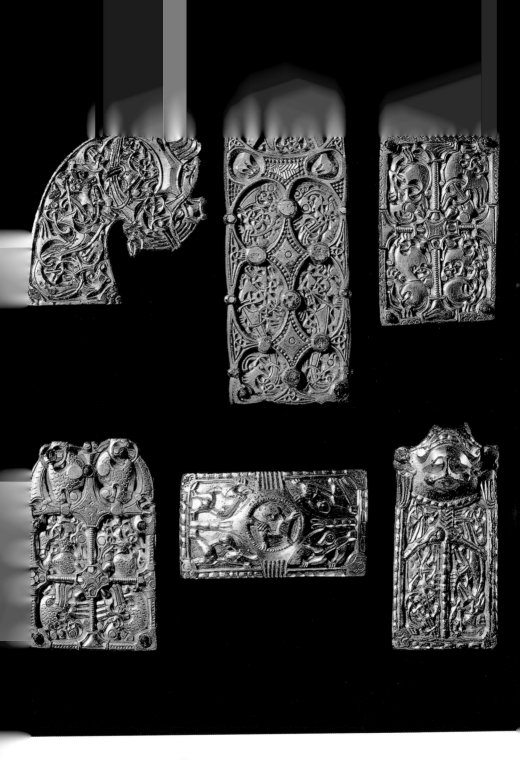

26, 27. Six gilt-bronze harness-mounts (max. L 9.0 cm) from a set found in a man's grave at Broa, Halla, Gotland. These masterpieces of Scandinavian ornamental metalwork in Style E, from the second half of the 8th century, herald the beginnings of Viking art. The drawings (below) illustrate (top) the paired animals and birds in the four fields on the bottom left-hand mount, and (bottom) the five 'gripping-beasts' on that bottom centre.

Although it was clearly popular during the last decades of the eighth century, it has not yet proved possible to establish a close date for the emergence of Style E. Debate also continues as to the origins of the 'gripping-beast' in Viking art, with most favouring an Anglo-Saxon but others a Continental ancestry. There are stylistic arguments in favour of both sources and, indeed, both could have played a part, as would seem to have been the case with the semi-naturalistic animals (and the birds in particular). What is clear, however, is that the Style E 'gripping-beast' was a Scandinavian innovation, whatever its western European prototypes may have been.

It was this combination of the semi-naturalistic and 'ribbon-animals' with the newly popular 'gripping-beast' that came to dominate early Viking art, in the so-called Oseberg style to be discussed in the next chapter, with Style E forming a cultural marker for the transition to the Viking Age in Scandinavia. Before considering some other aspects of Scandinavian art at the beginning of the Viking Age, it is worth taking a closer look at the Broa strap-mounts themselves.

The Broa Mounts

The harness-mounts from Broa i Halle on Gotland [26], which have already been introduced as the finest examples of Style E in metalwork, were found in a man's grave, around the skull of a horse. This set of twenty-two gilt-bronze strap-mounts is, however, made up from two groups – one of which (Group A) has been reused. In fact, the two groups are so closely related, in both design and finish, that they were presumably made in the same workshop, if not by the hand of the same craftsman. Among the differences to be recognized between the two groups are that a pair of the mounts in Group B actually take the shape of an animal head, seen in profile, and that many of the animals on the mounts belonging to the original Group A have punched decoration on their bodies.

Between them, the Broa mounts utilize all three of the zoomorphic motifs that characterize Style E [24–27]. It is of no surprise therefore, given the high quality of overall design and variety of ornament displayed by the Broa mounts, combined with their superb craftsmanship, that this phase of Scandinavian art is sometimes labelled the 'Broa style'.

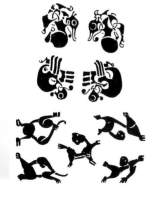

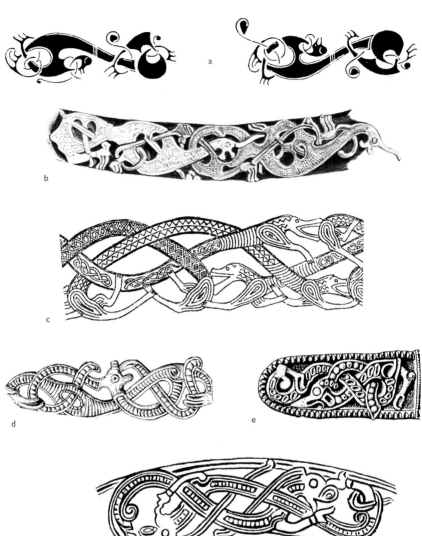

28. 'Ribbon-animals' (not
to scale): (a) Broa mount
(ills 24–25); (b) Oseberg ship's
prow (ills 43–44); (c) Oseberg
wagon side (ills 52–53); (d) Birka
brooch (ill. 87); (e) Gokstad
strap-end; (f) Jelling cup (ills
85–86); (g) Odd's cross-shaft
Kirk Braddan; and (h) Skaill
brooch terminal.

Viking Age Animal Motifs

Before considering the nature of such representational and narrative art as is known from Viking Age Scandinavia, it is useful to summarize the way in which certain animal motifs remained a constant feature of Viking art. Selected examples of the three main 'families' of Viking Age animals are assembled here in sequence [28–30], mostly drawn from artefacts illustrated elsewhere in the book. These provide a visual summary of the modifications to their form and disposition that resulted from three centuries of changing stylistic conventions.

This gradual transformation of the zoomorphic motifs utilized by Viking artists can most readily be traced through

29. 'Gripping-beasts' (not to scale): (a) Broa mount (ills 26–27); (b) Steinsvik sword-hilt (ills 21–22); (c–d) Oseberg 'Carolingian' animal-head post (ills 41–42, 48); (e) Vårby pendant (ill. 97); (f) Gokstad mount; with (g) an anthropomorphic variant from Oseberg.

30. 'Great Beasts' (not to scale): (a) Jelling stone (Face 2), with snake (ill. 107); (b) Tullstorp stone (ill. 109); (c) Norre Åsarp stone (ill. 131); (d) Heggen vane (ill. 139); and (e) the Lindholm Høje openwork brooch, with snake (ill. 151), representing the Mammen (a–b), Ringerike (c–d) and Urnes styles (e).

the varying treatment of the 'ribbon-animal', given its continuity of use throughout the period [28]. The 'gripping-beast' proved popular for well over a century – from its introduction in Style E through to its widespread use in the Borre style [29]. Finally, the development of the 'Great Beast', which was introduced in the mid-tenth century as a key motif for the Mammen style, can be followed as it was modified during the eleventh century, according to the stylistic developments that characterized the successive Ringerike and Urnes styles [30].

Human Figures and Narrative Art

Some of the most arresting images from the pre-Viking art of Scandinavia are the figurative scenes on a set of rectangular bronze dies [31] from Torslunda, on the Swedish island of Öland. Such dies were used for stamping metal foils to ornament 'parade' helmets of the type known from aristocratic graves at Vendel, in central Sweden (and a well-known version of which was deposited in the seventh-century Anglo-Saxon ship-burial at Sutton Hoo, in Suffolk). One of the Torslunda dies is renowned for its naturalistic scene of an apparently one-eyed warrior wearing a horned helmet, in the company of a wolf-headed figure [31, bottom left]. It would appear that a ritual dance is in progress, presumably connected with the cult of (one-eyed) Odin, the god of war, whose information-gathering intimates were a pair of ravens – no doubt this is why there are bird-head terminals on the helmet's horns.

31. Set of four bronze dies from Torslunda, Öland, used in the production of pictorial foils for the decoration of pre-Viking Swedish helmets. The scene with a spear-carrying warrior, wearing a horned helmet (bottom left), may well be connected with the cult of Odin, the god of war.

This type of scene provides evidence that naturalistic art was utilized in pre-Viking Scandinavia, if specifically for religious purposes. Such is further demonstrated by a remarkable series of small plaques of gold foil impressed with a human figure or facing couple. The couple is most often interpreted as a representation of the 'holy marriage' between the fertility god Frey (see p. 166) and the giantess Gerd. This ceremony – or a similar encounter – is well illustrated in the three different versions that together constitute a group of sixteen such foils from Hauge, Rogaland (in Norway) [32].

These so-called *guldgubbar* or *gullgubber* lack any functional features and are so slight that they can only be supposed to be votive in character. In some cases they may have been deposited in connection with fertility rites – such as on the occasion of human marriages or of the blessing of fields. Some have been found during the excavation of what may have been cult-buildings, although others are more certainly from large domestic halls in which chieftains will have presided over ritual feasts and other ceremonies, such as at Borg, in the Lofoten Islands. In another find, also from Norway, nineteen gold foils were associated with the postholes of a building excavated beneath the church at Mære, in Trøndelag. Most remarkable,

32.(above) Impressed gold foil (much enlarged here) depicting a 'loving couple', sometimes identified as showing an old fertility myth with the god Frey embracing the giantess Gerd. The foil comes from a group of sixteen of different sizes and three designs found at Hauge, Rogaland, Norway (max. H 1.72 cm).

however, has been the discovery in recent years, through metal-detecting, of thousands of these tiny plaques in the Danish island of Bornholm [33].

The great majority of figural foils are not from datable contexts, although 110 examples have been excavated at Uppåkra (the 'central place' predecessor of Lund) in a building that was in use up to the beginning of the Viking Age. Also in Sweden, an atypical pair from Håringe, on Bolmsö, in Småland, was deposited by a posthole in a hall erected about 710–20.

It is generally accepted, although of course it cannot be established beyond doubt, that a series of small female figures, of silver [34], are representations of the valkyries, the demi-goddesses who feature in the entourage of Odin (and thus reflect his worship). It was the role of the valkyries to care for valiant warriors killed in battle by escorting them to Valholl (or Valhalla), Odin's 'Hall of the Slain' (the meaning of Old Norse *Valhǫll*). Some of them are shown holding out a drinking vessel and are recognizable elsewhere in Viking art [e.g. 183, 184], including some significant appearances on several of the Gotlandic 'picture-stones' discussed next [e.g. 39, 182].

The male human mask also features in Viking art, with earlier Scandinavian prototypes [35], and, during the early

34.(right) Two Swedish silver pendants (both enlarged here), presumably worn as amulets, in the form of female figures thought to represent the valkyries who served the god Odin and attended the fallen warriors gathered in Valholl – his 'Hall of the Slain' – as is perhaps depicted on some of the Gotlandic 'picture-stones' (ill. 39; see also ills 181–84).

35. This pre-Viking human mask, with staring eyes and full moustache, on a mount from Valsgärde grave 6, Uppland, Sweden, foreshadows the later use of this motif in Viking art, especially in the later 10th-century Mammen style (as, for example, ills 117–18 and 121).

Viking Age, small human masks were integrated into designs in the same manner as animal masks. However, the motif of a stylized male face grew in importance to become significant in its own right in late Viking art, especially in the Mammen style [e.g. 117, 118, 121], although its significance is unknown.

The single scene depicting a specific event is the norm for narrative art, as on the Oseberg wagon [52], although of rare occurrence. Even the Oseberg 'tapestry', which proffers a unique survival of a much larger narrative scene, of a procession [54, 55], would still appear to represent a single event. The various scenes depicted on the Gotlandic 'picture-stones' are, however, separated into horizontal bands, and it cannot be assumed that they form a narrative sequence. In the case of the Ramsund rock-carving [195], various episodes in the legend of Sigurd (connected with him slaying the serpent Fafnir and subsequently the smith Regin) are depicted in no particular order. We shall return to these narratives and their occurrence in Viking art in Chapter 5.

With Christianity came the desire to depict the crucifixion (p. 178), as most famously on the Jelling runestone [6, 105]. The earliest known crucifix pendant of Scandinavian manufacture, of tenth-century date, is from Birka [2], with later Viking Age examples including those from Trondheim and Gåtebo [158, 159]. During the Conversion period, many objects and monuments show Christian motifs juxtaposed with the older pagan iconography and many Christian monuments have scenes from known pagan myths and legends, for example not only Ramsundberget [195], but also the Sigurd cross-slab from Kirk Andreas [196] and possibly the Alstad stone, with its horsemen, birds and dogs [130].

The myth concerning the god Thor's attempt to catch the World Serpent seems to have been a popular choice, as seen on such stones as Altuna [185], Gosforth [186] and the Ardre VIII 'picture-stone' [192]. The Gosforth cross itself [13, 200] juxtaposes scenes from Ragnarok (the downfall of the pagan gods) with the crucifixion, whereas one of the Manx cross-slabs presents Ragnarok (Odin and the wolf Fenrir) back-to-back with a triumphant Christian figure [199]. There is a secular warrior/chieftain on the Middleton cross [103], whereas the wooden panels from Flatatunga depict a row of saints [142], and the Dynna stone illustrates the 'Adoration of the Magi' in a scene unique for Viking art [201].

The Gotlandic 'Picture-Stones'

Gotland, the large island at the centre of the Baltic Sea, enjoyed not only great prosperity during the Viking Age, but also a degree of independence, which is manifest in various aspects of its material culture. The individual nature of its society is reflected, for instance, in the rejection by Gotlandic women of the pan-Scandinavian fashion for oval brooches: instead they wore pairs in the form of stylized animal heads [e.g. 154]. The lack of a local market for oval brooches did not, however, prevent some metalworkers from producing them – presumably for sale off the island. The prominent 'box-shaped' brooch [1, 23] also formed part of female dress in Gotland, where other Scandinavian women would have worn an equal-armed, trefoil or disc brooch as their 'third brooch' (for cape or cloak).

The most distinctive of Gotland's particular cultural characteristics is its tradition of stone sculpture, which was unique in Scandinavia at the beginning of the Viking Age. In fact, the extent of the carving on these so-called 'picture-stones' amounts only to the shaping and preparation of the limestone slabs, because the figural scenes themselves are lightly incised on one side only. It is clear therefore that, in order to be visible, they must originally have been painted, but the simple coloured backgrounds of the stones today are all modern and we have in fact no knowledge of how these monuments would have looked when newly erected.

The various scenes depicted on the 'picture-stones' are separated into horizontal bands, but it cannot be assumed that they form a narrative sequence. In most cases, their meaning is anyway only a matter of guesswork, because few of the pagan myths and heroic legends that will have been in circulation during the Viking Age can have filtered down to us through the Middle Ages. It can be seen, however, that part of the busy composition in the lower register of the Ardre VIII 'picture-stone' [192] features a scene that can be identified as part of the legend of Volund the Smith (see pp. 173–74), and also a rectangular enclosure in which a prone figure is surrounded by snakes. The latter scene is clearer on the Klinte stone [194], in a composition comparable to that on one end of the Oseberg wagon [53]. Any, or indeed all, of these might be supposed to depict Gunnar in the snake-pit (p. 174).

It is also possible that some of the stones provide evidence for Old Scandinavian cult practices, including a possible human

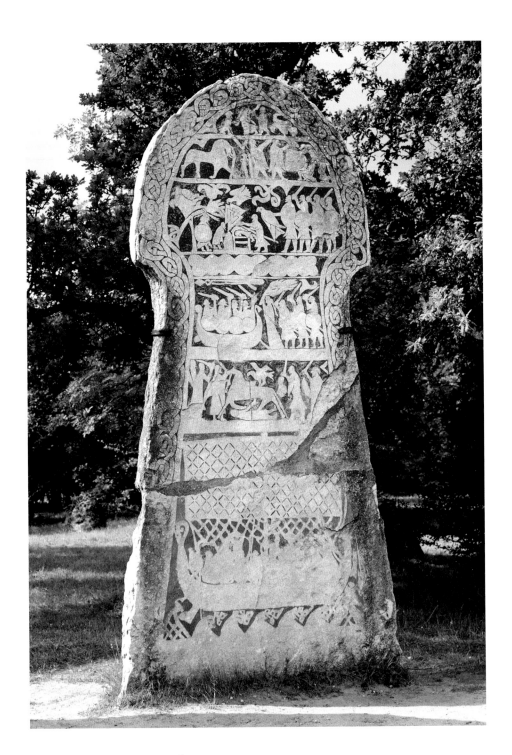

36, 37. (opposite and right) The Gotlandic 'picture-stone' from Stora Hammars, Lärbro, is one of the most complex of these monuments – with five narrative scenes, each contained in a separate register, above that of the large warship under sail, at the bottom. The detail (right) shows what has been identified as: (top) a human sacrifice taking place in front of a man hanging from a tree; (centre) a battle scene with the goddess Freyja; and (bottom) the corpse of a fallen rider on a battlefield. (H 3 m; paint modern.)

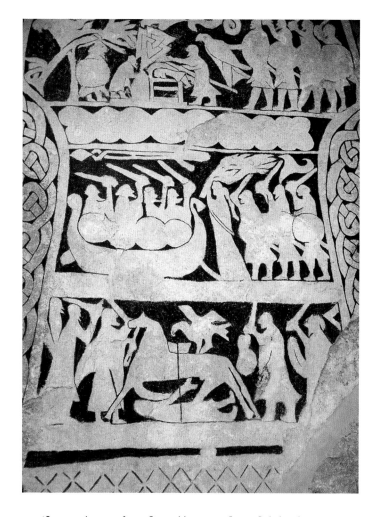

sacrifice on the one from Stora Hammars [**36**, **37**]. It has been suggested that the scene below this one, of a woman between two armed forces (one aboard ship), is of Freyja, the goddess who, according to a verse in the pagan poem *Gríminismál*, was entitled to pick out 'half the slain', with only 'the other half' being for Odin. In the next register below this somewhat enigmatic scene, a battlefield is certainly depicted, with pairs of warriors on either side of a corpse beneath a rider-less horse, towards which swoops a predatory bird (an eagle or raven?).

It is evident that a significant aspect of the 'message' being conveyed by these 'picture-stones' is found in their lowest register, containing a ship under sail, which suggests belief in a

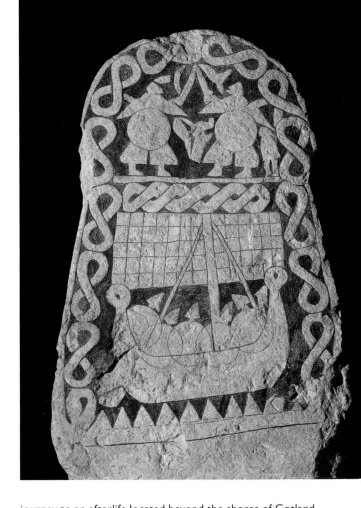

38. Simple 'picture-stone' from Smiss (I), När, Gotland, with a scene of two warriors, wearing short cloaks and flared trousers, engaged in single combat, while being watched by a small figure (on the right), above a ship full of helmeted Viking warriors. (H 1.26 m; paint modern.)

journey to an afterlife located beyond the shores of Gotland. On the simpler stones, with only two registers, the upper scene depicts either armed conflict, such as the couple of warriors in combat on that from Smiss [38], or what can be interpreted as a scene set in Valholl, featuring a welcoming valkyrie of the type encountered above in metalwork [182]. More elaborate depictions of Valholl, including what could be Odin's hall itself, are seen on the 'picture-stones' from Tjängvide [39] and Ardre [192], to be discussed further in Chapter 5 (pp. 161, 163). There can be no doubting an overall connection with a cult of death, even for those stones erected away from the pagan burial grounds.

It has been suggested that the distinctive 'key-hole' shape of these 'picture-stones' from the early part of the Viking Age

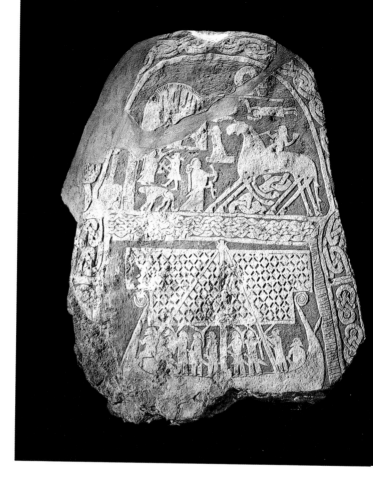

39. The lower register of this fragmentary 'picture-stone', from Tjängvide (I), Alskog, Gotland, is filled with a fine ship under sail; the elaborate scene in the upper register is generally considered to represent the reception of a dead hero in Valholl (see ill. 181). (H 1.75 m; paint modern.)

is intended to be phallic, but an alternative hypothesis is that they are to be viewed as doorways, shaped like that of the later Urnes church in Norway [162]. In other words, they might have been erected not just as memorials to dead Vikings, but also as portals, forming thresholds to the afterlife. Later examples in the sequence of Viking Age stone monuments in Gotland are presented below (pp. 147–49).

Sources for Viking Art

Although the Gotlandic 'picture-stones' provide an exceptional resource for the student of Viking art, they constitute a unique phenomenon given that stone carving was not practised elsewhere in Scandinavia until the mid-tenth century – except

in the case of undecorated runestones – with the erection of the royal monument at Jelling in Denmark (see Chapter 3). After this, with the gradual spread of Christianity in Scandinavia, the use of stone for permanent Christian memorials became well established in many areas (as is described in Chapter 4).

Wood would have been the natural medium for carving by Viking Age artists. This is revealed most clearly at both the beginning and end of our period, by chance in Norway – in the form of the carvings from the Oseberg ship-burial, from the early ninth century (to be described in the next chapter), and in the decoration of the Urnes stave-church, from the late eleventh century [9; see also 161, 162]. These remarkable survivals allow us to form at least an impression of what we are missing from the original corpus of Viking art, although wooden fragments and small-scale carvings in other materials (such as antler, amber and walrus ivory) provide further hints. The same is inevitably true of the textile arts, although weaving and embroidery were clearly well-developed crafts [54, 55; see also 110].

As indicated in the Introduction, the main history of Viking art has to be written from a study of the decoration on ornamental metalwork from a variety of different sources. Finds of precious metal normally take the form of treasure hoards [e.g. 4, 58, 72 and 99], most of which would appear to have been concealed for safe-keeping by owners who proved unable to recover them later, although some seem to have been deposited for ritual reasons – as offerings to the gods. Ornamental metalwork of a more everyday nature from the Viking Age is found in graves because of the widespread (pre-Christian) practice of accompanied burial. The body was laid out fully clothed, whether for the grave or pyre – often, it would seem, in full finery – and could be buried with objects from daily life, such as weapons, tools and household goods, as a reflection of his or her status. It is unknown whether such grave-goods were buried primarily for family and social reasons, as offerings, or whether it was believed that such equipment would be of actual use to the deceased in his or her afterlife.

Excavations of rural settlements have provided further insights into the nature and variety of Viking art, but decorated objects can be rare finds – perhaps no more than worn out or broken discards. On the other hand, urban settlements have

proved to be a rich source of material, in particular because they are more likely to provide evidence for the production of ornamental metalwork – whether by specialist gold- or silversmiths or by craftsmen engaged in mass production [e.g. 74, 153].

In some of the regions under discussion, where metal-detecting is permitted by law and the conditions are appropriate (such as in Denmark and England), there has been a recent spate of single finds of metal ornaments which, for the most part, represent casual losses. This source of evidence for Viking art is producing a rapidly expanding body of new material, which is doing much to increase our understanding of the distribution of different classes of decorated objects, but which also includes the occasional discovery of a previously unknown type of artefact.

A final source for information on the visual arts, even if of limited use for current purposes, is skaldic verse – a complex form of poetry composed during the Viking Age and passed on by means of oral tradition until written down at a later date. Some verses serve to remind us of the non-survival of most painted decoration, despite some rare exceptions on wood [e.g. 113, 156] and stone [145]. For example, the ninth-century skald (poet) Bragi Boddason mentions four, seemingly unrelated, scenes painted on a shield. These include Thor's fishing expedition (p. 165), which likewise appears in a tenth-century poem by Ulf Uggason, in a description of the pagan pictures in a newly built hall in Iceland.

Against this geographical, political and cultural background, the six main styles into which Viking art is divided – from Oseberg to Urnes – are presented in the next three chapters. For convenience, their sequence and chronology can be found summarized in the timeline on p. 9.

Chapter 2 The Oseberg and Borre Styles

The first stylistic period of Viking Age art is named the Oseberg style, which lasted for the first three quarters of the ninth century. It is not characterized by innovations of motif, but rather by adjustments to the forms taken over from Style E, such that some scholars choose not to separate it out in the mainstream of the development of Scandinavian art [40]. It is, however, convenient for both stylistic and chronological reasons to use it to mark the full establishment of the Viking Age. Such is made possible by the quality and variety of the remarkable wood-carvings found in the ship-burial at Oseberg, Vestfold (in southeastern Norway), after which the style is named. These not only provide an exceptional insight into the artistic achievements of the early Viking period, but also serve as a reminder of all that has been lost to us of Viking art through the natural decay of organic materials over the last thousand years.

Although seemingly popular throughout Scandinavia, the Oseberg style was of little consequence outside, but this is hardly surprising, for chronological reasons, given the gradual process of overseas settlement. The second half of this chapter contains a consideration of its immediate successor – the Borre style – which was both long lasting in its popularity and of widespread influence throughout the expanding Viking world.

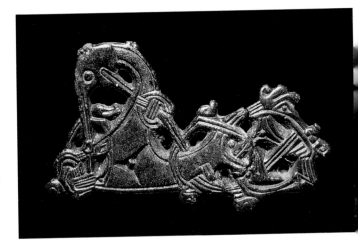

40. Animal-shaped bronze brooch in the Oseberg style (L 7.8 cm), from a female grave at Kaupang, Vestfold, Norway. The horse-like animal is treated in the tradition of Style E.

The Oseberg Style in Scandinavia

As described by Signe Horn Fuglesang (1986), 'in the Oseberg style, Scandinavian ornament was reshaped into a carpet-pattern play of light and shade through the numerous squat animals which are rendered into relief on many planes.' This preference for the use of 'squat animals' in relief, in particular of the increasingly popular 'gripping-beast' [41, 42], was at the expense of the Style E 'ribbon-animal' (for the time being, at least).

Foreign influences on the development of the Oseberg style have sometimes been sought, because similar design tendencies

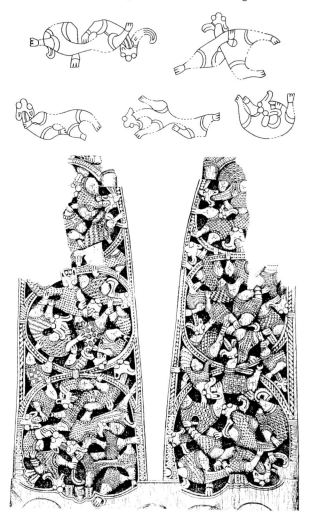

41, 42. The neck of the 'Carolingian' animal-head post from the Oseberg burial (see ill. 48) drawn out to reveal its complex use of massed 'gripping-beasts' in an oval framework. The top left animal in the detail (above) is taken from its position on the post seen at bottom right.

are present in contemporary art in western Europe, both Anglo-Saxon and Carolingian, but such resemblances need be no more than coincidental. It may well be, however, that the use of paired animals, of somewhat more naturalistic appearance, on a new type of oval brooch was inspired by Anglo-Saxon art where a similar motif was popular during the eighth century.

The Oseberg style appears to have developed in Scandinavia during the period of the existence of a seemingly 'royal' workshop in Vestfold, Norway, which was responsible for the manufacture and decoration of the wide range of wooden objects that were deposited in the Oseberg ship-burial in 834 (see below). Given that the style was not introduced into the Viking settlements in the West, it is generally thought to have begun to decline in popularity in the mid-ninth century. Some aspects of the style did, however, continue in use, but the transition to the Borre style seems to have already been underway.

The Oseberg Wood-Carvings

The Oseberg ship-burial is located in Vestfold, in the fertile part of southeast Norway – the region known as Viken – where Danish kings held power at the beginning of the Viking Age. The grave-chamber is known to have been constructed within the ship in 834, according to its dendrochronology. It accommodated the bodies of two women, who most likely died at the same time, with one aged about 60–70 and the other now considered to have been at least 50 (although once thought to have been much younger). The richness of the contents of the Oseberg burial surpasses that of any other Viking Age grave so far discovered and it is thus reasonable to suppose that we are here face-to-face with a royal burial – that of a queen and her companion, or maybe slave, although they appear to have shared the same diet.

The particular importance of the Oseberg burial for archaeology and art-history is not only its high status, but also the exceptional degree of preservation of the numerous organic grave-goods contained in the mound, beginning with the ship itself and extending through assorted household and other wooden artefacts to the textiles, which included clothing, bedding and wall-hangings in the precisely dated grave-chamber.

43, 44. A coiled snake's head forms the reconstructed prow (opposite left) of the Oseberg ship excavated in 1904. It was discovered in a burial mound constructed in 834 for a wealthy female, perhaps a queen, at Oseberg, Vestfold, Norway. The drawing (right) shows a detail of the Style E animals from one of the decorative friezes on the ship's prow, carved in about 820.

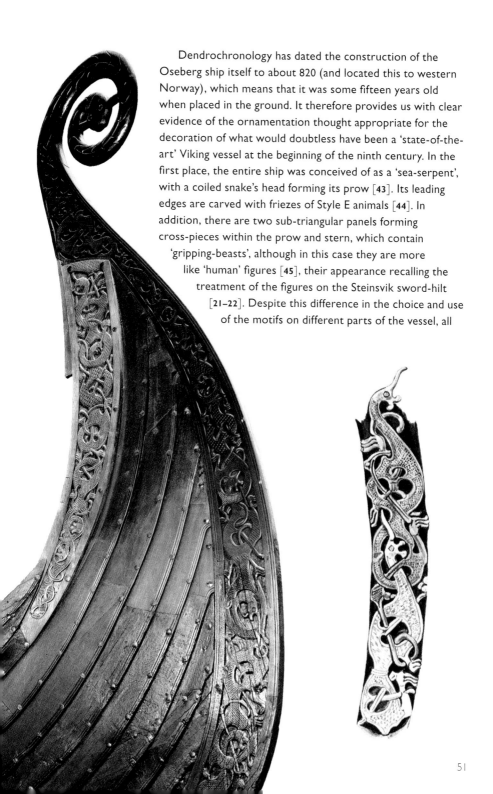

Dendrochronology has dated the construction of the Oseberg ship itself to about 820 (and located this to western Norway), which means that it was some fifteen years old when placed in the ground. It therefore provides us with clear evidence of the ornamentation thought appropriate for the decoration of what would doubtless have been a 'state-of-the-art' Viking vessel at the beginning of the ninth century. In the first place, the entire ship was conceived of as a 'sea-serpent', with a coiled snake's head forming its prow [43]. Its leading edges are carved with friezes of Style E animals [44]. In addition, there are two sub-triangular panels forming cross-pieces within the prow and stern, which contain 'gripping-beasts', although in this case they are more like 'human' figures [45], their appearance recalling the treatment of the figures on the Steinsvik sword-hilt [21–22]. Despite this difference in the choice and use of the motifs on different parts of the vessel, all

the carvings are generally considered to be by the one 'Ship's Master', working in the manner of Style E.

The wooden objects selected for deposition alongside all the other grave-goods in the Oseberg ship include numerous plain artefacts, of the basic kind required in the course of daily life at the court (including spinning and weaving), but there are also several pieces of varying size (including vehicles and furniture) that display carved ornament. We can do little more than suggest which ones among them might be the work of individual craftsmen – and only attempt to place them in some chronological order. It is generally considered, however, that we are dealing with the work of a 'Vestfold school', or workshop, whose wood-carvers seem to represent a single generation of artists. These included both conservative and experimental craftsmen, hence the names introduced for them by Haakon Shetelig (1920) for individual hands, such as the 'Academician', whose fine and precise work is traditional in style (Style E), to be contrasted with that of the innovative 'Baroque Master' who is taken to exemplify the new 'Oseberg style'.

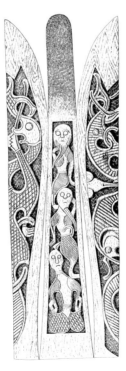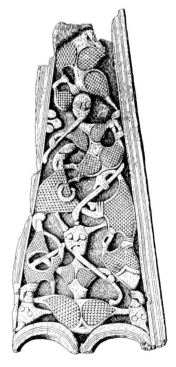

45. Two cross-pieces (here much reduced in size) from inside the stem and stern of the Oseberg ship (ill. 43). They are filled with anthropomorphic versions of the 'gripping-beast' motif, distinguished for the most part by their long beards.

The decorated wooden objects in the Oseberg burial consist of a wagon, five animal-head posts (of unknown function), four sledges and five sledge-poles, together with sixteen planks that have animal-head terminals (from beds and tents). These all display a stylistically coherent range of ornament, although the wagon [53] is exceptional in its incorporation of a couple of narrative scenes – and so it will be considered last, together with the narrative wall-hangings from the burial chamber.

The animal-head post attributed by Shetelig to the 'Academician' is carved in flat relief on the head alone – contrasting with the plain neck [46, 47]. The design on each jaw consists of a pair of birds, back to back, with their tendril-like wings and elongated bodies intertwined to form a carefully controlled network of loops. This masterpiece exemplifies Style E in wood-carving, executed with all the delicacy of treatment encountered in metalwork. Other aspects of Style E can be seen elsewhere among the Oseberg carvings, such as the well-handled 'gripping-beasts' on the so-called 'Carolingian' animal-head post [41, 42, 48], and in the elaborate and varied

46, 47. One of the five animal-head posts (max. H 59 cm), of uncertain function, from the Oseberg ship-burial (below left). This is the work of the sculptor known as the 'Academician' for his traditional and precise use of Style E, carved in low relief. The intertwined heads of the four birds that wrap around the animal-head (in two interlaced pairs) can be distinguished on the shaded drawing (below right).

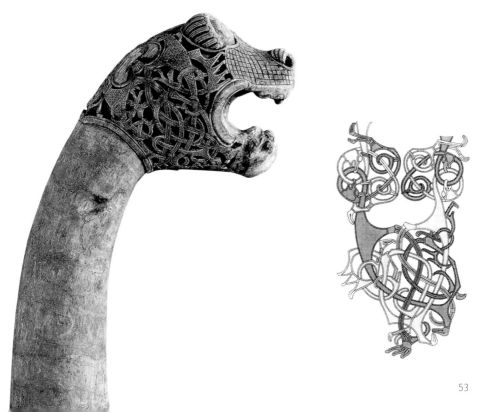

48. The so-called 'Carolingian' animal-head post from the Oseberg burial is decorated in low relief with 'gripping-beasts' that writhe and interlace together, in and around a framework of linked ovals, as can be seen most clearly on its neck (drawn out in ill. 42).

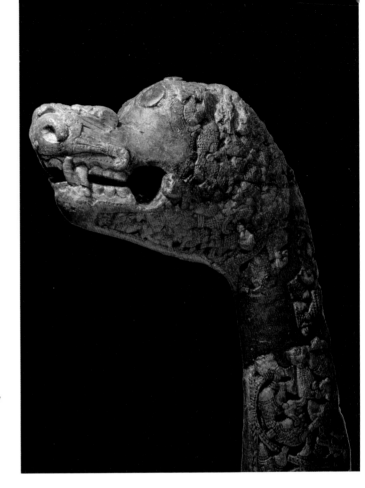

49. (below) One of the three decorated sledges from the Oseberg burial. Known as 'Shetelig's sledge', it is elaborately carved on three planes, with geometric frameworks overlying Style E animals, and has traces of paint. The fierce animal heads 'guarding' its four corners are also worthy of note.

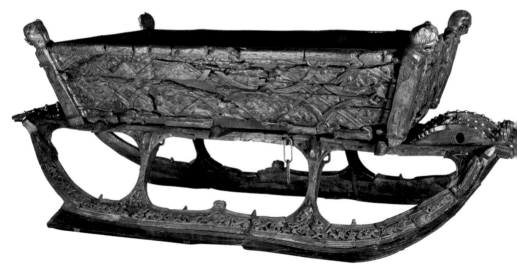

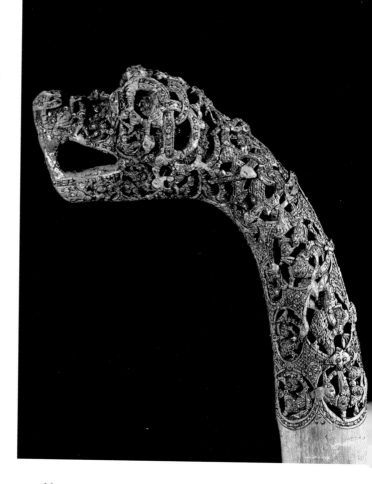

50. One of a pair of animal-head posts from the Oseberg burial attributed to the so-called 'Baroque Master', who combined old and innovative elements to create a new stylistic unity. It is carved in high relief, on many planes, enhanced by the addition of decorative metal rivets.

use of frameworks in the decoration of the 'fourth' sledge. In the context of the detached animal-head posts, there may be some relevance for understanding their possible significance in the animal-head corner-posts that 'guard' the four corners of this and Shetelig's sledge [49].

The 'Baroque Master', whose hand Shetelig identified on two animal-head posts and two sledge-poles, was clearly trained in the use of Style E, but his approach differs from that of the 'Ship's Master' and the 'Academician' in both overall composition and carving technique. The 'first' animal-head post of the 'Baroque Master' [50] exemplifies the contrast, with its variety of birds and animals in seeming confusion, as opposed to the use by the 'Academician' of a single motif and the clean lines of his open loops. The animal's neck is treated as a carpet pattern, combining a strong framework with a further

51. Detail of the decoration on the draw-bar of a sledge from the Oseberg burial also attributed to the 'Baroque Master'. Like his animal-head post illustrated here (ill. 50) the carving is embellished by dome-headed metal rivets.

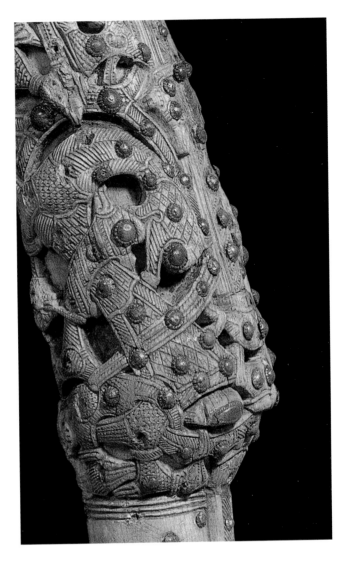

abundance of animal ornament, resulting in the suppression of the background. The carving of the 'Baroque Master' introduces a plasticity of relief, which is further enhanced in this instance by the application of dome-headed metal rivets, as also to be seen on his 'complete' sledge-pole [51].

The Oseberg wagon [53] has a removable body held in a pair of cradles that uniquely terminate in naturalistic human heads, each given its own characteristics. On the front there is a depiction of a bearded man surrounded by snakes (see

52. Enigmatic scene (right) involving three figures carved on one of the long sides of the Oseberg wagon (below), above a frieze of archaic looking 'ribbon-animals' that are treated like 'gripping-beasts (ill. 28c). The man with a raised weapon has seized the reins of the rider's horse, but is being restrained by a long-haired woman wearing an elaborate necklace.

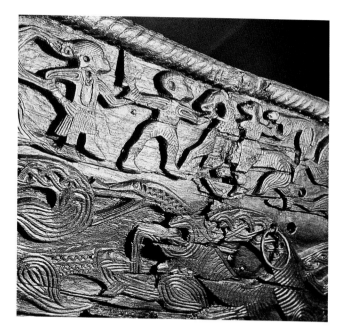

53. The oak wagon from the Oseberg ship-burial has a separate body resting on two curved pieces of wood that terminate in semi-naturalistic human heads. The scene on the front face is confused to modern eyes, but includes a man grappling with snakes (see also ill. 52).

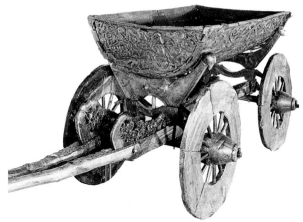

p. 177). Chains of 'ribbon-animals' decorate its sides [28c], interrupted in one place by a dramatic scene (of unknown significance) being enacted between three figures [52]: a man holding a weapon in his right hand confronts a rider, who is accompanied by a hound. The raised arm of the standing man is restrained by a woman, with flowing hair, who is wearing an elaborate necklace. Everything about the Oseberg wagon suggests that it was a ceremonial vehicle, perhaps even used for the funeral procession.

54. (right) Fragment of the textile wall-hanging from the Oseberg burial chamber (constructed in 834). It provides a rare example of Viking Age narrative art, otherwise encountered at Oseberg only on the ceremonial wagon; however, decorated textiles are themselves rare survivals from this period in Scandinavia (cf. ills 110 and 180).

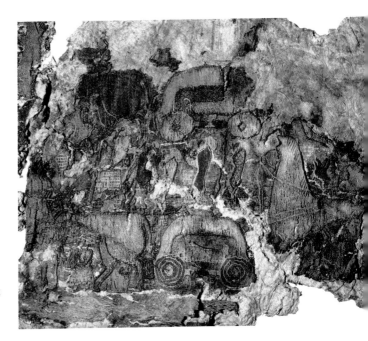

55. (below) This reconstruction of part of the Oseberg wall-hanging (including ill. 54) clearly shows a procession of men and women, walking and riding, together with many spears (Odin's special weapon); another fragment (not shown here) depicts a tree with people hanging from it, suggesting a further connection with the cult of Odin, 'God of the Hanged'.

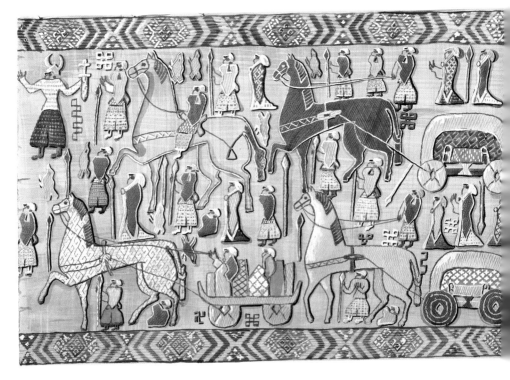

It is of particular interest therefore that the poorly preserved textile hangings from the burial chamber [54] appear to depict a religious ceremony involving a procession towards a great tree in which corpses appear to be hanging. As reconstructed [55], the walking figures, both male and female, many of whom are armed, accompany a number of horse-drawn wagons. Some of these figures wear ritual costume: one has a horned helmet, and another an animal-head mask [cf. 31].

The Later Oseberg Style and the Hoen Hoard

The Oseberg style continued to be used to some extent, even after it had been replaced in popularity by the Borre style, because of the mechanical copying involved in the production of standard brooch types. It has to be said, however, that such copying led to debasement, which means that some of the decoration on oval brooches, for example, cannot realistically be attributed to any mainstream style of Viking art.

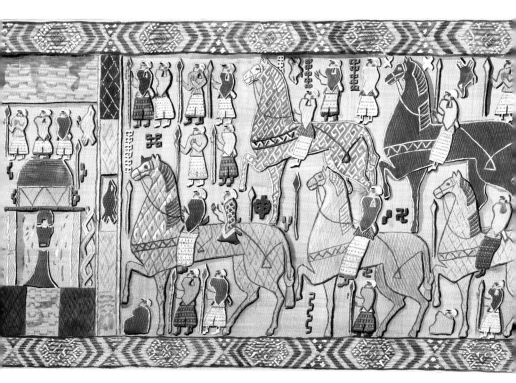

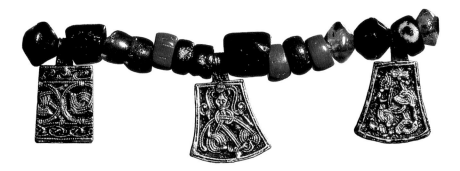

56, 57. (above and below) Three gilt-silver mounts, decorated with 'gripping-beasts', adapted for use as pendants on a necklace (above) from the late 9th-century hoard found at Hoen, Buskerud, Norway (opposite). The 'gripping-beast' on the central example has adopted the Borre-style pose (W 1.9 cm). The cruciform mount (below; much enlarged) was cut from a gold filigree-decorated ornament of 'Terslev type' (see p. 73,), also for re-use as a pendant.

58. (opposite) The Hoen hoard contains 2.5 kg of gold and silver ornaments, including twenty coins mounted as pendants, together with 132 beads of glass or semi-precious stone, the most impressive item being the spectacular gold trefoil mount, of Carolingian manufacture (L 11 cm), adapted for use as brooch.

In addition to being the location of the Oseberg ship-burial, the wealthy southeastern region of Norway yielded the find-place of the largest gold hoard known from Viking Age Scandinavia (weighing about 5.5 lb, 2.5 kg), at Hoen in Eiker, Buskerud [58]. Although it includes twenty foreign coins, this is a jewelry hoard because they have all been converted into ornaments by the addition of suspension loops. The latest coin is an Arabic dinar struck in 848/49, but just how long after that the Hoen hoard was deposited depends on stylistic judgments; however, burial is not considered to have taken place before about 875 – and it may even have been a decade or so later. Moreover, it is clear that this collection of family wealth had been assembled over a period of time, but even if the Hoen hoard was buried some fifty years after the contents of the Oseberg ship and its contents, the two finds are more than just geographically related, given their stylistic connections. In addition, both reveal the existence of wealthy – and presumably powerful – women at the top of Scandinavian society in the ninth century.

The Hoen hoard, which was found in 1834, consists of a magnificent set of gold ornaments, including a necklace that combines glass and other beads with numerous decorative pendants (including the coins). There are several gold rings (for neck, arm and finger) and an extremely fine Carolingian trefoil-shaped mount, with acanthus ornament, adapted for use as a brooch [58 top left]. Some of the objects converted into pendants display 'ribbon-animals' and others have 'gripping-beasts' [56]. Signe Horn Fuglesang believes them to 'belong squarely' within Style E and the Oseberg style, whereas David Wilson has detected in some, at least, the emergence of the Borre style. However, in the case of one fragmentary mount, forming a cross-shaped pendant [57], Fuglesang (2006) has

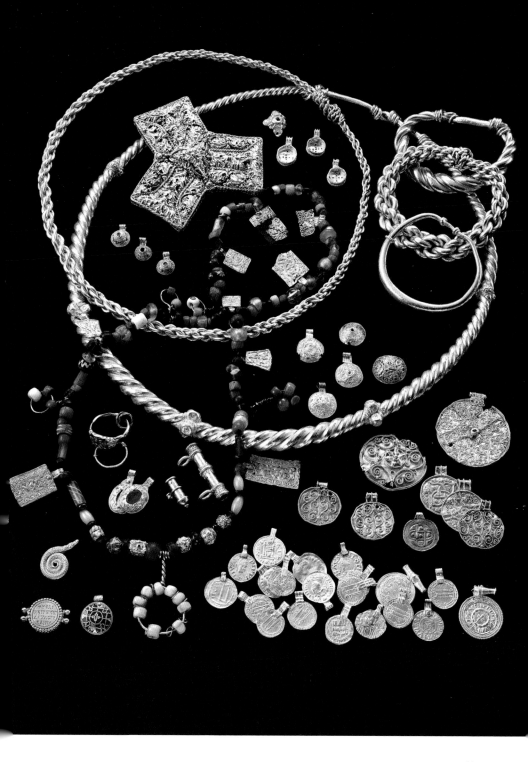

recognized the central element of a Terslev-type disc-shaped ornament (brooch or pendant) of the type to be discussed below as forming part of the mainstream Borre style.

It is worth drawing attention here to a somewhat unexpected connection between the Oseberg and Hoen finds. As already noted, one side of the Oseberg wagon depicts a scene involving three human figures in which the woman is shown wearing a long necklace in three loops [52]. This is the only possible manner in which the Hoen lady could have displayed her collection of beads and pendants, if they were all strung together.

The Hedeby coins

Before turning to a consideration of the next development in Viking art – the Borre style – there is a further aspect of Scandinavian design during the ninth century that is of particular interest because of its exceptional nature. This is the coinage struck in the town of Hedeby during the 820s, presumably under royal Danish authority. This was the only coinage being minted in Scandinavia at this period, for limited local circulation, although individual coins became more widely distributed when converted into pendants, such as those that have been found in a number of female graves at Birka, in central Sweden.

The first Hedeby coins were based on the official Carolingian coinage of the important Frisian trading-centre of Dorestad, at the mouth of the River Rhine (in Holland). There are, however, a few types that utilize original designs and the three illustrated here depict two different types of ship and a house [59]. One of the ships is clearly a Viking longship, with its sail furled – thus seen at rest, displaying a row of shields; there is a fish in the sea below. The other vessel is a Frisian-type cargo ship, in this case under sail, with two wave-like arcs replacing the fish. The house is of Scandinavian type, with slanting buttresses helping to support its hog-backed roof – and with animal heads projecting from the gables.

The inspiration for the Hedeby ship-designs was the Frisian ship used on coins at Dorestad and Quentovic, another North Sea port (on the River Canche, in the Pas de Calais, France). Likewise the house will have been modelled on the imperial temple or church used on the *Christiana religio* coins of Emperor

Louis the Pious (r. 814–40), which have a cross on the reverse. Indeed, it was at the court of Louis that the Danish king Harald Klak was baptized in 826.

Given the restricted occurrence of naturalistic art in Scandinavia during the Viking Age, the Swedish numismatist, Brita Malmer, has speculated that the designs created by these Hedeby moneyers were intended to express a Christian message – given the existence of a Carolingian Christian mission in southern Scandinavia during this period – with the ship representing the Church, in combination with the fish symbolizing the Christian faith.

The Borre Style in Scandinavia

As the successor to the Oseberg style, the Borre style was popular throughout Scandinavia. During the long period when it was in fashion its impact was also felt, to a greater or lesser extent, throughout all the main areas of Scandinavian settlement – in both the East and West.

The style has been named for the decoration on a set of horse-harness mounts found in a robbed ship-burial at Borre in Vestfold, Norway [**60**]. These gilt-bronze ornaments display the main motifs of the style, which comprise two groups [**61**]: geometric interlace/knot patterns and zoomorphic shapes (in the form of single animals). The principal animal motif is a 'gripping-beast', with a ribbon-shaped body [cf. **29f**]. In both cases, the visual impact of the style is normally achieved through filling up the available space, with the ribbon-plaits being tightly interlaced and with the bodies of the animals arranged accordingly to form closed compositions. In consequence, there is an absence of background, which is an aspect of the style that contrasts markedly with the appearance of the more open and fluid compositions favoured in the largely contemporary Jellinge style, to be discussed in the next chapter. Signe Horn Fuglesang (1982) also recognizes 'a juxtaposition between striated and polished parts' in ornamental metalwork, such as the Borre strap-ends [**60**, **61**], with their combination of striated interlace and raised, polished, animal-head terminals.

The decoration of the Borre mounts includes the 'classic' Borre-style interlace/knot motif known as the 'ring-chain', in which the ribbons are combined to create a pattern that

59. Three Danish coins minted at Hedeby in the 9th century. The upper two display different types of ship, whereas that below depicts a house with slanting posts buttressing its hog-backed roof, which has projecting animal heads like those on the Cammin casket (ill. 126).

60. Gilt-bronze mounts from a horse harness found in a ship-burial at Borre, Vestfold, Norway, which has given its name to the Borre style of Viking art. The two strap-ends (bottom), with animal-head terminals (L 5.1 cm), are decorated with the 'ring-chain' motif of knotted interlace, their double strands displaying the nicked contours imitative of filigree work.

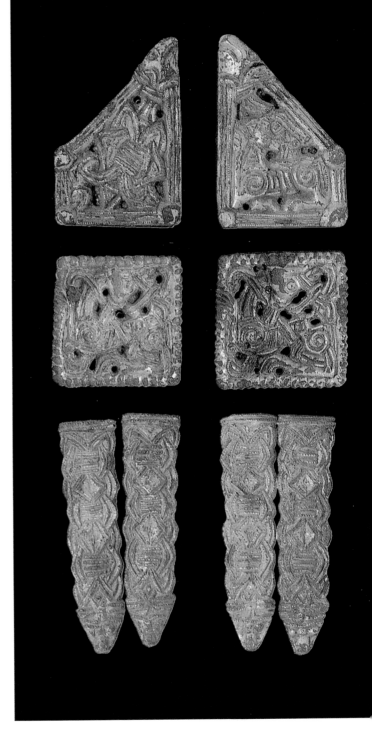

61. Six of the Borre mounts, including examples with the Borre-style 'pretzel' knot at top left and bottom right (with animal-head) and 'ring-chain', top centre. The backward-looking animals in profile (bottom left and centre) are less common in the Borre style than single 'gripping-beasts' (as seen in ill. 29f), but their bodies have been characteristically arranged to fill all the available space.

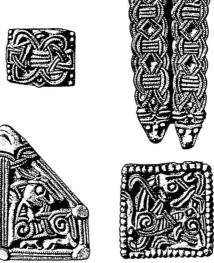

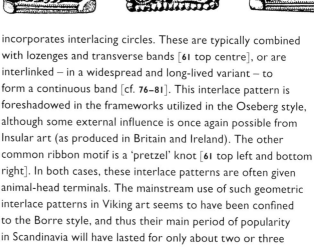

incorporates interlacing circles. These are typically combined with lozenges and transverse bands [61 top centre], or are interlinked – in a widespread and long-lived variant – to form a continuous band [cf. 76–81]. This interlace pattern is foreshadowed in the frameworks utilized in the Oseberg style, although some external influence is once again possible from Insular art (as produced in Britain and Ireland). The other common ribbon motif is a 'pretzel' knot [61 top left and bottom right]. In both cases, these interlace patterns are often given animal-head terminals. The mainstream use of such geometric interlace patterns in Viking art seems to have been confined to the Borre style, and thus their main period of popularity in Scandinavia will have lasted for only about two or three generations.

The Borre-style interlace patterns would appear to have been worked out in fine metalwork because the double strands, with their nicked contours, on the cast (gilt) ornaments appear to imitate filigree work. On the other hand, Fuglesang has suggested (1982) that the 'nicking' or transverse striations are more 'probably bound up with the play of light and shadow' carried over from the Oseberg style. The one interpretation does not, however, exclude the other.

It is certainly true that there exist some remarkable masterpieces of the Viking Age goldsmith's art executed in

the Borre style, including the Hiddensee hoard (to be discussed below). Even more exceptional, however, are the contents of another hoard, found at Værne Kloster in Østfold, Norway [62], consisting of a gold spur, strap-end and belt-slide. These are of far too fine workmanship and delicate construction to have been used other than for presentation and display.

The 'ribbon-animal', with its origins in Style E, is used singly in the Borre style, being reshaped so as to have more naturalistic proportions, with spiral hip-joints. Its head, shown in profile, with extended tongue, is frequently backward looking so as best to fill the available space [61]. Likewise the Borre-style 'gripping-beast' is used singly and departs from the version introduced in the Oseberg style [29e–f]. Its mask-like head en face, which is generally triangular, with protruding ears, forms the apex of a triangular composition. The expanded

62. The gold hoard found at Værne Kloster, Østfold, Norway, contains a remarkable spur (prick missing), with a strap-end (L 4.3 cm) and belt slide, bearing delicate filigree decoration that includes the Borre-style 'ring-chain' given zoomorphic character by the addition of animal-heads in profile.

(polygonal) fore- and hindquarters form the other two angles, linked by a ribbon-shaped neck and body. The four paws grip its own body and the surrounding frame, as can be seen here on an oval brooch from Åsen in Norway [63] and a unique silver ornament, in the form of a stylized ship, from Randlev in Denmark [64].

A particularly fine example of a Borre-style composition based on the 'gripping-beast' motif is provided by a silver filigree-decorated disc brooch from Finkarby, in Sweden [66]. The design consists of four animals with their heads at the centre, snouts touching so as to form a central cruciform pattern. The four 'gripping-beasts' on a cast quatrefoil brooch, from Rinkaby, in Skåne, are more clearly depicted, each being in its individual field, with the arms of the dividing cross terminating in Borre-style masks [65].

63. Bronze oval brooch (L 10.8 cm) from Åsen, Nord-Trøndelag, Norway, with an original design incorporating seven openwork bosses, riveted to the surface, in the form of Borre-style 'gripping-beasts'.

64. Gilt-silver ornament (W 2.5 cm), with niello inlay, in the form of a stylized ship containing a Borre-style 'gripping-beast', cheerfully throttling itself, from Randlev, Jutland, Denmark.

65. (left) Gilt-silver quatrefoil brooch (W 6.8 cm), with niello inlay and a red glass setting, from Rinkaby, Skåne, Sweden, divided into four fields by a cross, terminating in inward-looking animal masks, each of which contains a classic Borre-style 'gripping-beast', differing in their details.

66. (right) Silver disc brooch (D 5.4 cm) from Finkarby, Södermanland, Sweden, with filigree decoration in the form of four animals whose snouts touch at the centre, belonging to the Borre-style family of 'gripping-beasts', related to those on ill. 65.

67. (opposite above right) Cast silver disc brooch in the British Museum (D 7.8 cm), probably found in Gotland. It is the finest known example of this type with Borre-style decoration incorporating three-dimensional figures (both men and beasts).

69. (opposite below right) Incomplete equal-armed brooch of cast silver, with gilding and niello (H 8.8 cm), from Elec, in the Upper Don region, Russia. Its elaborate Borre-style decoration includes free-standing animals and heads, making it more magnificent than any such brooch found in Scandinavia. The inclusion of a palmette in relief in its ornament suggests eastern influence: it might be the work of a Scandinavian craftsman in the early Russian state.

The more plastic treatment encountered in the Borre style means that the animals – as also occasionally humans – are sometimes to be found executed fully in the round. The decoration of a silver disc brooch in the British Museum, probably from Gotland, includes four free-standing quadrupeds, two animal torsos and two squatting human figures, gripping what may be their forked beards [67]. This is the finest extant example of a group of such Borre-style brooches, known mainly from central Sweden, but there is an even more elaborate example of this treatment in the form of a silver equal-armed brooch, if sadly incomplete, from Elec (or Jelets),

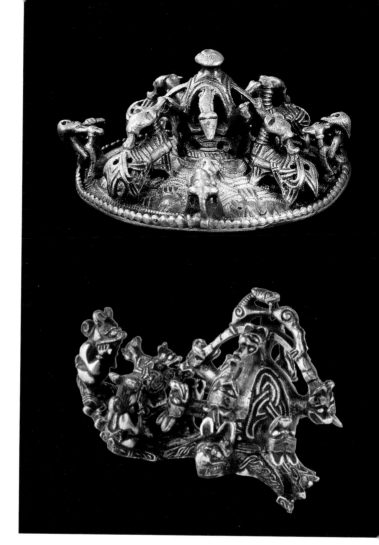

68. (above) These two amber carvings from Norway depict individual 'gripping-beasts' in the round: (top) from Haugsten, Råde, Østfold (H 4 cm), and (bottom) from Inderøen, Nord-Trøndelag (H 4.5 cm).

in the Upper Don [69]. This is the finest representative of another eastern Scandinavian type of brooch, but it is thought that it may well have been made by a Scandinavian craftsman working in Russia because its design incorporates a palmette of Oriental or Byzantine inspiration.

The popularity of the new version of the 'gripping-beast' was such that it could even take on a life of its own, as can be seen in the case of two three-dimensional carvings in amber from Norway [68]. The more naturalistic appearance of these two animals, despite their contortions, does however mean that they depart from the conventions of the Borre style proper.

During the period of popularity of the Borre style, the metalworkers responsible for the production of standard brooch types experimented with plant ornament, based mainly on Carolingian prototypes. In particular, this innovation resulted from the creation of the 'trefoil brooch', by copying the form of the trefoil (or three-way) strap-distributors worn as part of a Carolingian sword-belt [**70** top], although not all were so finely embellished with acanthus ornament as that which ended up in the Hoen hoard, fitted with a silver pin for use as a brooch [**58**]. Some trefoil brooches display well-copied foliate patterns, but on others these have degenerated into crude spirals – or have been replaced with animal ornament [**71**].

This diversion into plant ornament proved to be something of a blind alley, although later Viking art was to be reinvigorated by the incorporation of other foliate motifs (as will be described in Chapters 3 and 4). On the other hand, the paired-spiral motif derived from the acanthus/vine patterns of western European art did take immediate root and then continued to be used in Scandinavian art into the eleventh century.

Coin hoards containing Borre-style metalwork suggest that the style was at its maturity – and greatest popularity – during the first half of the tenth century. Its origins, however, date back into the second half of the ninth century – even if perhaps not, as has been suggested, to as early as about 850. It is also evident that some objects in the style continued in use – or, at least, in circulation – so as to have been deposited in late tenth-century contexts.

The 'Terslev Style' and the Hiddensee Hoard

The so-called 'Terslev style' is, in reality, just a variation on the Borre style – comprising knot patterns on jewelry (disc brooches and pendants) executed in gold or silver filigree, although there are also some gilt-bronze imitations, particularly in the form of small disc brooches. It has been separately designated on the basis of two finds of precious metal: a silver hoard from Terslev, Sjælland (in Denmark), and a magnificent hoard of sixteen gold ornaments from Hiddensee, a small island beside Rügen, off Germany's Baltic coastline. Over 300 pieces decorated in this manner are known, of which about forty are made in gold, and these – together with the evidence for their

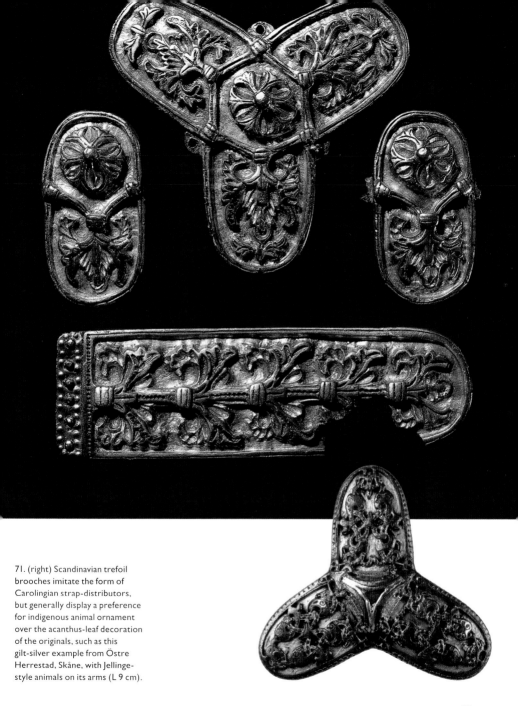

71. (right) Scandinavian trefoil brooches imitate the form of Carolingian strap-distributors, but generally display a preference for indigenous animal ornament over the acanthus-leaf decoration of the originals, such as this gilt-silver example from Östre Herrestad, Skåne, with Jellinge-style animals on its arms (L 9 cm).

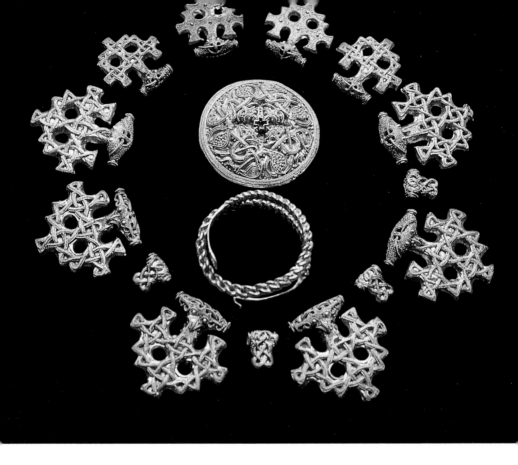

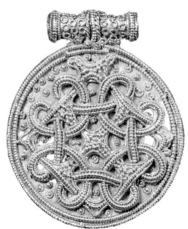

73. (right) One of a pair of gold-filigree decorated pendants (D 3.2 cm), from a woman's chamber-grave at Hedeby, in northern Germany, featuring the so-called 'Terslev style' knot-pattern belonging to the Borre style.

72. The spectacular Hiddensee gold hoard, from Rügen, on the north German coast, consists of a neck-ring, disc brooch (D 8.0 cm) and necklace, weighing in total nearly 600g. The bird-headed pendants relate to the metalworker's dies from Hedeby (ill. 74) and were most probably made in Denmark towards the end of the 10th century.

manufacture – are concentrated mainly in southern Scandinavia and northern Germany. They are clearly the work of highly accomplished goldsmiths who, for the most part at least, seem to have worked for the Danish royal court during the mid- to late tenth century, under Harald Bluetooth (who died in 987) and his son Svein Forkbeard (*d.* 1014), although their products did in fact spread all over the Viking world, from Iceland to Russia.

The commonest type of ornament decorated in the 'Terslev style' is a small, convex, disc brooch bearing a single knot motif: a symmetrical arrangement of four volutes combined with a circular or quadrangular band [cf. **57**]. There are several pendants decorated with this characteristic design in the Terslev hoard itself and three fine examples, in gold, are known from Hedeby, including a pair from a chamber grave [**73**].

The gold hoard found on the beach of Hiddensee, following storms in 1872 and 1874, consists of a classic Borre-style disc brooch, a neck-ring of four twisted rods and a necklace of ten stylized cruciform pendants, with four small 'spacers', although others may be missing [**72**]. Together these items constitute a single set of jewelry – in fine condition – and it has consequently been suggested that this hoard is to be interpreted as an extravagant gift from a Danish nobleman intended for presentation to a Slav woman of high-standing, when it had to be buried for safety en route, during some local emergency that resulted in it not being reclaimed.

All ten of the cruciform pendants from Hiddensee have bird-headed suspension loops, but otherwise they divide stylistically into two groups, in two sizes. The main group consists of six large pendants, with continuous interlace filling their multiple cross-arms, and these are matched by one of the smaller pairs. The arms of the other small pair are filled with minute granulation.

Evidence for the production of brooches and pendants in the Terslev/Hiddensee 'style' is provided by a remarkable find of forty-one bronze dies, as used for the manufacture of the pressed sheets onto which the filigree wires and granules were soldered [**74**]. These dies were kept together in a leather bag, which had been dropped into the harbour at Hedeby. An associated iron draw-plate has fifteen conical perforations of diminishing size that contained traces of the silver wires that it was used to produce. Although some of the Hedeby dies

74. A leather bag recovered from the harbour of the Viking Age town of Hedeby contained a set of forty-one bronze dies (patrices), used to shape the base-plates of disc brooches and pendants before decoration with silver or gold filigree, as seen for example in the Hiddensee hoard (ill. 72).

correspond closely in their form and decoration to the Hiddensee ornaments, their different sizes mean that the dies cannot actually have been used in the ornaments' production. What is of particular interest for our overall understanding of tenth-century Viking art is the fact that this single set of dies indicates the production of fine metalwork in both the Borre and Jellinge styles – the interaction between which is explored in the next chapter.

Among other evidence for the workplaces of travelling gold- and silversmiths in the 'Terslev/Hiddensee style' is a fragment of a clay mould found with other metalworking debris (including crucible fragments) in an excavation at Borgeby, in the west of Skåne. This would have been used to cast the die for the manufacture of a disc brooch and has parallels among those in the Hedeby hoard, although it also closely resembles one from the Swedish town of Sigtuna.

Among the Hedeby dies is a set of six for the production of 'leaf-shaped' pendants in the form of a stylized bird, with the beaked head forming the suspension loop. A damaged gold

75. Gold-filigree pendant in the form of a bird's head found in the Viking Age town of Sigtuna, Sweden (enlarged), related to the bird-headed pendants shown in ills 72 and 74.

pendant of this rare type has been found at Fyrkat, one of Harald Bluetooth's circular fortresses in Denmark. Its nearest equivalent is a further high-quality example from Sigtuna [75], which further suggests the presence of at least one such specialized goldsmith in this urban centre during the second half of the tenth century.

The Borre Style: Expansion

The Borre style was the first Viking art style to be adopted in the overseas Scandinavian settlements – from Russia to Iceland – with its adoption on carved stone monuments across northern England and in the Isle of Man being of particular artistic interest and regional importance.

In Russia, unfinished Scandinavian jewelry in the form of ninth- and tenth-century bronze ornaments has been found at both Staraya Ladoga, on the River Volkhov, and Rjurikovo Gorodishche (near Novgorod), where the river emerges into Lake Ilmen, and also, further south, at Gnëzdovo on the River

Dnepr, attesting the presence of Scandinavian metalworkers in the eastern settlements. It was suggested above (p. 69) that the magnificent equal-armed brooch from Elec was most probably the work of a Scandinavian silversmith in Russia [69]. At a more basic level, the decoration of woodcarvings from Novgorod demonstrates the adoption there of elements drawn from the Borre style [76].

The Scandinavian settlers were, however, fairly soon assimilated in Russia and the Ukraine, even if new groups continued to arrive bringing their own weaponry and other belongings. It is therefore the case that, during the Viking Age, Scandinavian stylistic influences were felt more strongly east of the Baltic Sea, among the Finno-Ugrian and Baltic peoples – and only rarely so in the art of the western Slavs to the south of the Baltic.

One of the Slavic areas with Scandinavian settlement east of the Baltic Sea that has evidence of Borre-style influence was

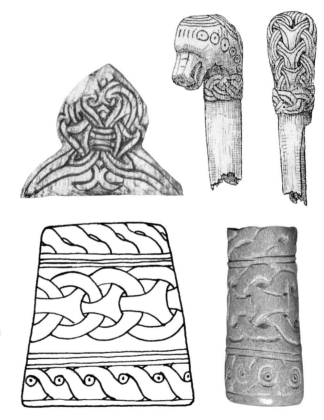

76. Wood-carvings found at Novgorod demonstrate the spread of Borre-style interlace motifs to the settlements with Scandinavian communities in the early Russian state, as at Staraya Ladoga and Rjurikovo Gorodishche.

77, 78. An antler collar decorated with a band of Borre-style 'ring-chain' is among a number of objects excavated at Wolin, in northern Poland, that demonstrate Scandinavian influence on a local workshop.

Wolin in West Pomerania. Wolin is located in the estuary of the River Oder, and the wide range of imported Scandinavian artefacts found there includes a couple of the small 'Terslev' disc brooches. The influence of Scandinavian art on a local workshop is suggested by the discovery of numerous objects decorated with a Borre-style ring-chain ornament [**77**, **78**].

There is no evidence from Ireland for the adoption of the Borre style beyond the 'ring-chain' pattern, which is present in Dublin on only a couple of bone 'motif-pieces' and an Insular type of strap-end. It seems also to have been used there, in combination with indigenous interlace and fret-patterns, to decorate the border of the well-known wooden gaming-board from the high-status native settlement of Ballinderry crannog, Co. Westmeath [**79**]. This lack of popularity may, in part at any rate, be explained by the expulsion of the Scandinavian elite from Dublin by the Irish in 902, although they were to re-establish control there fifteen years later.

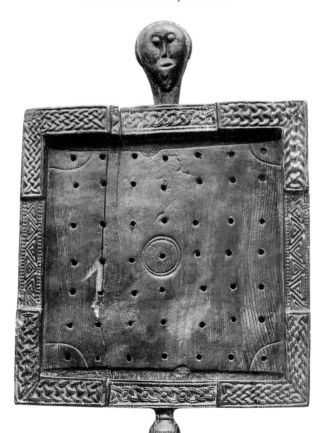

79. The 'ring-chain' is used to fill two corner panels on the decorated border of this yew-wood gaming-board from Ireland (W 24.3 cm). It was most likely made in Dublin, although found on Ballinderry crannog (no. 1), a native settlement-site in Co. Westmeath.

It was presumably at this time, during the early tenth century, that the Borre style became established in the Irish Sea region, with a shift in Scandinavian patronage towards the Isle of Man and northwest England. The impact of the Borre style in this area, although evident in the decoration of carved stone monuments, was limited to its interlace and knot patterns, for these alone seem to have appealed to the local sculptors.

The Norse runic inscription on a cross-slab at Kirk Michael, in the Isle of Man, records that it was raised by a smith with the Celtic name of Mailbrikti 'for his soul', and that 'Gaut made this, and all in Man', with the implication being that this was one of the very first such Christian runestones to have been erected in the island [80]. There existed, however, an indigenous Manx tradition of Christian stone monuments and it was this that was modified for the Vikings when the second-generation settlers embraced the Christianity of the islanders whose territory they had seized.

It is not just the use of Norse runes on the stone carved by Gaut at Kirk Michael that reveals its Scandinavian heritage, but also the use of the Borre-style 'ring-chain', which fills the cross-shaft on the front, together with the knotted interlace in the cross-arms – even if other interlace motifs betray Insular influences (alongside the form of the cross itself). David Wilson's suggestion that Gaut was active in the Isle of Man around 930 has met with general acceptance and, although only one other surviving monument is actually signed by him, others may be attributed to his workshop on stylistic grounds. Some later Manx crosses and cross-slabs are discussed below, in particular the stones from Kirk Braddan with Mammen-style decoration [114], but see also those from Kirk Andreas [196, 199]. It is, however, worth illustrating here a cross-slab from Ballaugh that is transitional in its variety of interlace ornament, including the tendril-like pattern, with its beaded band, that fills the cross-shaft on one main face, alongside which is a 'ring-chain' topped by a cross [81].

It is possible that the Borre-style interlace displayed on these Manx stones was introduced from northern England where the style was more deeply rooted than elsewhere in Britain and Ireland. The classic Cumbrian version of the 'ring-chain' – inverted in comparison with the manner in which it was used in the Isle of Man and east of the Pennines – is

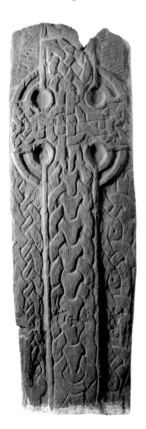

80. This 10th-century cross-slab (H 1.8 m) from Kirk Michael, Isle of Man, has a Norse runic inscription carved by a man named Gaut who claimed to have 'made this, and all in Man'. His use of the 'ring-chain' is thus a characteristic of the first Christian memorials to have been erected for some of the newly converted Viking settlers.

exemplified by that used to decorate one side of a cross-shaft at Muncaster. It likewise features on the remarkable cross that stands in the churchyard at Gosforth [13]. The iconography of the Gosforth cross is of particular interest for its combination of Christian and pagan scenes [200], as was appropriate on such a grand monument erected during the Conversion period, and thus it will be described and discussed below (in Chapter 5).

The church at Gosforth contains the remains of a decorated stone slab, probably carved by the same hand as the cross was. This depicts the story of Thor's fishing trip: in a boat, hammer-wielding Thor, accompanied by the giant Hymir, is attempting to hook the World Serpent from a fish-filled ocean [186]. Also in the church are two 'hogback' stone grave-markers, one with a military scene depicted along its side. These house-shaped 'hogbacks' represent an entirely new form of monument for northern England, created in the tenth century by the Viking settlers. One distinctive variety,

81. The rune-inscribed face of the Manx cross-slab from Ballaugh (H 1.37 m) gives the same prominence to the 'ring-chain' on its cross-shaft as at Kirk Michael (opposite), but on the other face (below left) it appears alongside the shaft that is filled with two interlaced bands with interlocking tendrils.

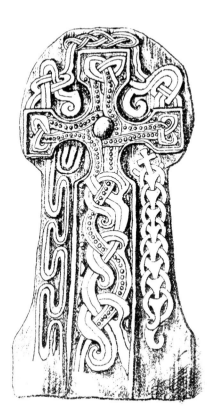

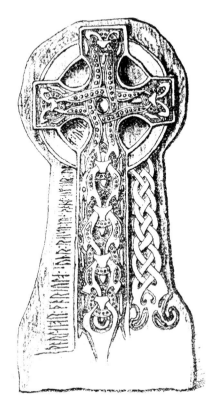

82. Three of the 10th-century 'hogback' stone monuments in Brompton church, North Yorkshire, belonging to a distinctive group – the Ryedale 'school' – of these house-shaped grave-markers that have their gable-ends mysteriously clasped by bears. (Average L c. 1.3 m.)

represented here by a group of stones at Brompton, in North Yorkshire [82], has its gable ends clasped by bears (some muzzled) whose significance is unknown.

Before the Viking settlement of northern England, stone sculpture had been an ecclesiastical art in Anglo-Saxon Northumbria. It was the new Viking chieftains and landlords who, on their conversion, chose to commission permanent stone memorials to themselves – unfamiliar, as we have seen, among the art of ornamental stone carving in their Scandinavian homelands. In the creation of this original Anglo-Scandinavian style, design elements from the Celtic West were also incorporated, as in the form of the ring-headed cross, seen at Gosforth [13] and elsewhere in northern England [103].

The craftsmen producing ornamental metalwork in the Viking kingdom of York at this period, alongside the sculptors, also took up interlace motifs from the Borre style, as can be seen in the attempt at a 'ring-chain' on an Anglo-Saxon type of strap-end from York itself, and in the more superior treatment of the knot pattern on a belt-slide excavated at the rural settlement of Wharram Percy, in Yorkshire [83]. The Scandinavian 'gripping-beast', although present on some imported ornaments, such as a silver pendant found at Little

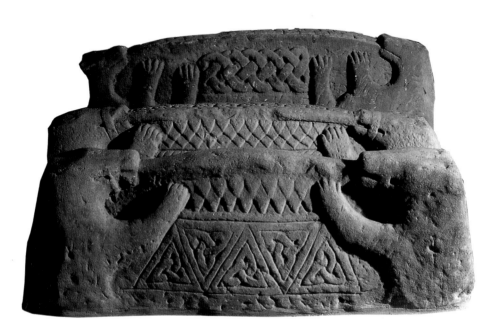

Snoring, in Norfolk [84], failed to find a new home for itself in the Scandinavian settlements of either Britain or Ireland. On the other hand, the single backward-looking animal was adopted for a series of small disc brooches that became popular in the so-called 'Danelaw' territories.

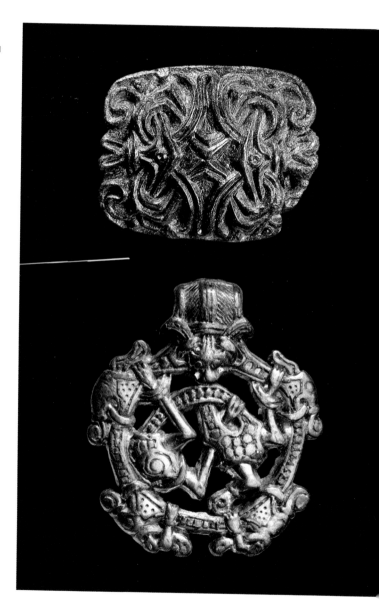

83. This cast bronze belt-slide, with a Borre-style knot-pattern, (L 3.5 cm) excavated from a rural settlement at Wharram Percy, in East Yorkshire, is most probably of Anglo-Scandinavian workmanship.

84. The form and ornament of this fine gilt-silver pendant, with niello inlay, (H 4.2 cm) from Little Snoring, Norfolk, indicate its Scandinavian manufacture. The same openwork type, with its classic Borre-style 'gripping-beast', is present in the Vårby hoard (ill. 97).

Chapter 3 The Jellinge and Mammen Styles

There can be little doubt that the Scandinavian Jellinge style is deeply rooted in the native artistic tradition, with clear origins in Style E. As we shall see, it was largely contemporary with the more innovative Borre style, just discussed, and their occasional overlap and cross-fertilization will be explored in due course below. It is hardly surprising therefore to encounter statements about the development of Viking art during the tenth century such as 'the Jellinge style has a special relationship with the Borre style', at the same time as 'it is impossible to discuss the Jellinge style without reference to the Mammen style', which was to emerge from it during the tenth century.

The existence of close links between the Jellinge and Mammen styles is highlighted by the fact that the two were only differentiated by Sune Lindqvist in 1931 and not properly separated from each other until 1966 by David Wilson, although Haakon Shetelig had earlier (1920) suggested that the Jellinge style should be subdivided into an earlier and a later group. Thus they will be considered together in this chapter, although it is now recognized that the Mammen style marked a particularly innovative phase in Scandinavian art, and it is increasingly the case that it is discussed, entirely logically, together with the Ringerike and Urnes styles, which flow from it in succession, forming the three-style entity that is considered to constitute 'Late Viking Art'. The intimacy, or otherwise, of the earlier relationship between the Borre and Jellinge styles can only be considered after we have reviewed the main criteria that are employed to characterize the Jellinge style itself.

The Jellinge Style in Scandinavia

The Jellinge style is named after the ornamentation on a small silver cup, or beaker (only 1.7 in, 4.3 cm, high), with traces of gilding and niello inlay [85, 86], found in the North Mound of the burial ground and assembly complex established in the mid-tenth century by the Danish royal family at Jelling, in Jutland [5]. The term 'Jellinge' (with its final 'e') is

conventionally used to label the style, thus differentiating it from the place name for the site itself, which is even more famous for its great runestone – a key monument in the ensuing Mammen style [105–7].

The North Mound at Jelling contains the remains of a wooden burial-chamber that was constructed, according to dendrochronology, in 958/59. It had, however, been entered in antiquity, at which point the body and the majority of the grave-goods were removed. There are good grounds for supposing that the body was that of King Gorm, given splendid pagan burial by his son, and successor, Harald Bluetooth. A few years later (as will be established below), Harald was baptized a Christian and took personal responsibility for the conversion of his kingdom. Then, beside his father's grave-mound – and within an earlier ship-shaped stone setting (probably constructed by Gorm as a memorial to his queen, Thyre) – he built a wooden church beneath which was a grave that contained the disarticulated remains of an elderly man, packed in gold-threaded textiles. It would appear that Gorm, for the salvation of his pagan soul, had been removed into the House of God by his son – the ardent new convert.

The royal cup was presumably overlooked in clearing out Gorm's grave because of its tiny size [86]. At the same time, some stylistically important pieces of carved and painted wood were presumably abandoned because of their already fragmentary nature [113]. Around the bowl of the cup is engraved zoomorphic ornament, the greater part of which

85, 86. This small silver cup, with gilded interior (H 4.3 cm), is one of the few extant objects from the pagan chamber-grave constructed in 958/59 in the North Mound at Jelling, Jutland, Denmark, probably for King Gorm (ill. 5). The niello-inlaid and gilt ornament around its bowl, incorporating a classic pair of entwined 'ribbon-animals' (cf. ill. 28), has given its name to the Jellinge style of Viking art.

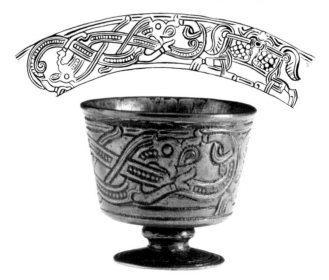

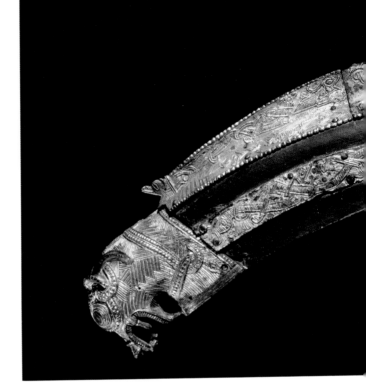

87. (below) Bronze tongue-shaped brooch (W 5.4 cm) from Birka, Sweden, decorated with a pair of standard Jellinge-style 'ribbon-animals' (cf. ill. 28), except that the head-lappet extends through an opening in the body in the manner of its Style E ancestors.

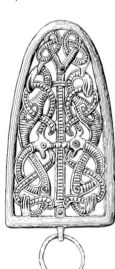

features an interlaced pair of S-shaped animals [**85**; cf. **28**]. This S-shaped animal forms the main motif of the Jellinge style: its essential characteristic being its ribbon-shaped body, of even width, without perforations or indentations. As seen on the Jelling cup itself, the solid body of the animal is frequently double-contoured, filled with a row of beading, and has an insubstantial spiral – or hook-like – hip. The 'ribbon-animals' on the Jelling cup also have the characteristic heads of the style, being depicted in profile with a circular eye, a pigtail (or head-lappet) and open jaws, the upper one of which is embellished with a curlicue (known as a lip-lappet).

It will be apparent that this depiction of the animal head in profile, with lappets, is a feature that particularly distinguishes this beast from most of those encountered in the Borre style. The essential ribbon-shaped appearance of the body differentiates it from the fuller treatment of the main animal motif in the Mammen style. It is, however, this use of ribbon-shaped animals with their heads in profile that reveals how the Jellinge style is so firmly rooted in Style E. On a tongue-shaped bronze brooch from Birka, in Sweden, the head-lappet of each

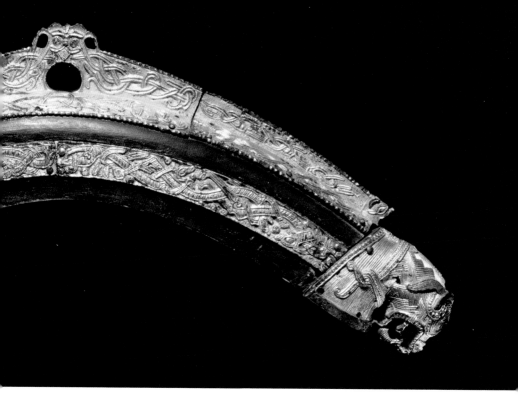

88, 89. (top and above) One of a pair of horse harness-bows (L 42.0 cm) from Mammen, in Denmark, decorated with gilt-bronze mounts, with the central one being perforated for the reins (top; the wood is modern). The longitudinal mounts are filled with Jellinge-style ornament, including (above) this chain of three ribbon-shaped animals in profile.

animal is shown looping through an unexpected opening in the slightly expanded body [87], in the manner familiar from Style E.

Such is the appearance of the main motif of the Jellinge style and its use. The layout of the ornament on the Jelling cup is also typical in its composition [85]. The two S-shaped animal bodies are used to form a regular interlace, without frequent or close intertwining, thus leaving an open background in marked contrast to the dense patterns favoured in the Borre style.

A more elaborate version of this classic composition – in a fully developed example of the Jellinge style – is to be found decorating the gilt-bronze mounts that form a frieze set into the (modern) wood of a pair of horse harness-bows from Mammen, in Jutland, as also along their crests [88, 89]. This is not a 'horse collar', as often stated, but a bow, which would have been placed across the back of a horse (in this case two

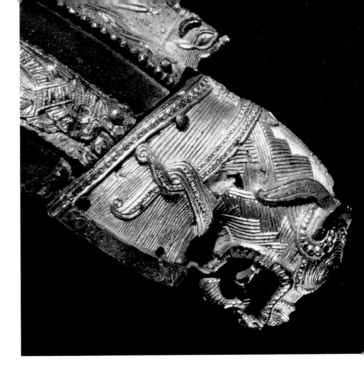

90. The three-dimensional animal heads that form the terminals of the Mammen harness-bows, with their Jellinge-style decoration (ill. 88), have open mouths each containing a 'gripping-beast' borrowed from the Borre style.

bows placed across a pair) pulling a high-status wagon, with the reins being gathered together through the central perforation on each crest. These harness-bows terminate in three-dimensional animal-heads, with silver- and niello-inlaid eyes, and open jaws in each of which – in a masterpiece of casting – is a single 'gripping-beast', borrowed directly from the repertoire of Borre-style motifs [90]. The ornamentation of the Mammen harness-bows is, however, in all other respects to be taken as representative of the fully developed Jellinge style, which has cast off all traces of its Style E origins.

In the sequence of silver filigree-ornamented disc brooches, as already encountered in the discussion of the Borre style (p. 67 and [66]), there is a particularly fine (if slightly battered) late Jellinge-style example in the Tråen hoard, from Buskerud, Norway, which was deposited at the very end of the tenth century. It is the basic design of the Borre-style examples that provides the template for the layout of the animals on the Tråen brooch, although their number is reduced from four to three [91]. The heads are thus located at the centre, although now depicted in profile, with prominent lip-lappets; their elongated head-lappets and tails form part of what, at first sight only, appears to be a confusion of interlace, but the animals are

91. Silver filigree-decorated disc brooch (D 7.3 cm) from the Tråen hoard, Buskerud, Norway, deposited c. 1000. Its design comprises three late Jellinge-style 'ribbon-animals', their profile heads touching at the centre.

placed in their standardized positions, with their forequarters to the right and hindquarters to the left – their two-toed (or U-shaped) feet being clearly depicted as *not* gripping.

In terms of chronology, it has already been noted that the Jelling cup itself was deposited in a burial chamber dated by dendrochronology to 958/59 – and so is presumed to have been used by King Gorm in his lifetime. However, a Jellinge-style strap-end was discovered in the burial mound containing the Gokstad ship, which has the earlier dendrochronological date for the construction of its grave chamber of 895–903 [28e]. It is therefore normally accepted that the Jellinge style emerged towards the end of the ninth century, to become fashionable during the tenth, although dying out before its end (with the Mammen style coming to the fore during the second half). Some central dates for the floruit of the Jellinge style are indicated by the contents of such Swedish coin hoards as those from Vårby (deposited c. 940; see below), Sejrø (c. 953) and Eketorp (after 954), together with the remarkable hoard from Gnëzdovo, near Smolensk, in Russia, which was likewise deposited in the mid-tenth century.

Such finds from throughout Scandinavia – and beyond – demonstrate that the Jellinge style was universal throughout

the Viking world, although its spread will be explored further below, after some consideration of its relations with the likewise popular Borre style.

The Borre and Jellinge Styles: Overlap

Despite their long period of chronological (and geographical) overlap, there are rather few examples of fusion between the Borre and Jellinge styles, although there are some such that are certainly distinguished in design and workmanship. A clear instance of the stylistic overlap in question is when a Jellinge-style 'ribbon-animal', complete with its head in profile, is treated in the manner of a Borre-style 'gripping-beast', as on a sequence of small disc brooches known from Birka to Dublin [92]. A further example is given in the design of a non-standard type of oval brooch, with the circular eyes of the three animals evident at its centre [93].

A different combination of the two styles is present in the silver filigree decoration of a pair of rectangular brooches from Ödeshög, Östergötland (in Sweden) [94], on which a pair of Jellinge-style 'ribbon-animals' face each other on either side of a ring-chain row that develops, at both ends, into a knot of Borre-style interlace (although the bottom has been damaged). A metalworker's die, for producing the metal backing-plate of impressed foil, for another such rectangular brooch is known from Mammen in Denmark [95, 96].

92. (below left) Small disc brooch (D 3.3 cm) from Birka, Uppland, Sweden, belonging to a widespread type decorated with a single Jellinge-style 'ribbon-animal', but with its body disposed in the manner of a Borre-style 'gripping-beast'.

93. (below right) Bronze oval brooch (L 11.3 cm) from Morberg, Buskerud, Norway. Its openwork upper shell is ornamented with a composition of three Jellinge-style 'ribbon-animals', heads at the centre, with their bodies arranged in the same way as that on the Birka brooch (below).

94. (right) Rectangular silver brooch (L 8.5 cm) with filigree decoration from Ödeshög, Östergötland, Sweden. Two Jellinge-style animals face each other across a version of the Borre-style 'ring-chain', with a typical knot-pattern at either end (one damaged).

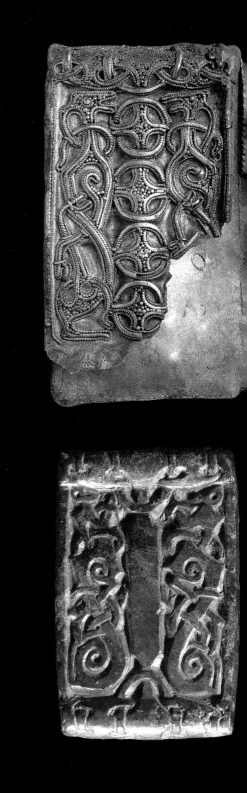

95, 96. (below and below right) Bronze die (patrice), from Mammen, Jutland, Denmark, (H 6.3 cm) for impressing the back-plate of a rectangular brooch, such as that from Ödeshög (above), with a pair of related Jellinge-style animals on either side of a plain band with knotted ends.

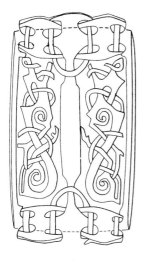

97, 98. These two silver-gilt pendants, with niello inlaid details, are both from the Vårby hoard (opposite), but display variant animal motifs: that above has a classic Borre-style 'gripping-beast' (D 3.4 cm), but the other, below (D 4.5 cm), comprises a pair of Jellinge-style 'ribbon-animals' that are, however, provided with gripping paws, in a combination of the two styles.

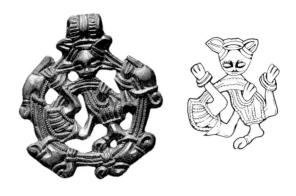

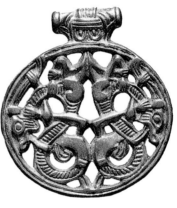

99. (opposite) Part of the silver hoard from Vårby, Södermanland, Sweden (weighing 1.4 kg), which was deposited c. 940. The two large penannular brooches (top), lacking their pins, are Scandinavian copies of a western (Insular) type like those in the Skaill hoard (ill. 116), whereas the series of silver-gilt belt-mounts (immediately below) are of eastern manufacture. The silver-gilt disc brooch (centre) is a fine example of a type with cast Borre-style decoration (D 9.0 cm).

A key find, in this context, is a well-known silver hoard from Vårby, Södermanland (in Sweden), not just because of the richness of its contents, but also because its deposition is coin-dated to c. 940 [99]. One of its silver-gilt pendants serves to demonstrate the artistic potential of Borre/Jellinge cross-fertilization, when compared and contrasted with another in the same series [97, 98]. The circular frame of the latter [97] encloses a classic Borre-style 'gripping-beast', with its triangular layout and mask-like head, which has the characteristic projecting ears. On the other hand, the contrasted design [98] utilizes a pair of Jellinge-style animals, with ribbon-shaped bodies in profile and heads with open jaws, with lip-lappet and extended tongue, as well as a long head-lappet, but their tightly interlaced limbs furnished with gripping paws reveal their mixed breeding. Examples of both types of pendant are also present in the Gnëzdovo hoard.

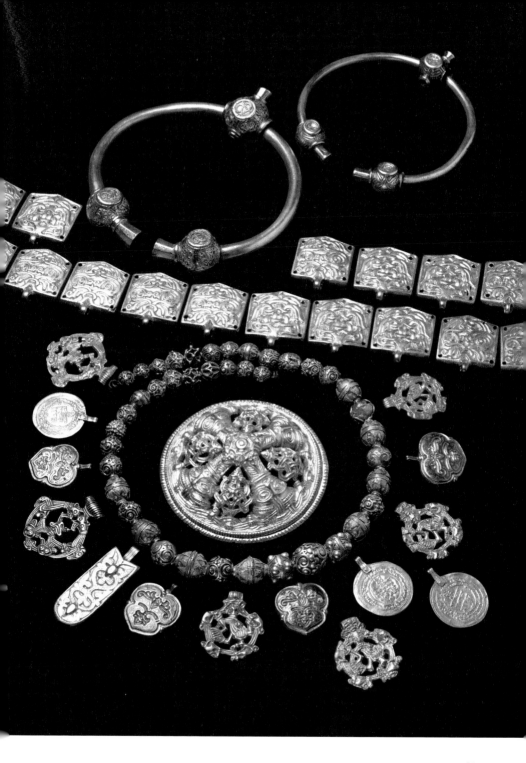

The Jellinge Style: Expansion

Scandinavian warriors carrying their swords in scabbards with bronze mounts (known as chapes) decorated in the Jellinge style reached as far to the east and south as the area of the Volga Bulgars (at Biljar) and the Lower Volga (at Danilovka) – but likewise in the West, there are finds of related chapes from York (and elsewhere) in England, and in a double burial in Iceland (at Hafurbjarnarstaðir). The York chape has a single Jellinge-style 'ribbon-animal', with its head at the top, cast in openwork [**100**]. The stylistically mixed contents of the Gnëzdovo hoard from Russia have already been mentioned.

Whereas objects carried by individuals, as part of their dress or weaponry – or as bullion – could readily end up far from their place of manufacture, the evidence of stone sculpture is normally indicative of local production, even more so when a piece has been abandoned in unfinished condition. Such is the case with northern England and the Viking kingdom of York where, as we have seen in Chapter 2, the Viking settlers acquired the art of stone-carving from Anglo-Saxon sculptors. Examples of such Anglo-Scandinavian monuments

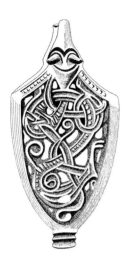

100. (above) Bronze scabbard mount (chape) of a well-known Scandinavian type, but found in York, England, (L 8.6 cm). It is decorated with an openwork S-shaped animal, with tendril intertwining in the late Jellinge style.

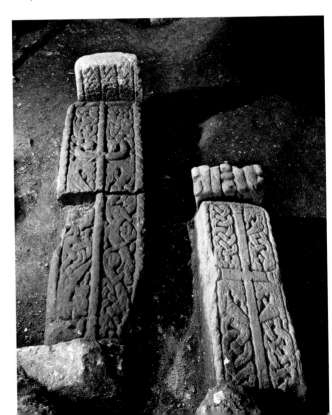

101. Anglo-Scandinavian grave-slabs from the 10th century as found during excavation of the cemetery beneath York Minster. The interlacing zoomorphic designs represent a mixture of Jellinge-style and Anglo-Saxon animal motifs.

in the form of crosses and grave-slabs, with Jellinge-style ornament, are to be found in York itself, in the cemetery later covered by the Norman Minster [101].

A fragment of carved stone, with two interlacing Jellinge-style animals, excavated from a tenth-century layer on the Coppergate site, in York, is of particular interest in this connection because it was abandoned unfinished, leaving evidence for the layout of the design, in the form of drilled holes [102]. Such details would have been covered by gesso as a base for paint, which is how Anglo-Scandinavian stone sculpture was finished at the time. However, little in the way of such decoration has survived to the present day, except where painted stones have been incorporated, while still in fresh condition, into the fabric of churches, as at Köping on Öland, or became buried, like the St Paul's stone in London [145].

Whereas the metropolitan sculptors of Viking York were well able to adopt (and adapt) the main conventions of the Jellinge style, those who created monuments for local chieftains in the hinterland of the kingdom were less successful. A well-known example of such a cross stands in the church

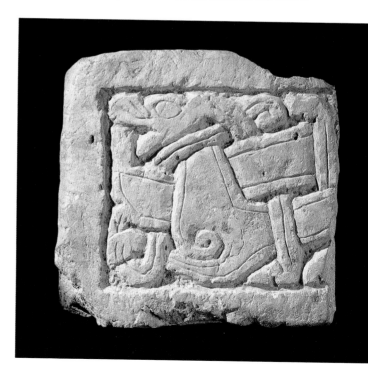

102. Corner fragment of an unfinished grave-slab (L 23 cm), from the Coppergate excavation, York, displaying the head and forequarters of one animal interlacing with the hindquarters and tail of another.

103. The 10th-century Middleton cross (H 106 cm), in a rural church in North Yorkshire, England, was presumably erected as a memorial to the local landowner depicted on the shaft, surrounded by his weapons. The drooping 'ribbon-animal' on the other side is, however, a poor rendering of this Jellinge-style motif.

at Middleton, North Yorkshire, often illustrated because of the figure of a seated warrior on the front of its shaft [103]. He is shown wearing his helmet and has a long knife suspended from his belt in a leather sheath that would probably have been highly ornamented, in the manner of examples found in York and elsewhere in the Viking world where sufficiently damp conditions have allowed for the preservation of such organic materials. The Middleton chieftain is surrounded by his other weapons (with shield, sword and axe arrayed to his left, and a spear standing on his right). In general, however, less attention gets paid to the reverse of the shaft, for this is filled with a panel containing a drooping animal in what amounts to a poor attempt at the Jellinge style.

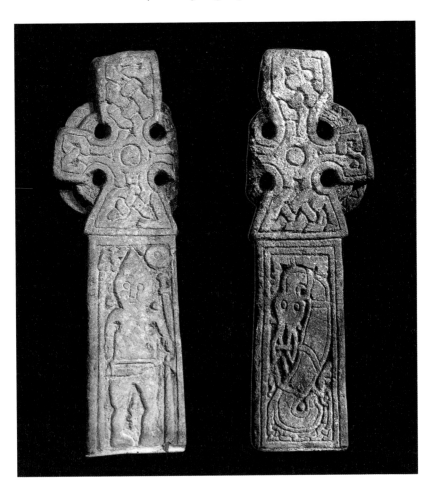

A further example of the artistic achievements of skilled craftsmen in York itself, during the first half of the tenth century, is encountered in the work of some of the moneyers responsible for striking coins for the town's Viking rulers. Although most of the coins that came to be minted for Scandinavian kings during the Viking Age – from Dublin to Sigtuna – were simply imitative of the then current western European (and occasionally Byzantine) issues, some of the York designs are unique for the period. Although unrelated to the Borre/Jellinge styles, these particular coins bear realistic images that include a sword, bow and arrow, a standard, a bird (Odin's raven?) and what may be interpreted as Thor's hammer [104].

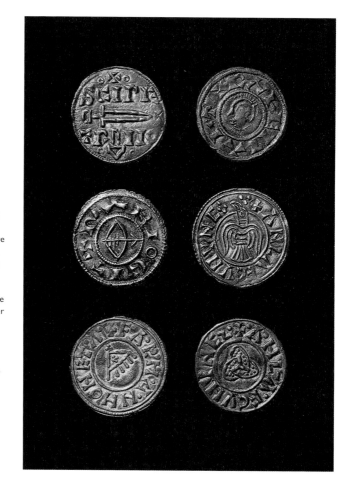

104. Coins struck for York's Viking rulers reflect the distinctive blend of Anglo-Saxon and Scandinavian cultures seen also in the 10th-century sculpture of northern England (ills 101–3). The bust on the coin at top right is of King Ragnald (c. 919–21), who also issued a novel design with a bow and arrow on one side (centre left) and a Thor's hammer on the other. The hammer was used again, together with a sword, on later coins struck in the name of St Peter, to whom York Minster was dedicated (top left). Olaf Guthfrisson (939–41) introduced the Viking symbol of a raven (centre right) and his cousin, Olaf Sihtricsson (941–44/45), followed this with an issue combining a distinctive cross-marked banner and a triquetra (at the bottom).

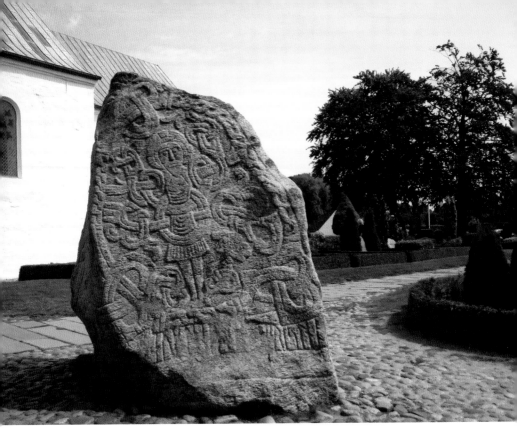

The Jelling Stone

When king of Denmark, Harald Bluetooth (who reigned from
c. 958 to 987) raised the largest and most elaborate runestone
ever to have been seen in his realm [105–7], at the recently
created dynastic centre of Jelling, in Jutland (see above).
This three-sided block of granite (about 8 ft (2.5 m) high,
from the ground) stands on its original spot in front of the
stone successor to the wooden church that Harald had built
adjacent to his father's grave-mound. It is, in fact, located
exactly between it and the second great mound (the South
Mound), which was likewise constructed during Harald's reign,
commencing about 970 [5].

105. The Jelling runestone stands
some 2.5 m high in its original
location (ill. 5), where it was
erected by King Harald in about
965, although its three sides
would originally have been
painted (see ill. 6). The
Crucifixion scene (Face 3, shown
above) depicts Christ with out-
stretched arms bound around
with tendrils, but without the
cross itself. The runic inscription
beneath reads 'and made the
Danes Christians'.

The construction of the first church and erection of the
great runestone will have taken place some five to seven years
after the death of King Gorm, with Harald's conversion to
Christianity in about 965. The stone itself reads like a book,

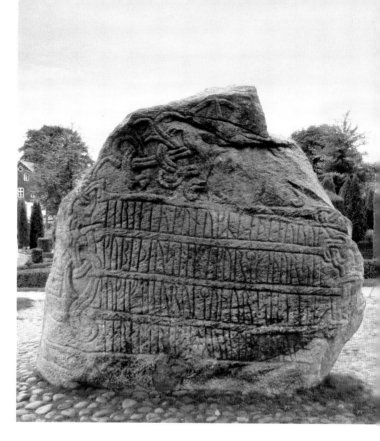

106. The Jelling stone (Face 1): the runic inscription begins here, with the first four lines reading from left to right (top to bottom) in the manner of a book – in contrast with the vertical lay-out of that on the earlier runestone commemorating Queen Thyre (ill. 108 overleaf). It continues around the bottom of the other two faces of the stone.

with its opening page (Face 1) consisting of four lines of runic text framed with bands, which have tendril extensions and incorporate a snake whose damaged head can just be made out towards the top of the design [106]. The inscription continues around the bottom of the other two faces; the second face depicts a large lion-like animal, entwined with a snake [107], and the third the crucified figure of Christ [105]. In a normalized English translation, it reads:

> *King Harald ordered these memorials to be made after Gorm, his father, and Thyre, his mother – that Harald who won for himself all Denmark and Norway and made the Danes Christians.*

The reference to the subjection of Norway is placed beneath the representation of the so-called 'Great Beast' (Face 2). The meaning of this lion-and-snake fight is unknown, for it can be interpreted as having either military or religious symbolism,

97

107. The Jelling stone (Face 2):
the innovative motif of the lion-
like 'Great Beast', shown in
combat with a snake (see also
ill. 30a), is placed above that part
of the inscription recording
Harald's claim that he had won
Norway for himself. It is likely
that the body of the 'Great Beast'
will have been filled with painted
spots, like that on the later
St Paul's stone (ill. 146), given
the popularity of pelleting on
small-scale Mammen-style
carvings (cf. ills 123–26).

given that the continuation of the inscription under the scene depicting the Crucifixion (on Face 3) ends with the statement about making 'the Danes Christians'.

The 'Great Beast' in profile is the defining animal motif for the Mammen style, as described below. On the Jelling stone, its lion-like characteristics are manifest in its large body, with semi-naturalistic proportions, mane, tail and clawed feet. It is, however, a 'lion' re-imagined with fleshy foliate appendages to tongue, mane and tail – the latter rising up to terminate in an elaborate bud [107; cf. 30]. Even the looping body of the snake, with its triangular head seen from above, sprouts a tendril where it encircles the tail of the 'Great Beast'. Such features as the profile depiction, lip-lappet, spiral joints and double contouring of the body all relate the Mammen-style 'Great Beast' to the S-shaped 'ribbon-animals' of the Jellinge style.

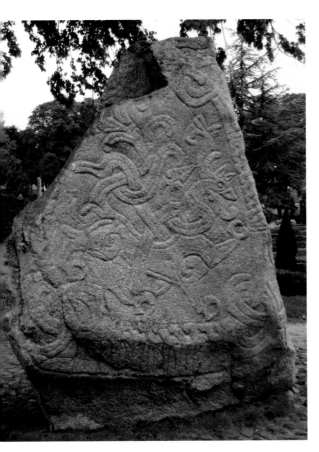

The plainness of the body itself is almost certainly misleading to modern eyes, for the whole monument will presumably have been painted, particularly given the low relief of the carving. Various attempts have been made on casts of the Jelling stone to recreate its possible appearance when newly erected [6].

Given that earlier Danish runestones, including that erected by Gorm at Jelling for Queen Thyre [108], have their inscriptions carved vertically with a minimum of decorative embellishment (if any), the whole concept of Harald's great monument is innovatory – and so it is hardly surprising that it spawned a series of imitations commissioned by magnate families in southern Scandinavia, notably in Skåne, as at Tullstorp [109] and Skårby. What is evident, however, is that whereas other sculptors were happy about copying the 'Great Beast', their experience did not include the depiction of the

108. (opposite right) It is not known where this, the smaller and older of the two Jellling runestones, originally stood. Its vertical inscription states that 'King Gorm made this monument in memory of Thyre, his wife, Denmark's adornment'.

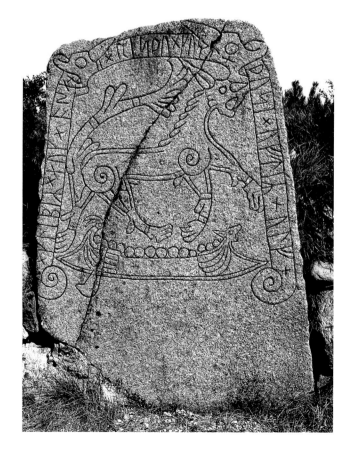

109. (right) The runestone (H 170 cm) at Tullstorp, Skåne, Sweden, is one of those in the old Danish kingdom that was set up in imitation of Harald's Jelling stone. Its 'Great Beast' (see ill. 30b) displays Mammen-style characteristics, having naturalistic proportions, with double contour, spiral joints and foliate tail.

human figure and so there were no further attempts to portray the Crucifixion in stone. On the other hand, a small pendant crucifix from a grave at Birka, in Sweden, takes the form of the bound figure of Christ, fashionably clad for the North in long trousers, created in silver filigree [2].

The nature of the horizontal lines of the inscription on the Jelling stone, laid out so as to be read like a Christian book, accompanied by two 'full-page' pictures, provides a clear enough indication of its western European inspiration. This evidence for external stylistic influence needs, however, to be taken together not only with the innovative nature of the carved stone monument itself, but also with the lion-like characteristics of the 'Great Beast', the foliate motifs and the iconographical inspiration for the figure of the bound Christ.

The novel desire for foliate embellishments, so evident on Face 2, finds further expression on Face 3 because the figure of Christ is depicted not in conventional pose, nailed to a cross, but with outstretched arms entwined in tendrils, which likewise encircle his waist. This particular choice of a 'living' cross, as best suited for such a Conversion-period monument, will be discussed in Chapter 5.

The Mammen Style in Scandinavia and Beyond

The Mammen style is named for the designs inlaid in silver on both sides of an iron axe [111, 112] excavated from a wealthy male grave in Denmark, marked by a mound (Bjerringhøj), at Mammen, in Jutland. Timber used in the construction of the grave-chamber was felled in the winter of 970/71, according to dendrochronology. The Mammen axe is a parade weapon that belonged to a man seemingly of princely rank: his clothing was trimmed with fur and silks, featuring elaborate embroidery [110]. Although the textile arts are poorly represented in the archaeological record, such fragments serve to remind us of the quality of workmanship that was achieved in the production of Viking Age dress – and its importance for the display of social status. Some tablet-woven braids, for example, can be reconstructed from their incorporation of gold and silver threads, as excavated from graves at Birka, in Sweden.

One side of the Mammen axe is filled with a ragged foliate design: sprouting from basal spirals, its pelleted tendrils meander and intertwine across the blade [111 below; 112 right].

110. The high status of the man buried in a chamber-grave (constructed in 970/71) at Mammen (Bjerringhøj), in central Jutland, would have been evident from his magnificent cloak, reconstructed here with its silk-embroidered borders and fur trimmings, as well as from his parade axe (ills 111–12). He doubtless belonged to the court of Harald Bluetooth.

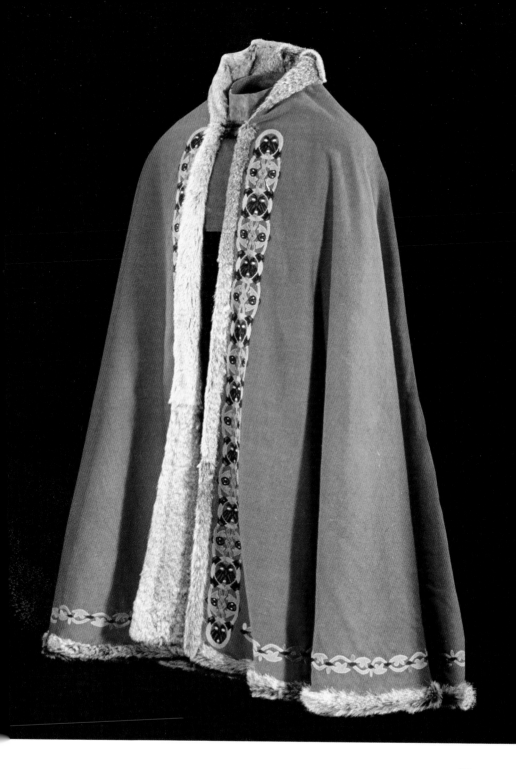

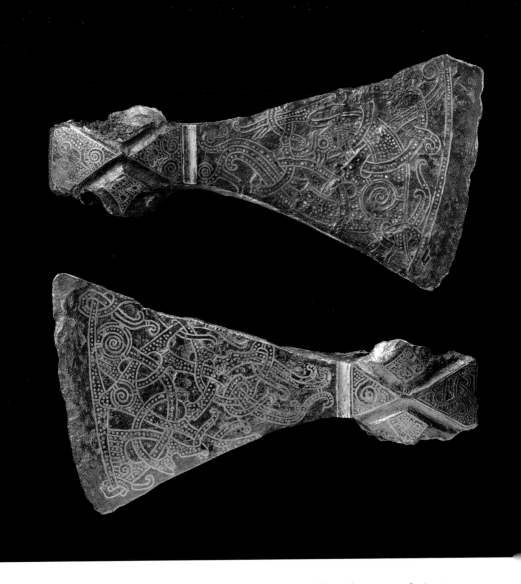

The other face, when viewed from the same angle, is seen
to be occupied by a bird (likewise filled with pellets) whose
crested head, with circular eye, is thrown back so that its
beak (with lappet) is upright [111 above; 112 left]. A prominent
shell-spiral is used to mark its hip, which is also the point
from which its two wings emerge; that extending to our right
interlaces with its neck, while the other interlaces with the
body and tail, the latter taking the form of a triple tendril. The
particular treatment of the tendrils, with their open (hook-like)
ends is a further characteristic of the Mammen style.

III. (opposite) The fine quality of the inlaid silver decoration on both faces of the Mammen iron axe (L 17.5 cm), with gold inlay in the groove between neck and blade, demonstrates that this is no ordinary weapon – rather a symbol of military rank. It is decorated in what was then (c. 960–70) the fashionable Danish 'court style' – and the ornament has given its name to the Mammen style of Viking art.

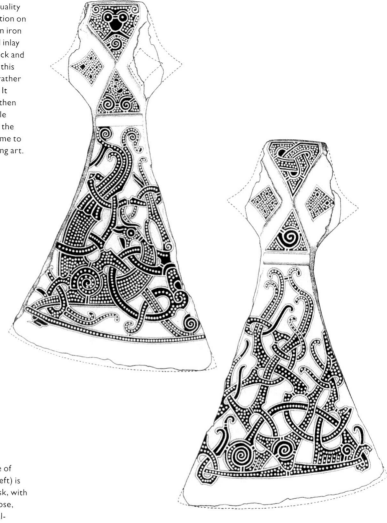

112. At the top of one side of the Mammen axe (above left) is a guardian-like human mask, with staring eyes, prominent nose, large moustache and spiral-marked beard. The main design on this face is of a bird with a large spiral joint (bottom left) from which tendril-like wings emerge to loop, on one side, around its body and tail, and, on the other, around its neck, interlacing with the head-lappet. The bird's tail (at top) terminates in hook-ended tendrils similar to those on the other main face (above right), which is filled with a disorganized foliate design, sprouting from basal spirals.

The design is further complicated by the bird's head-lappet, which not only interlaces twice with the neck and (right) wing, but also sprouts tendrils along the edge of the blade. The outer contour of the wings displays a particular Mammen-style feature in having a semi-circular nick. At the top, the blade is watched over by a human mask – a favourite Mammen-style motif, although one carried over from earlier styles. In this instance, it has a most prominent nose and a shell-spiral treatment of the beard. The designs on both faces are asymmetric, with loosely interlaced and ragged-looking

113. This fragmentary wood-carving, consisting of a plant tendril, formed part of the contents of the burial chamber constructed in 958/59 in the North Mound at Jelling (ill. 5). It retains some of its original red and yellow paint.

tendrils, when compared with the disciplined layouts and taut tendrils that characterize the ensuing Ringerike style.

The art of the Jelling stone (c. 965–70) was foreshadowed in royal patronage there by the Mammen-style wood-carvings that survive from the North Mound [113], in which they were placed in 958/59. One of these painted fragments (in red and yellow) takes the form of an openwork tendril pattern and another depicts a bearded man in profile, with his body surrounded by interlace, in a manner anticipating the treatment of the bound Christ figure.

Some early examples of the Mammen style are known in the West, in particular on a series of the Manx cross-slabs, with their Scandinavian runic inscriptions. The two key monuments are preserved in the church at Kirk Braddan and are thought by David Wilson to be the work of the same sculptor. One is Thorleif's memorial to his son Fiacc (a Celtic name); the other a cross raised by Odd [28g]. Thorleif's cross has been described by Wilson (1966) as not only 'one of the

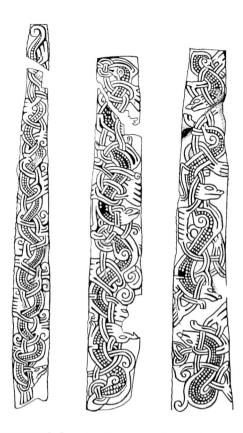

114. The two main faces of Thorleif's cross (H 1.48 m) at Kirk Braddan, Isle of Man, are occupied by friezes of Mammen-style animals, with tendril extensions, whereas the decorated side-face (on the left) has a continuous foliated band with an animal-head terminal.

most purely Scandinavian crosses in the Manx series', but also 'perhaps one of the earliest examples of an object decorated in the true and lively Mammen style' [114]. One side is occupied by an undulating band, filled with pellets, which is in fact the body of a Jellinge-style 'ribbon-animal', interlaced with its own head-lappet, which sprouts feathery or frond-like extensions, reminiscent of Style E. The two main faces of the cross-shaft are, however, characterized by friezes of S-shaped animals that have more substantial bodies, with the distinctive pelleting and shell-spiral joints, together with sub-foliate embellishments, of the Mammen style.

Some indication as to the dating of the Kirk Braddan stones is provided by the engraved ornamentation on three 'ball-type' brooches from the large silver hoard found at Skaill, on Orkney, which was deposited about 960–80, according to current thinking. One survives only as a single terminal on one face of which is a 'lively' animal, double contoured, with a shell-spiral joint for the front leg and a foliate extension to its interlacing

115, 116. The silver hoard buried at Skaill, Orkney (c. 960–80), includes brooches with ball-shaped terminals engraved with Mammen-style decoration related to that on the Manx runestones (cf. ill. 114). This terminal (L 8.6 cm) has a single animal, with spiral forequarters, and an elongated head-lappet sprouting a foliate extension.

118. (opposite) The human mask on this runestone (H 160 cm) from the Viking Age town of Århus in Denmark has its hair, moustache and beard treated in the manner of Mammen-style tendrils. The modern paint is an imaginative attempt to realize its original 10th-century appearance.

head-lappet; the prominent tooth, in the thrown-back head, is a casting flaw that the silversmith ingeniously incorporated into the design [115, 116]. The animals that surround both terminals of the second, complete brooch are seemingly the work of the same artist, being likewise deeply engraved and displaying the same confidence in the execution of the designs; there is a bird on the front of its pin-head. The third brooch (which is complete except for its pin) has a more complex – if unexplained – decorative scheme, lightly incised by another hand; there is a bearded man interlaced with a snake on the back of its pin-head, with an animal on one terminal [28h] and a bird on the other.

It seems probable, as argued by James Graham-Campbell (1995), that these brooches from the Skaill hoard, although buried in Orkney, were produced in the Irish Sea region, most likely on the Isle of Man. A similar argument may be advanced for a wooden terminal in the form a decorated animal head (perhaps from a chair) found at Fishamble Street in Dublin, where its Mammen-style ornament is unique among the extensive corpus of wood-carvings excavated there. In this case, the archaeological context included Anglo-Saxon coins dating from the 920s to the 950s, although the same layer (Level 5) on a nearby plot contained a coin of Æthelred from about 980.

Returning to Scandinavia, where the Mammen style seems to have flourished for little more than a couple of generations

117. (right) The socket of an antler handle, for a walking-stick, found when dredging in Køge harbour, Sjælland, Denmark, is incised on this side with an elaborate mask in the late Mammen/Ringerike style.

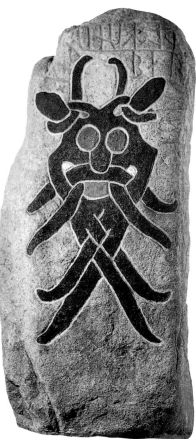

(c. 950–1000), there are several more pieces with ornament worth highlighting: a Danish runestone [118] and antler handle [117]; a cylindrical bone 'mount' from western Norway [119, 20], which (as has been recently suggested) might have been used as a salt container; and a lower sword-guard of elk-antler [121] from Sigtuna, in Sweden (a royal town founded only in about 980).

The Danish runestone in question was found in the fortified town of Århus, in Jutland, and has been selected for inclusion because its imagery is restricted to the (unexplained) motif of the human mask, shown here newly painted in Viking Age colours [118]. The stone was raised by four warriors 'in memory of their comrade Ful', who died in battle, but it is hardly likely that the stylized face was intended to invoke his image, given the widespread use of this motif in the Mammen style. The Danish handle, in the form of a natural antler, was presumably fashioned for use on a walking stick; it was dredged up off Køge Strand, on the coast of Sjælland. There is an animal incised on one side of its socket and another elaborate version of the human mask on the other [117].

The cylindrical bone 'mount' from Årnes, Møre og Romsdal, in Norway, is surrounded with three

119, 120. Carved bone cylinder from Årnes, Møre og Romsdal, Norway (H 6 cm), decorated with of a band of three interlaced animals in the Mammen style.

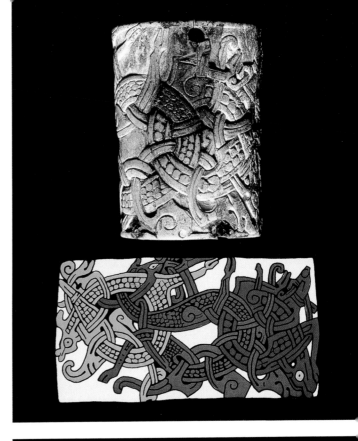

121. This lower guard of a sword-hilt found at Sigtuna, Sweden (L 10 cm), carved from elk-antler is a minor masterpiece of Mammen-style art: one side is filled with a complex bird-motif, the other has a human mask, with flowing hair and an exceptionally elongated moustache.

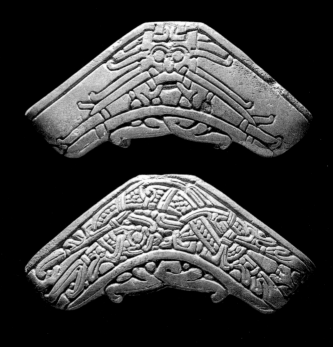

Mammen-style animals interlaced to form a traditional frieze-like composition [119, 120], but this is far more tightly interlaced than would have been the case in the previous Jellinge style, and it displays a tautness in the treatment of its tendrils that anticipates the succeeding Ringerike style. As with the handle from Køge Strand, one face of the Sigtuna sword-guard, evidently intended for a prestigious 'display' weapon, carries a further fine version of the Mammen-style human-mask, depicted with flowing hair, wildly exaggerated moustache and a tendril beard, with an S-shaped animal combined with vegetal ornament on the other side [121]. Both motifs display the same Ringerike-style tendencies as seen on the Årnes mount.

The Mammen Style: Expansion

Examples of carvings in the Mammen style are known widely, although rarely, from outside Scandinavia, in addition to those from Britain and Ireland discussed above. The most 'exotic' of these is the ivory hilt of the so-called St Stephen's sword in Prague Cathedral. This is a further example of a 'parade' weapon, its grip bound with silver wire. The animal ornamentation, carved on both sides of its guard, although much worn, seems to have been almost identical [122]. Stephen

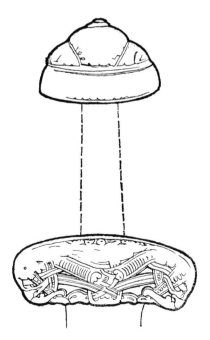

122. This sword, preserved in Prague Cathedral as a supposed relic of St Stephen (king of Hungary), has a Scandinavian hilt with a guard engraved with – much worn – Mammen-style animal decoration.

123. Circular bone plaque from the River Thames, in London (D 6 cm), carved with a man's body whose legs are bent upwards and bound together with his arms by a pair of snakes; all that remains of the missing head, which would have projected upwards, is the tip of a forked beard. The shell-spiral joints, double contouring and pellets filling the body are all details characteristic of the Mammen style (cf. ill. 125).

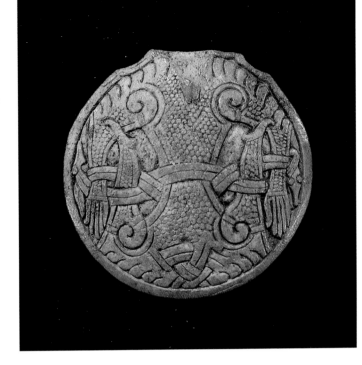

was crowned king of Hungary in 1001 and died in 1038; his relics were enshrined in 1083. It has been suggested that this sword could indeed have belonged to King Stephen and formed part of the Hungarian royal insignia taken to Prague in 1304 (and then not returned with the rest), although there is no reason why it should not have reached Prague directly from Scandinavia.

Other pieces in the Mammen style worth noting here include a mask on a piece of whalebone (usage unknown) from a burial at Ljótsstaðir, in Iceland, and a bone plaque from the River Thames, in London, depicting a bearded man (head missing) intertwined with a pair of snakes [123], in a manner reminiscent of the scene on the pin-head of one of the Skaill brooches. In the case of a pair of bone saddle-mounts from a chamber grave at Shestovitsa, in the Ukraine, David Wilson (1966) has suggested that they 'may have been made in the Viking states in Russia', but the evidence for the adoption of the Mammen style in the East is circumstantial (unlike on the Isle of Man). The quality of two Mammen-style objects found at Wolin suggests that they are most probably both of Scandinavian manufacture, in particular a fierce animal head, carved from wood.

What is particularly notable, however, is that three caskets or boxes of different shapes, with workmanship of exceptional quality, all bearing elaborate Mammen-style decoration, are known from outside Scandinavia – in Bavaria, West Pomerania and northern Spain. The suggestion is that they may have been Danish diplomatic gifts, as might also have been the case with the Prague sword. It is even possible that the donor was Harald Bluetooth himself, but however they reached their distant destinations, these three masterpieces certainly deserve separate consideration.

Three Mammen Masterpieces

The Bamberg Casket

The finest extant piece of Mammen-style art is the Bamberg casket, so called because it was for long housed in the treasury of Bamberg Cathedral, in southern Germany (it is now in the state museum in Munich). It consists of an oak box covered with carved sheets of walrus ivory, held in place by gilt-bronze bands, incised with tendril patterns [124]. The roof is slightly pitched and has four diagonal ridge-poles, dividing it into four large panels of ornament. At its apex is a rock crystal; it is topped with a cruciform mount that has animal-head terminals and a central setting of another rock crystal.

The sides of the box are all divided into three panels, with a projection above each central one carrying the triangular human-mask that we have seen to be such a characteristic feature of the Mammen style. The central panel on the front of the casket contains a single animal, whereas those flanking it both contain a bird with its head thrown back, recalling that on the Mammen axe. In every case, all the available room in each panel is crammed with detail, pellets being used to fill any spare space.

The Cammin Casket

The form of the Bamberg casket is well matched by that of a similar, if less ornate, version excavated from a grave near Århus, in Denmark (its plates perished in the ground), but the second, and much larger, casket to be described here – the Cammin casket – is unique, being shaped like a tenth-century Viking Age hall [126]. Or rather that should be 'was' because it appears to have been destroyed during the Second World War

(although casts and pictures exist [125–26]). It likewise survived from the Viking Age because it was used as a reliquary (of St Cordula), kept in the treasury of the cathedral of Cammin (Kamień), in northern Poland. Kamień Pomorski is located only about 19 miles (30 km) from Wolin, which, as already noted, was an important Viking Age town on the southern shore of the Baltic Sea (pp. 76–77).

Following the design of such tenth-century timber halls as those constructed for Harald Bluetooth in his large ring-fortresses, as at Trelleborg and Fyrkat, the Cammin casket has bowed sides and thus a hog-backed roof-line. Its gables are embellished with animal and bird heads in the manner to be seen on later Norwegian stave-churches, as at Borgund [203], but also shown on the Hedeby coin from Birka [59].

In the case of the Cammin casket, the wooden box is overlain with twenty-two sheets of antler, with gilt-bronze strips similar to those of the Bamberg casket used to hold them in place, although they display a wider repertoire of foliate/interlace ornament. Details [125] reveal the quality of the

124. This rectangular casket (W 26 cm), preserved in Bamberg, Germany, is covered with highly-decorated walrus-ivory plaques, with a rock crystal set on the lid (the lock mechanism has been moved to the side). Its elaborate ornament, combining birds, animals, human masks and plant motifs, represents the finest expression of the Scandinavian Mammen style, from the second half of the 10th century.

125, 126. (below) Replica of the Cammin casket (L 63 cm), the original of which was preserved in the cathedral at Kamień Pomorski, Poland (until the Second World War). The wooden core of this house-shaped container was covered with (?)elk-antler panels, fastened with gilt-bronze decorated mounts, with separate animal- and bird-head terminals projecting from the ends of the roof. The detail (right; a photograph of the original casket) illustrates a side-panel filled with a 'Great Beast', in classic Mammen style, close to that of the Bamberg casket (opposite).

carving and demonstrate how comparable its motifs and workmanship are to the Bamberg casket, even if more elaborate in its wider range of designs. As David Wilson has observed (1966), 'there are stylistic minor differences, but the close correspondence between the two objects is remarkable' – and together they may be considered to represent 'the earliest stage' in 'the process of development to the full Ringerike style'.

Nothing in the ornamentation of these two caskets has any particular Christian significance. Both were equipped with locks, which were subsequently modified. They are fine containers, but their primary significance would have been for the precious (royal) gifts that they would have housed. There was, however, nothing about the design and decoration of either to preclude its subsequent reuse as a reliquary.

The León Reliquary

The third masterpiece for consideration is much smaller and quite different in appearance from the other two, being a cylindrical container of antler, carved with dense openwork decoration; both its ends are closed with openwork metal sheets [127, here photographed upside down]. Although the original function of this little box is unknown, its contents were

127, 128. The León antler box, with metal fittings (H 4.5 cm), here photographed upside down. The extended drawing (below right), by Louise Hilmar, is shown the correct way up so as to make clearer the lay-out of the spread-eagled bird (the beaked head protruding from the base in the photograph), with its crossed-over wings, entwined with snakes.

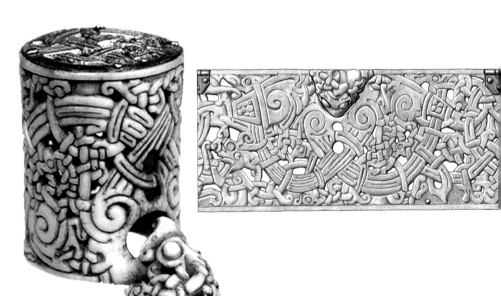

definitely intended to be seen – and not normally removed for handling, because the ends were once nailed to the body. This object was therefore probably a reliquary in origin, but in any case owes its survival (as with the other two boxes) to having been preserved in an ecclesiastical treasury – that of the collegiate church of San Isidoro in León, which was at the heart of an independent Christian kingdom in the tenth century. The quality of the design is superb, with the cylinder being treated as a single bird, with its head projecting from the top (the base in the photo); the elaborate treatment of the spread-eagled – and snake-entwined – body can only really be appreciated in an extended drawing [128].

The End of the Mammen Style

As will be evident from these examples, the Mammen style represented one of the innovative phases in the development of Viking Age art, with the adoption of the 'Great Beast' and the growth in the use of foliate motifs, which had previously had little or no long-term impact in the North, despite their common use in western European art throughout the tenth century. On the other hand, the style is rare in metalwork, no doubt in part because its floruit coincided with the decline in production of the mass-produced cast ornaments that were the vehicles for so much decoration in the Borre and Jellinge styles.

One cannot help supposing therefore that much of the popularity of the Mammen style, as exemplified by the Jelling stone and other high-status objects from Jutland (e.g. the Mammen axe), resulted from it having been made fashionable as the 'court' art of the powerful King Harald – that is until he was killed in 987 during a rebellion led by his son, and successor, Svein Forkbeard. The impact of this period of artistic development, as also of Harald's initiation of the conversion of his kingdom to Christianity, was to come to fruition towards the millennium with the emergence of the Ringerike style.

Chapter 4 The Ringerike and Urnes Styles

The two art-styles that flourished consecutively during the eleventh century in Scandinavia – until the end of the Viking Age, with the introduction of the European Romanesque – may be considered to encapsulate much of the essence of the Viking Age itself. Known as the Ringerike and Urnes styles, they both display not only continuity in the use of animal-motifs, but also design innovation, in a fully self-confident manner. Both styles were of considerable importance in the Viking West, especially in England during the reign of the two Danish kings, Cnut and Harthacnut, but also in Ireland (albeit at second-hand). At the same time, their impact was experienced in the areas of Scandinavian settlement and influence east of the Baltic.

The Ringerike style, the earlier of the two, drew extensively on western European artistic conventions, both Anglo-Saxon and continental, in its extensive use of foliate patterns, but reworked them with the confidence that was lacking during their period of introduction, as a formative element, in the preceding Mammen style. At the same time, the Ringerike style continued to make full use of the now well-established 'Great Beast' and bird motifs. In contrast, the subsequent Urnes style – an innovation of the second quarter of the eleventh century – rejected these external influences, thus returning Viking art to its animal-style roots, creating elegant compositions from the looping bodies of extremely stylized beasts and snakes.

Unlike the complexities presented by the overlapping styles of Scandinavian art during the late ninth to tenth centuries, the late Viking styles run in a linear sequence, with the Mammen style giving way to the Ringerike style, from which the Urnes style then emerged, even if there was inevitably a period of transition and overlap during the mid-eleventh century. During the twelfth century, the Urnes style in its turn made an important decorative contribution to the earliest Romanesque art in Scandinavia – both in stone and wood-carving, as well as in metalwork. It was the spread of this pan-European tradition that seems to have sapped the confidence of the native tradition of early medieval art in Scandinavia, even if some of the familiar motifs from the Viking Age were to survive into recent times in popular art – and were even to become the subject of nationalistic revival (as described in Chapter 5).

The Urnes style provides us with the most numerous examples of Viking Age art in Scandinavia, to a great extent because of the existence of a very large number of runic memorial stones, with more than a thousand known from the Swedish province of Uppland alone. In addition to its adoption for the decoration of Christian monuments, including stave-churches, the Urnes style and its derivatives saw considerable use on mundane objects of daily-life, such as wooden spoons, which have been excavated in the towns that were rapidly developing at this period across much of Scandinavia. The style's widespread popularity at all levels of society is evident from the broad distribution of crude versions of the elegant openwork brooches discussed below [151–53], many discovered in recent years by metal-detectorists in Denmark.

The Ringerike Style in Scandinavia

The Ringerike style is so called after the geological name for the sandstone beds in the Oslo region of southeast Norway, as used for a group of memorial stones carved with distinctive ornament, although only one such monument has in fact been found in the district itself. Indeed, the Norwegian memorial stone that is generally considered best to typify the fully developed Ringerike style – that at Vang, Valdres, in Oppland – consists of a worked slab of local micaschist [129].

The runic inscription on the Vang stone is placed vertically on the right-hand narrow face and can be translated as: 'Gåse's sons raised this stone after Gunnar [their] brother's son'. The ornamentation is confined to its front face and is dominated by a crossing double scroll, consisting of a pair of plant tendrils that sprout from basal spirals [129]. The lower of the two crossing-points is interlaced with lesser tendrils, with tightly scrolled ends, forming an open asymmetrical composition. The upper one, on the other hand, is tightly bound by a rosette-like cross that is formed from four broad, pear-shaped lobes between pairs of narrow tendrils. Above this dominant design, a lion-like beast, with open jaws, a pronounced mane and tail, strides towards a spiral with tendril offshoots, the longest of which terminates (between the beast's legs) in what appears to have been a snake's head in profile, with a double head-lappet. In the Mammen-style tradition of the 'Great Beast', it is well proportioned, with both spiral joints and a double-contoured

body. The simple manner in which these animal and plant motifs have been combined exemplifies what Signe Horn Fuglesang has described as 'the additive character of the full composition'.

The main foliate motif on the Vang stone exhibits not only the strict axiality in layout that distinguishes such Ringerike-style designs from those in the Mammen style, but also the use of intertwining tendrils combined with alternating lobes and tendrils. Fuglesang identifies the former composition scheme as being of Ottonian (pre-Romanesque, German) inspiration and the latter as having an Anglo-Saxon origin. This particular combination of elements, given also its Mammen-style foundations, indicates that the Ringerike style will most probably have emerged in Denmark by virtue of that kingdom's developing Church organization, with its network of external connections.

A particularly fine monument, from the Ringerike area, is that which formerly stood at Alstad (now in the Museum of

129. The ornament on the runestone (H 215 cm) at Vang, Oppland, Norway, is taken to exemplify the 'classic phase' of the Ringerike style of Viking art. The plant-scroll filling the front face, beneath a striding version of the 'Great Beast', is organized on an axial basis, with a multitude of taut tendrils forming dense clusters.

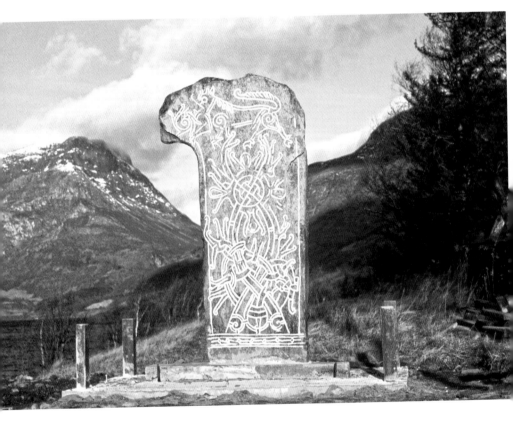

Cultural History, Oslo), with both its main faces covered in ornament [130]. On the front, which has two separate runic inscriptions, an eagle soars upwards, over a hunting expedition consisting of a man on horseback, with a hawk on his wrist, accompanied by a couple of dogs. At the bottom is another rider, holding a raised object, together with a rider-less horse. What is of artistic importance, beyond the representational nature of the scene itself, is the treatment of the birds and animals, which display their Mammen-style descent in both their form and treatment. On the reverse, the ascending foliate motif displays the greater discipline characteristic of the Ringerike style, in contrast with the Mammen axe [111], with tightly interlaced crossing-points where the diagonal strands intersect. The fact that its tendrils are open ended, rather than being tightly scrolled (as on the Vang stone), is a further indication of this monument's transitional position in the development of Viking art around the millennium.

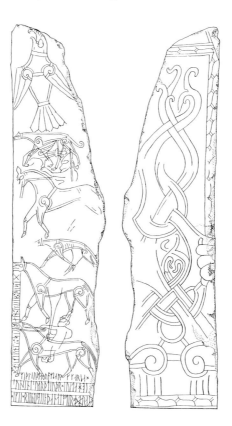

130. This memorial stone from Alstad is from the Ringerike district of southeast Norway, which has given its name to the 11th-century style. The monument (present H 270 cm) displays a composition of horses, riders, dogs and birds on one main face, and a characteristic foliate pattern scrolling up the other.

Another exceptional monument from the small Ringerike group, the Dynna stone, will be discussed in Chapter 5 because of the unusual nature of its Christian iconography, with a depiction of the 'Adoration of the Magi' [201].

The discussion of the Jelling stone in the previous chapter (pp. 96–99) indicated how a fashion for decorated memorial stones was introduced into southern Scandinavia during the reign of Harald Bluetooth, but these stones are in fact few in number. The classic example is that raised at Norra Åsarp, Västergötland (in Sweden) [131], which has a majestic 'Great Beast', well endowed with tendril extensions, striding across the centre of the stone, beneath the cross that corresponds with the Jelling Crucifixion. The runic inscription is, for the most part, contained within the body of the encircling snake, with its profile head and lavish foliate head-lappet.

It was to be in Sweden that the fashion for decorated runestones became most established, with Uppland forming its innovative artistic centre. This special development, related in large part to the adoption of Christianity, is of sufficient significance to require separate treatment below, together with the resurgence of stone carving on Gotland. Although earlier

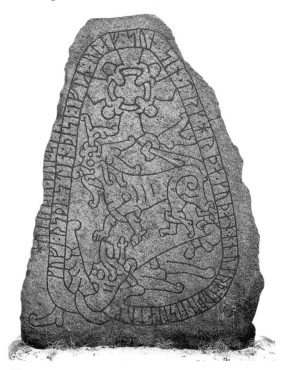

131. This runstone (H 210 cm) at Norre Åsarp, Västergötland, was clearly raised in imitation of Harald's monument at Jelling, with its 'Great Beast' (ills 105–7), but with a cross substituted for the Crucifixion.

scholars supposed there to have been a hiatus in the sequence of stone monuments on Gotland, between the 'picture-stones' discussed in Chapter I and those decorated with the late Viking Age styles, David Wilson has argued (1998) for the likelihood of some degree of continuity.

Turning now to secular ornament, a classic example of the 'Great Beast' in Ringerike-style metalwork is to be seen on a silver disc brooch from Sweden [132]. This forms part of one of the largest silver hoards known from Scandinavia (excluding Gotland), weighing about 19 lb (8.75 kg) and dating from the mid-eleventh century. It was buried at Espinge, in Skåne – that area in southern Sweden that then formed part of Viking Age Denmark.

A fine silver disc brooch from a Gotlandic hoard, deposited at Gerete in about 1055, displays a vigorous, but disciplined, design of three 'ribbon-animals', tightly interlaced together with their tendril extensions [133], forming a composition that Fuglesang considers to be transitional to the Urnes style. In contrast, one of two gold disc brooches, found together at Hornelund, Jutland, in Denmark [134], eschews animal ornament for a complex Ringerike-style foliated pattern.

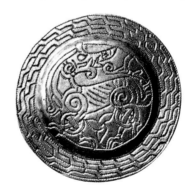

132. (top) Silver disc brooch (D 5 cm), from the large hoard found at Espinge, Skåne, deposited c. 1048, decorated with a standard Ringerike-style 'Great Beast'.

133. (below left) Gilt-silver disc brooch (D 5.9 cm), from an 11th-century hoard found at Gerete, Gotland, with a Ringerike-style design of three tightly interlaced animals, in combination with three lesser ones.

134. (far right) Gold filigree-decorated disc brooch, with plant ornament, (D 8.6 cm) found together with a second disc brooch of unique design, and a gold arm-ring, at Hornelund, Jutland, Denmark.

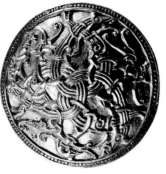

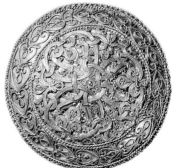

135. Gilt-bronze rim mount
from a drinking-horn
(D c. 8 cm), found at Århus,
Jutland, Denmark, decorated
with a frieze of seven
Ringerike-style birds.

136. Silver-gilt arm-ring
(D 7.1 cm), from Undrom,
Sweden, in the form of a
snake with a niello-inlaid
pattern of Ringerike-style
tendrils along its back.

137. Silver-gilt brooch
(W 4.8 cm), from the
Græsli hoard, Sør-Trøndelag,
Norway, deposited c. 1085, in
the form of a Ringerike -style
bird (a peacock?).

This consists of three encircled palmettes combined with buds and tendrils, within a border of interlocking heart-shaped lobes, each containing a palmette.

A more ordinary, if still splendid, example of decorative metalwork in the Ringerike style from Denmark is a cylindrical mount from the mouth of a drinking horn, found in Århus, Jutland. This displays the reworking of a familiar Mammen-style motif, in that it is surrounded with a highly disciplined frieze of seven birds, interlaced together to form a chain [135].

An innovative approach was taken by a skilled silversmith who fashioned an arm-ring, found at Undrom, Sweden, part of a hoard deposited about 1026–30. It takes the form of a snake, with a three-dimensional Ringerike-style head [136], its body engraved and niello-inlaid with the characteristic pattern of alternating lobe and tendril, as also can be found on one side of the Heggen vane from Norway (see below).

Another important piece for consideration is an elaborate openwork brooch in the shape of a crested bird (a peacock?), from Græsli, Sør-Trøndelag (in Norway) [137]. This formed part of another silver hoard, together with some hack-silver and over 2,000 coins that date its deposition to about 1085. Animal/bird-shaped brooches are a novelty of the Urnes-style phase – and the curving outlines of this bird, with its elongated S-shaped body, are indeed characteristic of the later style. Moreover, the classic Ringerike-style tendril-groups are lacking and thus the interlaced details are best considered as Ringerike-style elements lingering on in an innovative, but transitional, workshop.

It is therefore reasonable to conclude that the Ringerike style was fashionable in Scandinavia during the period between about 990 and 1050, by which time it was already in transition to become the Urnes style.

Some of the finest examples of the Ringerike style in Scandinavia are to be found on a series of gilt vanes, which are reminiscent in form of the tenth-century standard depicted on a York coin [104 bottom left]. They were most probably chieftains' insignia, for use on the mastheads of ships, or their prows, as depicted in a thirteenth-century sketch on a bone found during the excavations at Bergen, in Norway. It is thus not altogether surprising that their reason for survival is that they were reused as weather vanes on churches in Norway and Sweden, including Gotland.

Ringerike-Style Ship-Vanes

The three, near-complete, vanes for discussion here are: (1) from Källunge, on Gotland, which is two-sided in the manner of (2), that from Heggen, in Norway, whereas (3) the vane from Söderala, in Sweden, differs in having its design executed in openwork. All three vanes do, however, share the same construction, as well as featuring a three-dimensional casting of a 'Great Beast' mounted on top so as to survey the horizon. Each consists of a sub-triangular plate, with a zoomorphic pattern, bound with thicker strips that carry engraved vegetal friezes, although that from the lower edge of the Heggen vane is missing.

The vane (1) from the church-spire at Källunge, where it was in use until the twentieth century, has the 'Great Beast' on one face, together with its entwined snake [138]. This design is a match for that on the Jelling stone [107], except for the appearance of the tendrils in which both animals are ensnared, which have been given the Ringerike-style treatment. On the opposite face, two serpentine animals form a figure-of-eight

138. Gilt-bronze vane (L 31 cm) from Källunge church, Gotland, decorated with a 'Great Beast' entwined in a snake and enmeshed in tendrils in the Ringerike style. A pair of snake-like animals forms the basis of a figure-of-eight composition on the other side.

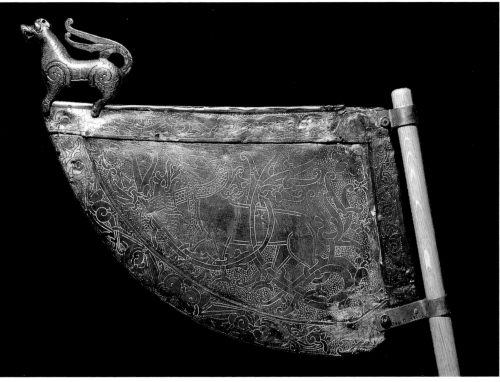

loop, tightly entwined with four snakes whose bodies have foliate off-shoots. The open-jawed heads of the main animals display the almond-shaped eyes, lip- and head-lappets characteristic of this style phase.

The treatment of the motifs on the Källunge vane is representative of the early Ringerike style and, as such, it may be contrasted with the designs on the Heggen vane (2), which represent the high-point in its development. Its more elaborate version of the 'Great Beast' [30d] is accompanied by a smaller backward-looking animal, whereas the opposite side is filled with a bird [139], recalling that on the Mammen axe [111], although in this case it has peacock-like characteristics and is ensnared by a snake that forms a (narrow) figure-of-eight loop around its neck, body and wings. As noted above, the original outer edge of the Heggen vane is missing, but the plain replacement strip has the same row of perforations as present on the Söderala vane; these were presumably used for the attachment of flowing streamers, or dangling chains.

139. Gilt-bronze vane (L 27.8 cm), probably from Heggen church, Buskerud, Norway. The framing strip along the curved edge is not original. The fine Ringerike-style ornament engraved on this face comprises a bird struggling with a snake, framed by tendrils (the other side has a scene of two beasts).

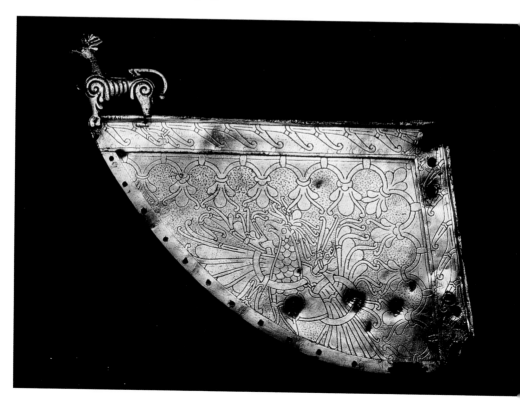

140. Gilt-bronze vane (L 37.7 cm) from Söderala, Hälsingland, Sweden, with an openwork design of a 'Great Beast', surrounded by tendrils, in the late Ringerike style. There is a smaller animal biting the front leg of the beast, and a snake is entwined with its hindquarters. The framing strips have engraved foliate ornament.

The vane (3) from Söderala, Hälsingland [140], displays the most stylistically advanced version of the 'Great Beast' motif of these three vanes. The detail of the composition repays close analysis, even if its overall effect might be considered, in the words of David Wilson (1966), 'over-fussy to modern eyes, even degenerate', in contrast with the scenes on the Heggen vane, which he observes 'delight the modern eye by the economy with which a rich effect is presented'.

Indeed, the Söderala 'Great Beast' stands to one side of the mainline development of this motif (although it relates to animals belonging to the Swedish 'Runestone style'), in having only one limb in the form of a single front-leg, with a shell-spiral joint. In this case, its diagonally extended leg is encircled by a lesser (although two-legged) beast, which bites its foot. Instead of a head-lappet, the main animal has a tendril extension at the base of its neck, issuing from a shell-spiral that forms a pair with that of its leg-joint. A further complication, in what otherwise might appear to be no more than a 'mess' of intertwining tendrils, is found in a snake, with its head in profile (touching the outer edge). This forms loops around both the body of the main animal and its neck-lappet, to occupy much of the space beneath it.

141. Socketed head of a tau-crozier (L 9.8 cm) from Veszprémvölgy convent, Hungary, carved from walrus ivory, with exuberant Ringerike-style ornament. The animal heads have blue glass eyes.

The Ringerike Style: Expansion

The Ringerike style spread extensively throughout Scandinavia, including to Iceland – and was made fashionable in England during the reign of the Danish king, Cnut the Great (1016–35). It had a considerable impact in Ireland, introduced by way of Dublin – as did the Urnes style in due course – and these developments will be considered together at the end of this chapter.

A true masterpiece of late Viking art has recently been excavated at the Veszprémvölgy convent, in Hungary, in the form of a Tau-shaped crozier head of walrus ivory, with elaborately carved Ringerike-style ornament [141]. Such a costly and delicate ecclesiastical artefact can only have reached Hungary as a gift from Scandinavia at the highest level, so it is notable that its ultimate destination was a royal foundation, built by King Stephen (d. 1038), who converted his country to Christianity (see also pp. 109–10).

It is clear that the adoption of the Ringerike style in the service of the Church was an important aspect in its dissemination, as is evident (for example) from the Flatatunga panels in Iceland. These four vertical planks of fir, with incised ornament forming part of a single decorative scheme, were retrieved from the rafters of a farm in northern Iceland when

it was pulled down in 1952. Above a row of haloed saints is an elaborate vegetal composition [142], which exemplifies one aspect of Fuglesang's 'classic phase' of the Ringerike style, closely comparable to the Heggen vane [139]. These planks had presumably once formed part of the panelling of a church and, given their undoubted date within the first half of the eleventh century, they represent the earliest surviving examples of Scandinavian church decoration.

The influence of the Ringerike style to the east of the Baltic, if less extensive, is also worthy of note. It is displayed, for instance, on the silver-plated sockets of a series of spear-heads manufactured in the Scandinavian settlements of Finland. A most remarkable example of its adoption and adaptation in the East is provided by the so-called 'Vladimir' axe, which is a stray-find from the Kazan region, in the central Volga area [143]. This 'steppe-nomadic' type of ceremonial axe is richly decorated with gold and silver inlay, with one side of its blade depicting a 'tree-of-life' flanked by two birds – a well-known Christian 'paradise motif', here attributed a Byzantine origin.

142. (below left and centre) Two of four incised wooden planks (max. H 74 cm) from a turf-built farmhouse at Flatatunga, Iceland, where they had been re-used in its roof-lining. Decorated with a classic Ringerike-style foliage pattern above a row of haloed figures, they are the earliest extant church decorations from Scandinavia, dating from the first half of the 11th century.

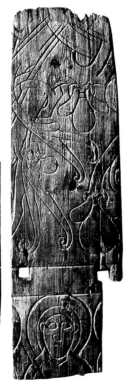

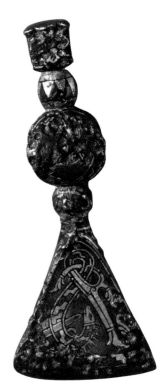

The other side is decorated with a looped 'ribbon-animal' with foliate extensions; its head has an oval eye and a lip-lappet. The body is pierced from below with a sword, in the same manner as Sigurd is shown killing the 'dragon', Fafnir, in other contexts (see Chapter 5). There can be no doubt of the Scandinavian influence behind both this familiar motif and the manner in which it is treated.

The introduction of the Ringerike style into England was part of a two-way exchange of artistic ideas, with Anglo-Saxon influence on the development of the Ringerike style in Scandinavia having already been noted. An example of a high-status object that appears to have been made in the Danish kingdom under strong Anglo-Saxon influence is the Dybäck sword, from Skåne [**144**]. The curved guards of both its hilt (the pommel is missing) and scabbard mount are of silver-gilt, inlaid with niello; gold wire was used to bind the grip. The ornamentation of the outer faces of the guards consists of birds and snakes interlacing, and the longer lower guard has an additional crouched animal at either end; their inner surfaces

143. (opposite right) Small iron 'parade axe', inlaid with gold, silver and niello (L 14.5 cm), from the Kazan region, Russia. The axe is of 'steppe-nomadic' type, but with decoration (on both sides) inspired by Scandinavia and Byzantium. On the face shown here, the serpent pierced by a sword presumably represents Fafnir being slain by Sigurd (cf. ill. 195).

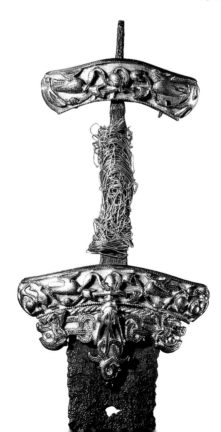

144. (right) Sword hilt (with missing pommel) and scabbard mount of cast silver with gilding and niello (max. W 10.2 cm), from Dybäck, Skåne, Sweden. The hilt was made either in England or in Denmark under strong Anglo-Saxon influence, whereas the scabbard mount has been attributed to a separate Danish workshop (in the Jellinge-Mammen style).

are decorated with foliate scrolls. Whereas the birds display their undoubted Anglo-Saxon pedigree, the snakes are Scandinavian in appearance and 'the stylized ornament of the scabbard' is, according to Leslie Webster (1984), 'quite alien to Anglo-Saxon art of the period'.

The finest example of the Ringerike style known from England – the rune-inscribed stone from the churchyard of St Paul's Cathedral in London – can only be the work of a Scandinavian-trained artist, such is the classic nature of its design and the excellence of its execution [145]. The sculptor remains anonymous, however, because the inscription on the one surviving fragment – the end-slab of what must originally have been an elaborate monument – records only (in translation): 'Ginna and Toki had this stone set up'.

The composition on the St Paul's stone immediately brings to mind that on one side of the Heggen vane, although in this case the lesser beast takes the form of a 'ribbon-animal' entwined around the front foot of the 'Great Beast', so they are not shown in actual 'combat', as on the Söderala vane [140]. Sufficient of the original paint survives [147] to allow for a complete reconstruction of the finished design, thereby increasing the art-historical importance of this remarkable monument to a Scandinavian buried in London.

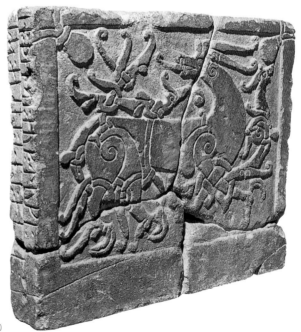

145, 147. (right and opposite) This carved stone from St Paul's churchyard, London, is the end slab of a box-tomb (W 57 cm), remarkable for the surviving evidence of its original paintwork. The surviving part of the runic inscription records only that 'Ginna and Toki had this stone set up'. Its fine depiction of the 'Great Beast' is fully characteristic of the 'classic phase' of the Scandinavian Ringerike style. The original paint remaining on the runestone – dark red, black-blue and white on a gesso base – is recorded in the water-colour by Eva Wilson (opposite).

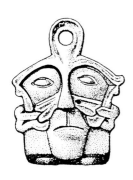

146. Bronze mount (H 3.9 cm) from a stirrup-strap, found at Deal, Kent, in the form of a Ringerike-style human mask.

Some further Ringerike-style stone carvings are known from the City of London, and from Rochester in Kent, and these may well be the products of the same workshop, but in England the style's influence was also felt in other media, most notably ornamental metalwork, but also small-scale bone-carving, with fine examples of both known from Winchester.

An unfinished (failed) casting of a buckle-loop, with Ringerike-style decoration, found in the River Thames at Barnes, might have been intended for use as part of equestrian equipment, given the use of such Ringerike-style motifs on the numerous stirrup-strap mounts that have been found in recent years by metal-detectorists. One related series of these Anglo-Scandinavian mounts features a human mask displaying a tightly interlaced tendril moustache, the finest of which is from Deal, in Kent [146]. Indeed, it appears that the influence of the 'court' art of Cnut (who gained the English throne in 1016) and Harthacnut, his son and successor (who died in 1042), was such that it gave rise to a widespread fashion for 'Ringerike-style' equestrian equipment. The use of inverted commas here is intended to indicate that such decoration is, for the most part, in a manner which can only be described as 'reminiscent' of the Ringerike style proper, despite the occasional pieces that rise above this level, such as [145].

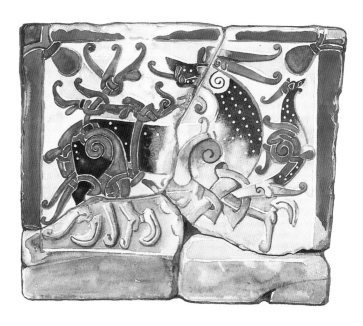

The Ringerike style was occasionally adapted by Anglo-Saxon craftsmen, who had been trained in their native English Winchester style, for use on such ornaments as the large silver disc brooch from a hoard deposited at Sutton, on the Isle of Ely, Cambridgeshire. The Sutton disc brooch had been damaged by the time it was buried during the reign of William the Conqueror (1066–87). Its rather poor workmanship displays a mixture of Anglo-Saxon and late Viking design elements, with the selection of somewhat debased motifs including English Ringerike-style snakes and foliate motifs, alongside a couple of rudimentary 'Great Beasts'. The silversmith who produced an equivalent disc brooch decorated with English Urnes-style animals, recently found at Bredfield, in Suffolk, was evidently better acquainted with the 'proper' appearance of his motifs [149].

A finer example of Ringerike-style inspiration in a Winchester-style setting is provided by a decorated initial in the psalter associated with Winchcombe Abbey, in Gloucestershire, dating from the 1020s or 1030s [148]. Ornament elsewhere in the Winchcombe Psalter displays further Ringerike-style characteristics, as do some other

148. (below) An initial 'd' in the psalter from Winchcombe, Gloucestershire, England, is turned into an animal with clear Ringerike-style characteristics.

149. (right) This silver bossed brooch (D 10.5 cm) from Bredfield, Suffolk, belongs to the Anglo-Saxon tradition of such disc brooches, but its animal ornament has been influenced by the Scandinavian Urnes style.

Winchester-style manuscripts, but here (as in other media) it is really only a matter of the addition of a few elements derived from Scandinavian models that happened to appeal to the Anglo-Saxon artists.

The Urnes Style in Scandinavia

Although the Urnes style is named for a stave-church in western Norway, this is more to do with an accident of survival rather than because this area, the Sognefjord, was an innovative centre of artistic excellence during the mid-eleventh century. Moreover, it is in the art of the Swedish runestones, in particular, that the transitional process from the Ringerike to the Urnes style can most readily be observed – as shall be seen below. There is, however, one particularly fine piece of silverwork with ornament that is held to be transitional between Ringerike and Urnes.

This is a fluted bowl, which was deposited in about 1050 as part of a silver hoard at Lilla Valla on Gotland [150]. Around its rim runs a frieze of eight 'ribbon-animals', arranged in confronted pairs, each linked by a palmette-loop. The heads of the animals are given the new Urnes-style look and it is only the treatment of their hip-spirals that betrays their Ringerike-style affiliations. The slender heads, in profile (which are frequently open-jawed, with scrolled ends), have elongated forward-pointing eyes and a pronounced downward-curving lip-lappet. The elegant design on the roundel at the base of the bowl consists of a single animal, with its body arranged to form a classic figure-of-eight loop, as established in the Ringerike style, but developed to become an essential element in

150. Fluted silver bowl (D 16.5 cm) from the Lilla Valla hoard, Gotland, deposited c. 1050. Its gilded rim is incised with a band of eight Urnes-style animals, linked by palmette-loops.

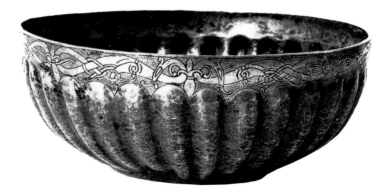

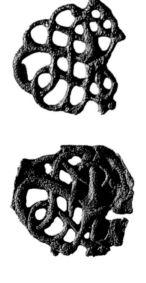

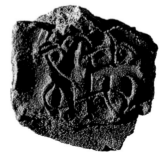

151. (opposite above left) Openwork silver brooch (W 3.2 cm) from Lindholm Høje, Jutland, Denmark, in the form of an Urnes-style 'Great Beast', its head resting on its chest, with a snake looping around its front leg and hindquarters.

152. (opposite above right) The Urnes-style animal forming this openwork silver brooch (W 4.6 cm) from Tröllaskógur, Iceland, which has rows of niello-inlaid dots on its body and legs, is entwined with two snakes.

Urnes-style compositions. Overall, this bowl is unusually restrained in its decorative treatment for a mainstream masterpiece of Viking art.

A type of openwork brooch shaped like a 'Great Beast', enveloped in Urnes-style loop-schemes, was another novel creation of this style-phase. Such brooches exist both as individual products of skilled silversmiths, like the examples from Lindholm Høje [151], in northern Jutland (the finest in the series), and Tröllaskógur in southern Iceland [152], both combined with snakes, but also in mass-produced series from workshops such as the one dating from the first half of the twelfth century that has been excavated in Lund [153].

From this it can be seen that, in addition to the redesigned 'Great Beast' motif, 'ribbon-animals' and snakes were essential elements in the creation of both the figure-of-eight designs and the more complex multi-loop schemes that form the basis for Urnes-style compositions. The latter can be seen on the late series of the distinctive animal-head brooches worn by the women of Gotland [154]. The former are exemplified by part of a wooden wall-plate, dated by dendrochronology to 1060–70, which survives from the church at Hørning, in Jutland; its excavated plan forms the basis for a full-size reconstruction built at Moesgård Museum in Denmark [155]. What remains of the carved and painted decoration consists of a frieze of snakes forming classic figure-of-eight loops [156]. At the same time as

153. (opposite below) Clay mould and three unfinished bronze brooches (H 2.5–2.7 cm), in the form of an Urnes-style animal (as opposite above), from the site of a workshop excavated in Lund, Skåne, Sweden (c. 1100–50).

154. Animal-head brooch (L 5.7 cm) of a mass-produced type worn in pairs (in place of oval brooches) by Gotlandic women, in this case decorated with an Urnes-style animal enmeshed in a multi-loop composition.

155. Reconstruction of the 11th-century wooden church excavated at Hørning, Jutland, Denmark (Moesgård Museum), with carved and painted decoration based in part on the surviving fragment illustrated opposite (ill. 156).

this continuity in treatment of animal forms, plant-based motifs diminished in importance, although they were not altogether forgotten.

The fact that the Urnes style was fashionable during the period of the widespread adoption of Christianity in Scandinavia will have contributed to its dissemination and general popularity. It will be seen below how well its motifs and conventions were suited for use in all media, not only in the decoration of the wooden churches being constructed under the patronage of local chieftains, such as at Hørning

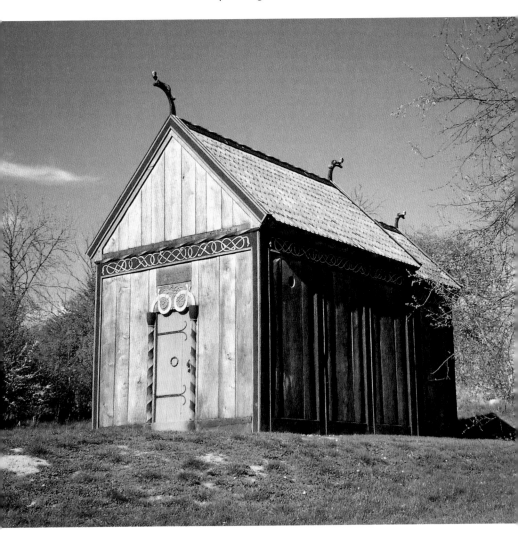

and Urnes itself. The bodies of its 'ribbon-animals' and snakes were put to good use to form the runic inscription bands on stone memorials. Metalworkers used the style to embellish such ecclesiastical artefacts as the head of a Tau-staff (a possible bishop's crozier) from Thingvellir, in Iceland [**157**].

A silver crucifix-pendant from a hoard buried at Gåtebo, on Öland, is a reliquary-cross of Byzantine type [**158**], but its ornament clearly reveals its Scandinavian manufacture in the late eleventh century. Just as the hands and the bindings on one of the Trondheim crucifixes [**159**], from a hoard deposited

156. Fragment of grooved beam from the top of the original wall of Hørning stave-church (opposite), carved in flat relief with a typical Urnes-style snake, painted red against a black background (dated 1060–70).

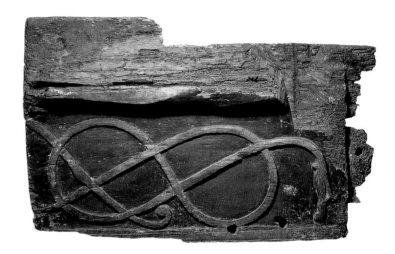

157. Socketed bronze head of a tau-crozier, found at Thingvellir, Iceland (W 8.6 cm), formed from a pair of Urnes-style animal heads. The remains of its wooden shaft has been identified as dogwood, which does not grow in Iceland.

137

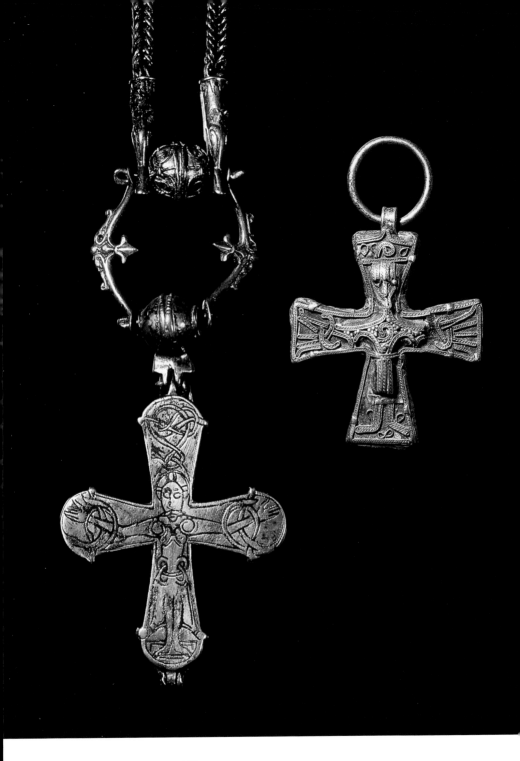

158. (opposite left) Silver pendant reliquary (W 6.2 cm), on an elaborate chain, from the Gåtebo hoard, Öland, with a niello-inlaid depiction of Christ bound to the cross with intertwining tendrils. Other tendrils fill the space above the haloed head; the cross type itself is Byzantine in origin.

159. (opposite right) Filigree-decorated crucifix pendant (H 6.4 cm), from a silver hoard found in Trondheim, Norway (deposited c. 1035), with Christ's hands stylized in the manner of Ringerike-style tendrils.

160. (below) Carved wooden plank, with damaged end (L 56.0 cm), from an excavation in Trondheim, Norway, with Urnes-style decoration in flat relief. It probably formed part of a piece of furniture, such as a chest or bench.

about 1035, were reinterpreted by the silversmith as Ringerike-style tendrils, the bindings of the niello-inlaid figure of Christ on the Gåtebo cross [158] have Urnes-style characteristics that are even more evident in the looped tendrils above Christ's head, emerging from the halo. It was doubtless made at the same time as its elaborate chain and suspension-device with its fine Urnes-style animal heads.

In the secular sphere, urban excavations across Scandinavia have produced everyday items, such as wooden or bone pins and spoons, which are decorated by amateur carvers with motifs drawn from – or inspired by – the Urnes style. More elaborate wooden objects given the Urnes-style treatment include wooden furniture, such as chairs, benches and chests. A good example of this is provided by a decorated plank [160] found in Trondheim (the Norwegian episcopal seat then called Nidaros), which displays carved ornament of superior quality, as might be expected of a professional workshop operating in such a metropolitan centre.

The Urnes style came to dominate the art of Scandinavia during the second half of the eleventh century while the Viking Age was drawing to its close. In 'its restless and constant movement', it seems to some to have been an expression of its period. It did, however, bring to an end the long tradition of Germanic animal ornament, whose continuity in use throughout the three centuries of the development of Viking art – from the Oseberg to the Urnes styles – could not have been more evident in the works examined here.

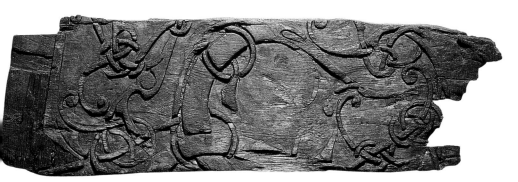

Urnes Church

Until recently, the small wooden stave-church at Urnes in Luster beside the Sognefjord (in western Norway), was most easily accessible by boat [9]. This relative isolation helps account for the remarkable preservation of several decorated elements from a Viking Age church constructed on the site during the second half of the eleventh century, although the present church has been preserved as an ancient monument since 1880. Well known to visitors is the doorway [162] incorporated into the north wall of the Romanesque church (which replaced an earlier building, the second of its two predecessors, in the 1130s). It is, however, more convenient to commence with an analysis of the ornamentation of the original west gable, which remains in its correct position, but is boarded over for protection, as is the east gable, which has a similar – if less complex – design.

The carving of both the triangular gables is executed in low, flat relief. An analytical drawing of the west gable [161] reveals the skill with which the artist combined the three animal motifs of the Urnes style into an imposing composition. This centres on a single standing (or walking) quadruped – a slender version of the 'Great Beast' – which bites the body of one of three ribbon-shaped animals that form figure-of-eight loops (distinguished here by diagonal hatching), each of which has a single foreleg and hindleg. The top two-legged animal bites the

161 (right) Analytical drawing, by Eva Wilson, of the zoomorphic ornament on the west gable of the 11th-century stave-church at Urnes, Sognefjord, Norway, (ill. 9). The design utilizes three different types of animal to create a multi-loop composition, carved in flat relief.

162. (opposite) Detail of the highly decorated portal and door of Urnes stave-church, as re-used in its 12th-century successor, with its superbly carved animal ornament – a truly remarkable survival of such wooden sculpture from the Viking Age.

body of the lower right-hand one, which in turn bites the neck of the 'Great Beast'. The lower left-hand animal completes the network by biting the body of that at the top. All four profile heads are depicted with almond-shaped eyes (which point forwards), with their open jaws having both upper and lower lip-lappets.

Threading their way through and around these four animals are seven snakes, although the heads of only six remain. Their filament-like bodies, with small profile heads and mostly foliate tails, form further figure-of-eight loops. They are shown biting, with three clamping their jaws onto the 'Great Beast' itself, thus forming a further version of the 'combat motif'.

In comparison, the ornamentation on the east gable is far easier to 'read', consisting as it does of a single, elongated, 'Great Beast' and three biting snakes, which entwine to form a far simpler 'combat motif'.

The same style of flat low-relief carving is used to decorate the Viking Age door, but its portal and associated planks [162] are carved in rounded high-relief (up to c. 5 in (12 cm) deep). The 'Great Beast' that stands guard to the left of the door is a truer representative of the Urnes-style version of the 'Great Beast' than those on the gables, given the curving contours of its tapered neck, body and legs. It does, however, form part of a related scene of animal combat, in combination with biting bipeds and sinuous snakes.

One can only suppose that it is the foliate tails of the snakes that have led some commentators to suggest that the designs on Urnes church incorporate the pagan Norse 'World Tree' in syncretism with the Christian 'Tree of Life'. It should, however, be clear from the analysis presented here that the surviving ornamentation at Urnes is essentially zoomorphic in character, in the mainstream of the style to which it has given its name.

The survival of these remarkable carvings highlights once again just how few of the finest achievements of Viking artists are known to us today because of the normal decay of wood. In this instance, at least, as with the Oseberg burial from the beginning of the Viking Age, we are vouchsafed a tantalizing glimpse of what we are otherwise missing.

The 'Runestone Style' in Sweden

The origins of the Urnes style would appear to lie in Sweden, and indeed the term 'Runestone style' has been applied in that country to embrace both the Ringerike and Urnes styles, with over 2,000 decorated examples of such memorials on record. Moreover, it has even been suggested that we may be able to put a name to the 'inventor' of the Urnes style – in the person of Asmund Karason of Uppland, who (it has been postulated)

might have been linked to the Swedish royal court at Uppsala. From his ten signed stones, Signe Horn Fuglesang (2001) has characterized him as being 'an innovative artist with good international contacts', one with 'the artistic ability necessary to take up an existing tradition, to reshape it and to fuse the novel form with new motifs'. Asmund's output belongs to the earliest phase of the Urnes style, whereas that of one Öpir represents the last in the sequence of signed memorials, with Balli and Fot (among others) being active in the middle period.

There are two groups of memorials among the central Swedish runestones that are especially notable for both artistic and historical reasons: (1) a group of twenty-one (certain) stones, in the area around the Mälar lake, which all commemorate men who died during an ill-fated expedition to the East, led by Ingvar (known as 'Ingvar the Far-travelled'); and (2) a sequence of runestones raised in memory of members of the family of Jarlabanke, one of Uppland's leading Christian magnates.

The date of the Ingvar expedition is disputed, given that the traditional date of 1041 is derived from late Icelandic sources, whereas it has been argued, on stylistic grounds, that the runestones in question are to be dated at least a generation earlier. Although by several different hands, their designs are closely similar: using the body of a snake (or sometimes two), with head seen from above, to form the inscription band, for example at Gripsholm, Södermanland [163]. This stone was raised in memory of Ingvar's 'brother', Harald, by his mother; its memorial text is completed by a verse, the first word of which is placed outside the snake's body:

Like men they journeyed far for gold
and in the east they fed the eagle,
in the south they died in Serkland.

A dead man about to 'feed the eagle' was seen above (p. 43), depicted on the Stora Hammars 'picture-stone' [37].

The Jarlabanke stones span four generations of this Uppland family, commencing with one raised for Jarlabanke's grandfather, Östen, which has pre-Urnes-style designs. The next are early Urnes style, one raised for his father, Ingefast, and the Fot-related stones raised by Jarlabanke himself. The final monument in the sequence was raised in his own memory, by his widow

and son, which is signed by Öpir. That illustrated here [164] is one of Jarlabanke's own stones, which still stands (as one of a group of four) beside the road that it commemorates: 'Jarlabanke put up this stone in his own lifetime, and made this causeway for his soul, and he alone possessed the whole of Täby: may God help his soul'. The construction of a 'bridge', road or causeway across marshy ground formed part of the 'good works' to be expected of a Christian magnate, to enable people to reach their local church in all weathers.

Some further stones of particular historical interest were raised in memory of men from Uppland who had served with

163. The runic inscription contained in the body of the snake that loops around this memorial stone at Gripsholm, Södermanland, Sweden, records the death 'in Serkland' of Harald, the brother of Ingvar who led there an ill-fated expedition 'after gold'. 'Serkland' is undefined territory, but probably refers to the Abbasid Caliphate.

Cnut in England, including two raised at Yttergårde by the sons of Ulf [3]. Ulf had taken part in levying three Danegelds – periodic Danish attacks on England for tribute payments – of which Cnut's (for his homeward-bound troops in 1018) was the last, so that an estimate for his death in the 1020s, and thus also for the creation of his memorial, does not seem unreasonable. It is decorated in the same style as those signed by Asmund whose designs, utilizing sleek and simple runic animals with their heads in profile, belong to the earliest Urnes-style phase in Uppland, following on from those of the Ingvar stones.

164. One of four runestones (H 2.2 m) marking Jarlabanke's 'bridge' in Täby, Uppland, Sweden. Its inscription text is in two sections on a pair of linked snakes facing a cross. It records how Jarlabanke constructed a causeway for the good of 'his soul.'

Asmund seems to have been active during the second quarter of the eleventh century and his great variety of patterns includes what to Fuglesang (2001) seems to be 'the earliest version of the Urnes-style multi-loop composition', as on his stone at Västeråker church. He also 'seems to have been the man who introduced the winged dragon in Scandinavian art', but this new form of beast remained rare until more generally adopted as part of the innovations of Romanesque art in the twelfth century [204-6]. On the other hand, Asmund eschewed the use of both the 'Great Beast' and the 'combat motif', using a 'ribbon-animal' or snake to form his runic framework, but with the Urnes-style head in profile, as can be seen on the Ängby stone [165]. His innovations, and the overall quality of his ten (surviving) signed stones, demonstrate that he is, indeed, to be identified as one of the truly creative artists known to us from the Viking Age in Scandinavia.

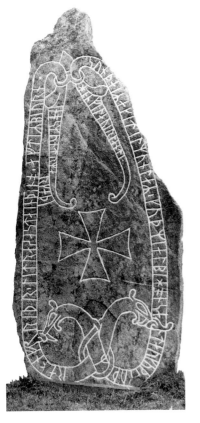

165. (below) One of the ten runestones signed by Asmund stands at Ängby, Uppland, Sweden. His simple but elegant design consists of a central cross framed by a pair of Urnes-style snakes, which link together to form the runic bands.

Öpir, on the other hand, who has left us far more in the way of signed stones, a total of forty-six (with over eighty inscriptions attributed to him), was more of an average craftsman, with a limited repertoire of basically two straightforward designs, as seen on the Sjusta boulder, which commemorates four men, one of whom 'met death in *Holmgarðr* [Novgorod] in Olaf's church' [**166**]. Olaf, the martyr-king of Norway, met his death in 1030 at the battle of Stiklestad (p. 17).

The apogee of the Urnes style, as represented in the art of the Uppland runestones, is to be seen on a rock-face at Nora, in the form of the classic 'combat motif' between beast and snake [**10**]. The inverted drawing [**167**] reveals the typical details of the head and body of the 'ribbon-animal', forming the inscription band, combined with the elegant figure-of-eight loop of the entwining snake.

On Gotland, far from Uppland and with its own traditions (as described in Chapter 1), the resurgence of stone carving noted in connection with the Ringerike style was carried forward into the Urnes style, with a monument such as Ardre III – erected in honour of Liknat by his sons – belonging to the transitional phase [**168**]. Its ornament is similar to that on the

166. (opposite right) The boulder at Sjusta, Uppland, Sweden, carved by Öpir (who signed forty-six stones, making him the most prolific of the known runemasters), was commissioned by two women in memory of four men (all brothers), one of whom died in Novgorod.

167. (right) The carving on the rock-face at Nora, Uppland, Sweden (see ill. 10), displays an elegant example of the Urnes-style animal-and-snake 'combat motif' with a central cross. The snake forms a figure-of-eight loop around the beast whose body bears the inscription.

Lilla Valla bowl [150], aside from the addition of two figures. The central male figure, between the two 'ribbon-animals', is shown seated and holding up a ring – with the suggestion being that this could be a depiction of Odin and his magic arm-ring, Draupnir.

Four further decorated stones (Ardre I, II, V and VI), found beneath the floor of Ardre church, which was probably built about 1170, can be reconstructed together to form a box-tomb. This is one of the finest runic monuments known from Sweden [169] and was erected for Ailikn, Liknat's wife. Both the runic letters and the background to the elaborate Urnes-style ornament were originally painted red. This monument is of particular artistic interest in that it is one of two on Gotland that appear to draw on an earlier 'picture-stone' for their figural scenes, in this case Ardre VIII [192], which was likewise found beneath the church floor. In what seems to have been a

168. This memorial stone from Ardre church, Gotland (Ardre III), raised to Liknat by his sons (see also ill. 169) is dominated by a pair of S-shaped animals, their necks linked by a palmette, although the Urnes-style design incorporates two small figures, with that at the centre holding up a ring.

conscious act of revival, Odin's eight-legged horse, Sleipnir, being ridden by a man armed with a sword, is seen making a reappearance, this time on a Christian memorial.

It is important to conclude this section with a reminder that the carved lines on many (and probably most) runestones were originally painted; indeed, some even record this fact in their inscription. The painting on those illustrated above is not original, but some such treatment was clearly necessary to increase their legibility. A remarkable find of about sixty fragments of runestones, which had been used as building-stone in the church at Köping, on the Swedish island of Öland, assists in our understanding of this matter because they were broken up while still in fresh condition, presumably not long after they had been raised. The main colours used are red (red lead) and black (from soot), used sometimes to pick out alternate words, or for filling in the whole area between the lines.

169. Box-tomb from Ardre (stones I, II, V & VI), with traces of red paint (H from bottom of decoration 48–50 cm). The monument was raised by Liknat's sons for their mother Ailikn. The shape of the earlier Gotlandic 'picture-stones' is preserved, but the figural scenes (which include an eight-legged horse) are now dominated by the runic inscriptions and Urnes-style animal ornament.

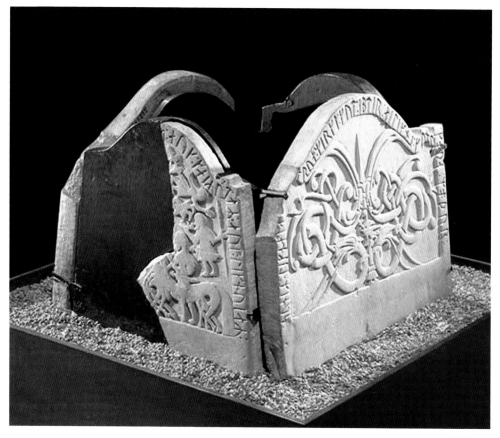

The Urnes Style: Expansion

Given the popularity of the Urnes style in Sweden and Gotland, it is scarcely surprising that its influence was, to some extent at least, felt across the Baltic, following on from the earlier impact of the Ringerike style. The distribution of a particular group of spear-heads (known as Type G), with silver-encrusted sockets decorated with Urnes-derived motifs, is confined to eastern Scandinavia, the east Baltic and Russia. In the West, the introduction of the Urnes style to Iceland has been noted above [152, 157], as has the 'Runestone-style' memorial inscription carved on the shoulder of one of the two marble lions that guarded the entrance to the Greek port of Piraeus (until it was carried off to Venice, in 1687, as a war-trophy) – the southernmost discovery of any Scandinavian work of art from the Viking Age [11].

Evidence from England for imported objects decorated in the Scandinavian Urnes style remains scarce, despite the recent discovery by metal-detecting of two of the familiar openwork 'Great Beast' brooches, from Lincolnshire and Suffolk [as 151–53]. Localized adaptation of the style is, however, exemplified by a circular brooch found in the churchyard at Pitney, in Somerset. The openwork ornament of this gilt-bronze brooch depicts a 'ribbon-animal', biting its own body, with an elegant lip-lappet, scrolled joints and a foliate tail, in combat with a snake, with tendril off-shoots, which bites its neck [170]. This version of the 'Great Beast', with its body of

170. Openwork disc brooch of gilt-bronze (D 3.9 cm), from Pitney churchyard, Somerset, England. It features an animal-and-snake 'combat motif' in the English version of the Urnes style.

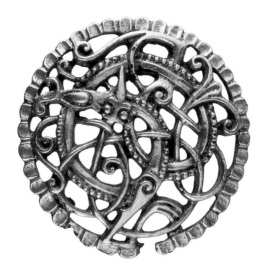

even width, and the lack of clarity in the organization of the multi-loop scheme, are two aspects of the design of the Pitney brooch that reveal its English manufacture, despite the clear Scandinavian inspiration for its 'combat motif'.

A cruder version of the Pitney brooch is known from Wisbech, Cambridgeshire, and – as was the case with the English Ringerike style – there are buckles and stirrup-mounts with likewise poor-quality imitative ornament. There are some finer openwork mounts, however, such as one from a stirrup-strap found at Hemel Hempstead, Hertfordshire, with the beast/snake 'combat motif', and another, of unknown function, excavated at Lincoln, which is composed of five animals [171]. These display the English Urnes style at its best – even if that fails to capture the full spirit of the Scandinavian style itself.

An enigmatic use of the English Urnes style is its choice for the decoration of the socket of a crozier made for a Norman bishop of Durham, found in his grave in the chapter-house of the cathedral. It is made of iron covered with a sheet of silver that has been incised with a niello-inlaid design of a 'ribbon-animal' interlaced with a snake [172, 173].

A capital carved in Caen stone for the cloister of Norwich Cathedral, in about 1120–30, displays two interlinked figure-of-eight animals incorporated into looping scrollwork, with foliate details. This design suggests copying from a piece of Urnes-style metalwork, such as the Pitney brooch, rather than any persistence of an Urnes-style tradition. A similar explanation

171. Openwork bronze mount (L 6.1 cm), found at Lincoln, England, consisting of five animals. This is a fine example of small-scale decorative metalwork in the English-Urnes style.

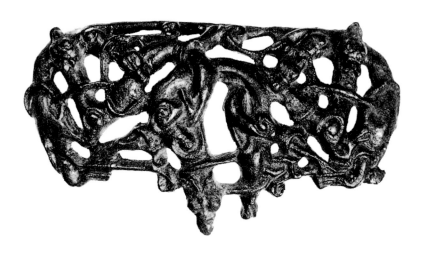

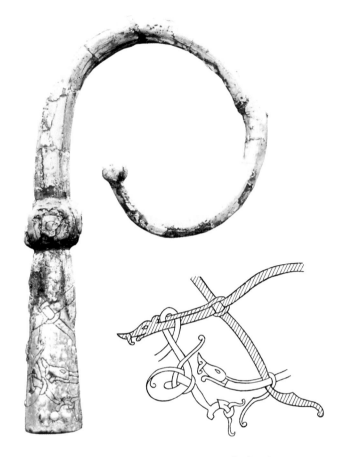

172, 173. Bishop's crozier found in the chapter-house of Durham Cathedral, England, made of iron covered with a thin sheet of silver (H 17.8 cm). Its socket is incised with niello-inlaid decoration in the English-Urnes style.

would account for such occasional Urnes-style details as can be detected in other Romanesque sculpture, for example in the treatment of the dragon confronted by the winged figure of St Michael on a (reused) stone in Southwell Minster, Nottinghamshire [210].

There was therefore no long-term impact by the Urnes style on the development of Anglo-Norman art. In Ireland, on the other hand, Fuglesang (1986) has described the style as having been 'a vital force in Irish Romanesque in the first half or three-quarters of the twelfth century'.

The Ringerike and Urnes Styles in Ireland

It would appear that the Ringerike style reached Ireland by way of southern England rather than directly from Scandinavia. The Hiberno-Scandinavian town of Dublin can be recognized as the metropolitan centre where this late Viking art-style was assimilated and from which it was then transmitted to other centres of patronage. In a study of 150 pieces of ornamented wood from the Dublin excavations, James Lang identified only three that display a 'pure' version of the Ringerike style, and even these are considered to betray southern English influence. In this context, it is important to recall that it was to the Archbishop of Canterbury (rather than to Lund in Scandinavia) that Dublin looked for ecclesiastical leadership during the eleventh century.

A particularly remarkable expression of the art of a wood-carver belonging to the so-called 'Dublin school' is found on a pair of elaborately plumed, bird-headed terminals on a mount of unknown function. The forward-pointing eye in the profile head and use of foliate tendrils represent Ringerike-style motifs, but the disciplined – even rigid – treatment of the design, as favoured in this eleventh-century 'Dublin school', derives from earlier Insular art.

The composition on a Dublin bone 'motif-piece', consisting of a pair of interlinked figure-of-eight 'ribbon-animals', with the characteristic foliate extensions, is readily recognizable as being in the mainstream of the Ringerike style. In Irish ecclesiastical art, it finds its counterpart on one end of the Shrine of the Cathach (Kells, Co. Meath). The early part of this book-shrine bears an inscription dated to between 1062 and 1094. This includes the name of its maker, Sitric mac Meic Aeda, the form of which suggests that he may have been of mixed Irish-Norse descent, for Sitric is the Irish rendering of the Norse name Sigtrygg.

Although the major extant works in the Irish version of the Ringerike style – primarily reliquaries, but also illuminated manuscripts – were not produced until the late eleventh and early twelfth centuries, the variety of decorated wooden objects and bone 'motif-pieces' excavated from eleventh-century levels in Dublin demonstrates that craftsmen there were familiarizing themselves with Ringerike-style motifs from early on in the century.

174, 175. The silver and niello inlaid decoration on the curved crook of the magnificent crozier associated with the Abbots of Clonmacnoise in Co. Offaly, Ireland, (L 97.1 cm) exemplifies the metropolitan 'Dublin school' of the Irish-Ringerike style. The figure of a mitred bishop on the front is a later addition.

176. (opposite) The Cross of Cong, Co. Mayo, (H 76.5 cm) is a processional cross made to enshrine a relic of the True Cross that had been brought to Ireland in 1122. The front of the cross and the knop at its base are divided into panels containing cast openwork bronze plates decorated in the Irish-Urnes style (see also ill. 177).

In turn, towards the end of the eleventh century, Irish art began to be influenced by the Urnes style, but its compositions and motifs were once again modified by indigenous tradition. The Irish version of the style became popular in both stone and metalwork, featuring in the decoration of some of the finest twelfth-century ecclesiastical works to be produced in Ireland. The multi-loop schemes of the Urnes style were subjected to the more symmetrical Irish approach to laying out animal and interlace ornament. An example of the transitional Ringerike-Urnes style, arising from the 'Dublin school' of woodcarving, can be seen in the decoration of the crook of the Clonmacnoise crozier [174, 175], traditionally associated with the abbots of this major monastery on the River Shannon, in Co. Offaly.

The classic Urnes-style motif of an intertwined beast and snake is clearly utilized, for instance, on the Cross of Cong, Co. Mayo [176], but the overall effect of the end-result, balanced

177. (right) Detail of the animal-
and-snake combat motif, in
openwork, from the knop at
the base of the Cross of Cong
(ill. 176), with its obvious origins
in the Scandinavian Urnes style
(cf. ills 151–52).

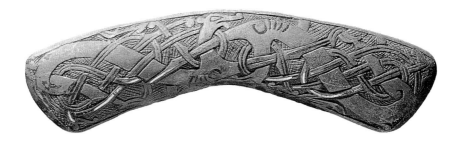

and symmetrical, is clearly at odds with the much freer appearance of the classic Scandinavian version. In the detail illustrated here, it can be seen that not only is the body of the 'Great Beast' of even width, but also that the figure-of-eight patterns produced by its own tail and the snake's body are diagonally arranged around a central crossing-point [**177**].

The Cross of Cong is a processional cross, made as a royal commission to enshrine a relic of the True Cross, which had been acquired in 1122 by Turlough O'Connor, the High King of Ireland. The distinctive ornamentation of the Cross of Cong, as well as that of the closely related St Manchan's Shrine (Co. Offaly), suggests that these major pieces are most probably the products of the workshop of a well-endowed monastery that was not directly dependent on Dublin for its inspiration.

In the alternative sphere of secular metalworking, there is good evidence from the Dublin excavations for the production of sword fittings in late Viking style. The splendid cross-guard, made of brass with silver and niello inlay, recently recovered by a diver from the seabed off the Smalls Reef, some 15½ miles (25 km) from the coast of Pembrokeshire (south Wales), is to be identified as the product of one such Dublin workshop [**178**].

The Irish version of the Urnes style was so popular that it lived on in metalwork until the mid-twelfth century – and even longer in sculpture, for the creation of Hiberno-Romanesque monuments, as for example Cormac's Chapel on the Rock of Cashel, Co. Tipperary. This was consecrated in 1134 and contains a spectacular sarcophagus [**179**]. The design of a pair of intertwined animals, tightly interlaced with snakes and their own tails, gives every appearance of having been taken over from metalwork.

The lack of direct contact by Ireland with artistic developments in Scandinavia during the eleventh and twelfth centuries is exemplified by the fact that, when the earliest Irish pieces displaying Urnes-style influence were created, Scandinavian art was already developing into its late Urnes-Romanesque phase, to be described in the next chapter.

178. (opposite centre) The animal ornament on this bronze sword-guard (L 11.8 cm), recovered from Smalls Reef, off the coast of Pembrokeshire, South Wales, suggests that it is the product of a Dublin workshop.

179. (opposite) Cormac's sarcophagus, Rock of Cashel, Co. Tipperary, decorated in the Irish-Urnes style as seen in metalwork on the Cross of Cong (ills 176–77). Cormac's Chapel was consecrated in 1134.

Chapter 5 Content and Legacy

The messages conveyed by the Viking art presented in the previous three chapters are most immediately those of social status, military rank and political or religious affiliation. Greater wealth was necessarily required to commission work from a gold- or silversmith than to purchase the mass-produced wares of an urban craftsman. A chieftain in the king's service was distinguished by his parade weapons and the adoption of the latest 'court' style. Pagan Danish settlers in East Anglia could assert their identity among Christian Anglo-Saxons by displaying a Thor's hammer – and by decorating their jewelry with ornament based on whatever was currently fashionable in their homeland. A Christian landowner might undertake 'good works' and proclaim allegiance to his or her new faith by erecting a commemorative runestone.

180. Fragment of a late Viking Age wall-hanging from Överhogdal, in northern Sweden, consisting of a strip of linen worked with coloured wools. The event(s) depicted seem to be taking place from right to left, recalling the procession on the much earlier hanging from the Oseberg ship burial (ills 54–55), but the presence of houses and of a ship under sail suggest something more in the nature of an expedition – military or otherwise.

Message and Meaning?

It is a natural desire to wish to interpret such narrative scenes as those on the Oseberg wagon and tapestry, but more especially those on the Gotlandic 'picture-stones' (some of which are discussed further below). The problems, already acknowledged, are those of having to transfer the content of the few extant literary sources that are relevant for the purpose across both space and time: from Iceland to mainland Scandinavia, and from the High Middle Ages back to the Viking Age. There are no satisfactory ways in which to calibrate fully the written sources with the artefacts – and we cannot begin to calculate the depth of our ignorance.

By way of an example, it is instructive to consider the narrative scene(s) on one of a group of five Viking Age wall-hangings known from Överhogdal, in northern Sweden. This (Överhogdal III) is a narrow band of linen, worked with coloured wools (woven from right to left), which has been radiocarbon-dated to the late Viking Age [180]. It is both incomplete and worn, factors that are in themselves cause

for caution against over-interpretation. The action, which takes place in a strip framed by a wide ornamental border, appears to be an expedition. At the rear (right-hand end) are two axe-bearing warriors, behind an equestrian figure associated with (departing from?) a house in which there are three standing figures (two in female dress, with one child?). This scene is separated from the next by a stylized tree, although it is possible that they are two episodes in a single sequence of events, given that all the figures are facing/moving to the left. Another equestrian/house combination is preceded by a ship under sail, below which is a row of (walking?) figures, one of which (at the rear) is large enough to be seen to be wearing female dress. In front of this again (still moving from right to left) are further figures/riders – one in female dress holding a staff (or spear?) – but here the fragment reaches its frayed end.

These two crowded compositions, and sense of movement from right to left, inevitably bring to mind the procession on the wall-hanging from the Oseberg grave-chamber [**54, 55**]. The fact that this can reasonably be interpreted (in its burial context) as either a funeral procession or a ride to Valholl (with warriors accompanied by valkyries) does not mean that this is what is depicted on Överhogdal III, given that it is not even possible to determine whether it has mythical/legendary content or tells the story of an event in the life of the person who commissioned it. All that can be said in this connection is that it contains nothing specifically Christian in its composition.

As will have become apparent from this survey, a love of decoration and bright colours runs through Viking art, with surfaces for the most part completely covered with ornament, whether on an animal-head post from Oseberg or a stave-church portal at Urnes. There is a strong likelihood, however, that much of this ornament also carried symbolic meaning for those who used and viewed it, even if we are barely able to do more than guess at it today. Wolves, bears, serpents and birds all had a symbolic role in Nordic society and when utilized in Viking art (be it on a brooch or sword, a bridle or a ship) it is reasonable to suppose that they were intended to invoke protection for the wearer or user. So if Viking art in part, at any rate, provided a degree of protection to its owner, it is only to be expected that some objects (mostly pendants), among the archaeological evidence for Scandinavian paganism, are best interpreted as amuletic in function.

Paganism and Viking Art

Much of what we know about the pagan deities worshipped during the Viking Age in Scandinavia derives from the knowledge of Snorri Sturluson, an Icelander writing at the beginning of the thirteenth century, some 200 years after his country had officially adopted Christianity. In his work known as the *Prose Edda*, Snorri states that 'Odin is the highest and oldest of the gods; he rules all things … his chosen sons are all those who die in battle. Valholl is for them.' It was the female valkyries who escorted the fallen warriors to Valholl where others were waiting to welcome them. The first element of 'valkyrie' is *valr*, meaning 'the slain' – hence the word means 'chooser of the slain'.

Valholl is the name given to Odin's 'Hall of the Slain' (*Valhǫll*), which housed his army in training for the epic battle that was to mark the end of the world. Among the many names accorded Odin were ones connected with battle and death, with his birds and animals being those that feed on corpses – ravens and wolves. Snorri also tells us that he possessed a supernatural eight-legged horse, called Sleipnir.

It is possible to suggest that the scene on the upper half of the Gotlandic 'picture-stone' Tjängvide I from Alskog can be interpreted as set in Valholl [181]. There is a rider on an eight-legged horse being welcomed by a valkyrie, with a hall in the background, surrounded by some fighting. Accordingly, the

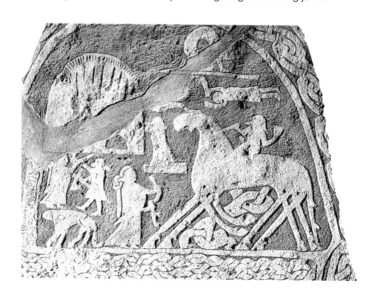

181. Detail of the upper register of the Tjängvide I 'picture-stone' (ill. 39), generally considered to depict the arrival of a (newly revived) dead hero at Valholl – the 'Hall of the Slain' itself being the hog-backed shape at top left – riding on Odin's eight-legged horse (Sleipnir) and being welcomed by a long-haired valkyrie. (The paint is modern.)

182. (opposite) This modest Gotlandic 'picture-stone' (with modern paint) (H 86 cm), from Stenkyrka Lillbjärs, shows a helmeted horseman with a circular shield riding towards a female figure holding out a horn – another valkyrie in the service of Odin?

mounted figure could be either a slain warrior being received in Valholl or Odin himself returning home. There are, however, some who believe that the scene illustrates the hero Sigurd on his horse Grani (sired by Sleipnir), riding to meet the valkyrie Brynhild, as related in Vǫlsunga saga ('The History of the Volsungs').

A related scene fills the top register of the 'picture-stone' Ardre VIII [192], whereas that on the stone from Stenkyrka Lillbjärs III features a welcoming female figure standing in front of an equestrian warrior [182].

Another version of a 'valkyrie' scene is now known in metalwork from both Viking Age Denmark and England. A shield-bearing woman faces a female rider, with braided hair, armed with sword and spear. The well-preserved detail of the silver-gilt and niello-inlaid example found at the aristocratic 'manor' or 'central place' at Tissø, Sjælland, shows clearly that the standing (helmeted?) figure is offering a horn to her superior 'sister' [184]. Spear-carrying women form part of the procession on the Oseberg wall-hanging [55], and shield-shaped amulets have been found, worn as pendants, in a number of female graves.

Before proceeding to the nature of other pagan amulets from Viking Age Scandinavia, it is useful to explore first some

183, 184. (below) Female figures in gilt-silver from the high-status site at Tissø, Sjælland, Denmark, seemingly of amuletic significance. The standing woman (H 6 cm) holding her braided hair wears a prominent brooch and might be the goddess Freyja, or else a valkyrie like the female warrior on horseback (right) being met by a shield-bearer holding out a drinking-horn.

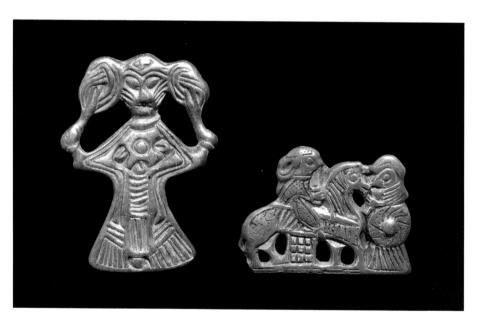

of the limited evidence for the depiction of the deities themselves, together with their attributes. It is reasonable to suppose that wooden idols were erected in the open air as a focus for sacrificial rites; so much at least is indicated by Ibn Fadlan in his first-hand account of the Nordic merchants (Rus) whom he encountered on the Volga, in 922.

It was seemingly unusual for special buildings to be set aside for pagan worship and many religious ceremonies appear to have taken place in the halls of chieftains. One of the special cult-buildings was that at Uppsala, described by Adam of

185. The scene on the lower part of the runestone at Altuna, Uppland, Sweden, (H 195 cm) is an unambiguous representation of the god Thor fishing for the World Serpent. (The paint is modern.)

Bremen who was writing around 1075. His account was based on second-hand evidence, but among what he learnt was that the 'temple' housed images of three gods: Odin, Thor (said to be seated) and 'Fricco', who is normally taken to be Frey.

The most important of the gods was Odin, the 'All-father', although Adam understood Thor to have been the most powerful, if vulnerable without his magic hammer (Mjǫllnir). Thor was engaged in a feud with the World Serpent or Midgardsorm, with each to be the death of the other at Ragnarok, the great battle that would mark the end of the old world, with Odin being consumed by the wolf Fenrir [199]. Frey, with his sister Freyja and their father Njord, formed a distinct group of deities (known as the Vanir) connected with fertility and prosperity.

In the light of Snorri's account of Thor, the 'fishing scene' on the runestone at Altuna, Uppland (in Sweden), from about 1000, is rich in detail for identification purposes [185]. In this instance the figure in the boat is readily recognizable as Thor both because of the hammer held up in his right hand and because one of his feet is shown projecting below the hull. This is the moment during Thor's attempt to catch the World Serpent when, pulling on his fishing line, he pushed down so hard that his feet went through the bottom of the boat. Amidst the coils of the World Serpent, in the ocean below, can be seen its head with the jaws closing on the ox-head bait, which dangles on the end of Thor's line.

A similar scene is depicted on a tenth-century slab in the church at Gosforth, in northwest England [186], although lacking the detail of the projecting foot. On the other hand, the

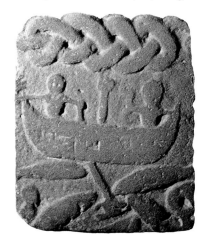

186. A fragmentary slab (H 70 cm) in the church at Gosforth, Cumbria, depicts a similar scene to that on the Altuna stone (opposite), but with two men in the boat. According to Snorri, Thor was accompanied by the giant Hymir on his fishing expedition.

187. Bronze phallic statuette of a squatting figure wearing only a helmet and an arm-ring (H 6.9 cm), from Rällinge, Södermanland, Sweden. This is generally identified with the fertility god, Frey, seemingly in the act of stroking his beard (the other arm damaged).

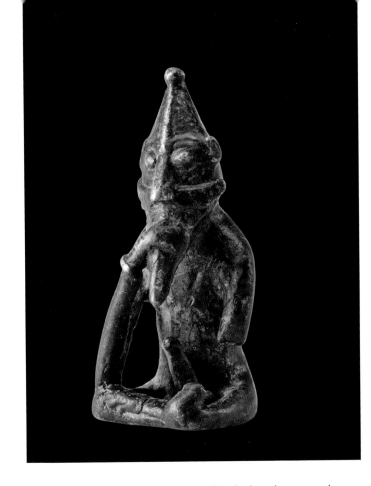

hammer-wielding Thor is accompanied in the boat by a second figure, presumably the giant Hymir who features in Snorri's account of the expedition. The popularity of this particular mythical encounter, across the Viking world, is emphasized by the contemporary descriptions of painted versions of this event, which were mentioned above (p. 47).

Icelandic sagas contain references to 'gods of the pouch' (or, as we might say, 'pocket deities') and one of the best candidates from Viking Age Scandinavia for identification as such is the cast-bronze figurine of a cross-legged man from Rällinge, Södermanland (in Sweden) [187]. He is naked, apart from a conical helmet and a ring on both arms, and is usually identified as Frey, the fertility god, on account of the prominence given to his erect phallus – the defining characteristic of his image in the cult-building at Uppsala, according to Adam of Bremen. He is depicted in the act of holding or stroking his long beard, as a

188. Seated bronze figure of a man holding a long forked beard, wearing a helmet (H 6.7 cm), from Eyrarland, in northern Iceland, often considered to be the god Thor. His moustache is formed from a pair of Ringerike-style tendrils and lobes, dating the image to the early 11th century.

further sign of his virility. The shoulders and buttocks are indicated by large spirals, and his moustache is given tendril-like treatment, so that he displays Mammen/Ringerike-style characteristics. Although the identification with Frey is the most economical for this unique object, there is plenty of room for further speculation, as to whether (for example) it might even be Odin or 'some other notoriously libidinous creature such as a dwarf or a giant, or even an elf', as Neil Price has observed (2006). But why then put so much effort and expense into the creation of a non-deity?

Another helmet-wearing, beard-clutching figurine, similar in size to the Rällinge example, is known from Eyrarland, in Iceland. He is shown seated on a chair or throne, with a forked beard that has its two ends united to form a trefoil-shaped terminal [188]. The strong case for identifying this figure with the god Thor has been restated by Richard Perkins (2001), who

189. This small wood-carving (H 2.9 cm) of a helmeted and bearded man, excavated at Gnëzdovo, Russia, has been identified as a possible cult figure – or 'god of the pouch'.

believes it to have been a 'wind-charm' (with Thor shown 'sounding the voice of his beard'). The Ringerike-style moustache tendrils indicate a date for this figure no earlier than about 1000, and it is more probable that it was made somewhat later – in the first half of the eleventh century – and therefore post-dates the official conversion of Iceland to Christianity.

Some unidentified anthropomorphic 'idols' can be added to these two well-known examples of 'gods of the pouch', including a small figure of a bearded man carved in wood [189] and another cast in lead, found during recent excavations at the urban settlement of Gnëzdovo, on the River Dnepr. The latter is from a metalworking horizon thought to date from the end of the tenth or very beginning of the eleventh century.

Amulets are considered to be objects worn to provide protection against danger – or just to bring good luck. The most obvious Nordic variety of these is in the form of miniature hammers, which were presumably worn by the devotees of Thor. Some of them are simply representational in character, but others are more elaborate, constituting minor masterpieces of Viking art, such as the silver filigree-decorated example from Skåne [190], which has a bird's head suspension-loop, with hooked bill and staring eyes, in the same manner as the Hiddensee cross-pendants [72].

One distinctive type of cast pendant takes the form of a female figure in profile. The majority of the eleven examples

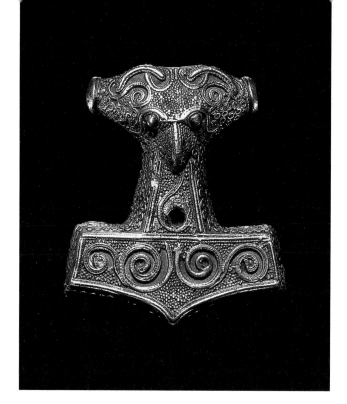

190. Silver Thor's hammer pendant (H 5.1 cm) from Skåne, Sweden, with filigree foliate decoration. The beaked head forming its suspension-loop recalls those of the cruciform pendants in the Hiddensee hoard (ill. 72).

on record are from Sweden [33], although their distribution extends from Tissø, in Denmark, to Rjurikovo Gorodishche, near Novgorod, in Russia. One variant has the woman holding (or offering) a beaker or drinking-horn in the same manner as the female figure already noted on the 'picture-stones' from Tjängvide [181] and Stenkyrka [182]. The association on these stones of this woman with a rider, and in the case of Tjängvide with one seated on Sleipnir, has been taken as evidence that these pendants are likewise to be identified as valkyries. On the other hand, the fact that some of them have been found in female graves has given rise to the alternative suggestion that they are to be interpreted instead as representations of Frey's sister, Freyja.

Evidence for the casting of such 'valkyrie' pendants, in the form of mould fragments, is known from two workshop sites: one dating from the early ninth century at Birka, in central Sweden, and the other from the first half of the tenth century at Staraya Ladoga, on the River Volkhov, in Russia. A later variant in Russia is provided by a pendant shaped from a thin gold sheet, with scratched details, found in the upper layer at

Gnëzdovo, where not only has a large quantity of typically Scandinavian 'magic' objects (miniature hammers) been found, but also evidence for their production. In this case, the pendant's peculiarities suggest local manufacture in the second half of the tenth or early eleventh century.

These figurines and plaques share the fact that they represent atypical ventures into representational art on the part of the Viking (and pre-Viking) craftsmen who produced them. As described in Chapter 1, this factor can be taken by itself as evidence for their religious content/purpose. The same can be said of a range of small pendants that are likewise out of the ordinary in being naturalistic reproductions – in miniature – of objects such as weapons (in addition to the hammers, already mentioned). An excellent example is provided by a silver amulet ring that forms part of a hoard from Klinta, Köping, Öland, which also includes a 'valkyrie' pendant. The six miniature artefacts suspended from this ring consist of a sword, a (broken) spear-head, three staves and a fire-steel (or strike-a-light). Staves form part of a number of such pendants and their use has been associated with the cult of Odin, as with the weapon-dancer on the pre-Viking die from Torslunda [31 bottom left]. Fire-steel pendants have also been found associated with Thor's hammers, although elsewhere with miniature agricultural implements, which is more suggestive of a fertility cult – and thus of Frey – but then the life-giving force of fire is of universal significance.

A rare form of amuletic pendant is that of a coiled snake (as known from both Birka and Hedeby). Indeed, the prow of the Oseberg ship terminates in another such coiled snake's head [43]. In the latter case it would have likened the complete vessel to the 'sea-serpent' of Viking Age poetry, although doubtless it will also have provided protective power.

Silver miniature chairs from Viking Age finds are interpreted as symbolic 'high-seats' (possibly representing the throne of Thor, who was described as seated in Adam of Bremen's account of the temple at Uppsala). The 'high-seat' was the place of honour in the hall of a chieftain, who would have presided over ceremonial rituals (and exercised other 'priestly' functions). Alternatively, these miniature chairs have been interpreted as representing thrones for sorcery, forming part of the equipment of a sorceress (*vǫlva*), given that they have been found in women's graves.

The recent discovery of a figure seated on a throne, from the Danish 'central place' of Lejre [191], is therefore of exceptional interest. It is made of niello-inlaid silver and dates from the tenth century. The back of the throne terminates in a pair of animal heads, reminiscent of the animal-head posts at Oseberg. The person is wearing female clothes, with covered hair, a long dress and a cloak, which is parted to reveal a multi-looped necklace. Overall, it would seem reasonable to interpret this figure as the goddess Freyja. On either side of her, however, is a bird perched on the arm of the throne, facing inwards as if in communication. Such a pair of birds suggests the ravens Hugin and Munin, Odin's messengers, but although Odin often assumed disguises it seems improbable that he would have been portrayed in female dress on such a significant religious object. It was, however, from Freyja that Odin is said to have learnt the powers of sorcery (seiðr).

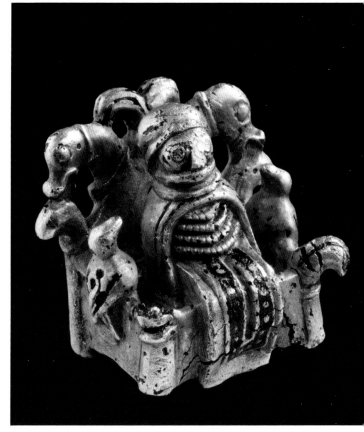

191. Seated silver figure (H 1.8 cm) found at Lejre, Sjælland, Denmark. It has most reasonably been interpreted as a representation of the goddess Freyja, unless it is to be identified as Odin – in female disguise – because of the two attendant birds (Hugin and Munin?).

The complex composition in the main field on the Ardre VIII 'picture-stone' [**192**], already mentioned for its apparent depiction of Valholl above, centres on a rectangular smithy identifiable as such by its hammers and tongs; to its right, there is a pair of headless male corpses. This combination means that the scene is to be related to the saga of Volund (Wayland the Smith), as summarized by Jörn Staecker (2006):

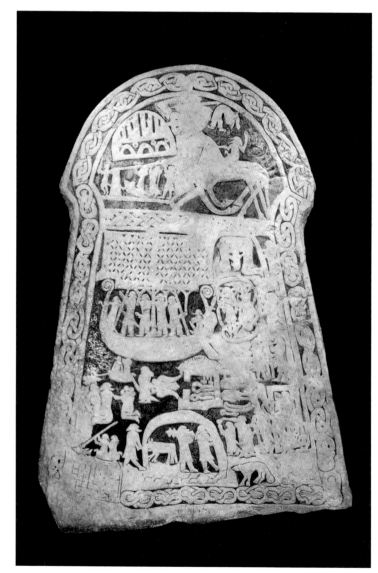

192. The upper register of 'picture-stone' Ardre VIII, Gotland (H from bottom line 210 cm; paint modern), contains a similar 'Valholl' scene to that on Tjängvide I (ill. 181). The lower section is a confusing combination of discrete events, alongside the standard ship under sail, but including Volund's smithy, with himself in bird form (at centre).

The master-smith Volund is captured by the evil ruler Nidud and forced to serve him on an island. The smith is not able to escape because Nidud has his knee tendon cut. But Volund takes revenge: he kills Nidud's two sons and makes bowls of the skulls. And he rapes Nidud's daughter Baduhild.... After his revenge Volund is able to flee from the place thanks to a magic ring which gives him the ability to fly.

Baduhild is to be seen to the left of the smithy, with Volund having already taken the form of a bird to make his escape. A remarkable recent find, from the 'central place' at Uppåkra, Skåne, is surely to be interpreted as a unique representation in metalwork of Volund – the mythical man in a flying machine [193].

The scenes surrounding Volund's smithy on the Ardre stone include Thor's fishing trip with Hymir (upper left, immediately below the ship under sail), balanced by another such expedition, at bottom left, in which a fish is shown being speared – perhaps Thor in action again, capturing Loki (in the form of a salmon).

The prone figure being attacked by snakes and other animals in the seemingly disorganized composition on the front of the Oseberg wagon [53] has tentatively been identified as Gunnar, being punished for his murder of Sigurd (see below).

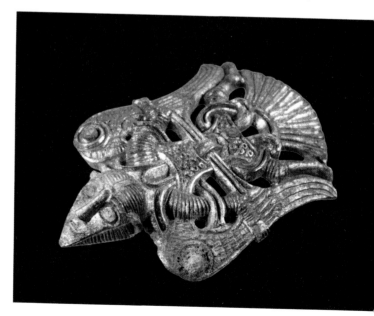

193. Gilt-bronze amulet from Uppåkra, Skåne, in the form of the mythical smith, Volund, who has been transformed into a bird to make his escape after taking revenge on the evil King Nidud by killing his sons and raping his daughter.

Gunnar was, however, thrown into a snake-pit, and such a scene is more clearly depicted on the Klinte Hunninge I 'picture-stone' [194]. Even so, we cannot be certain this is Gunnar, because the scene lacks the diagnostic details of later depictions, which reflect a later version of the myth in which his hands were bound and he used his toes to play a harp in an attempt to charm the poisonous snakes (see p. 177).

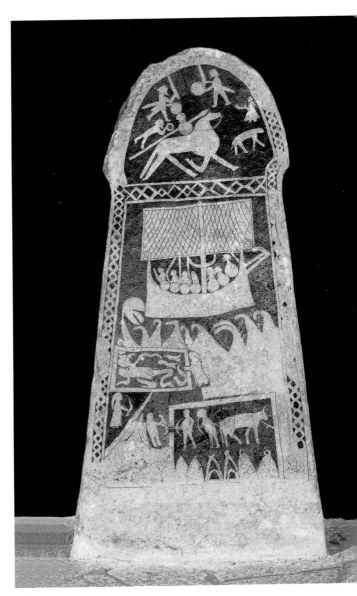

194. The scene immediately below the ship on 'picture-stone' Klinte Hunninge (I), Gotland, (H 284 cm; paint modern) includes a figure lying in a rectangular enclosure surrounded by snakes, which is reasonably interpreted as an illustration of Gunnar meeting his fate in the snake-pit.

The Sigurd Legend

Although the famous hero Sigurd had business with the gods, he was not himself a pagan deity and his legendary exploits, as related in *Vǫlsunga saga*, were thus suitable for portrayal in Christian contexts. Indeed, Sigurd the Volsung, as slayer of the 'dragon' (serpent) Fafnir – guardian of a hoard of gold – could be interpreted in a Christian context as a hero overcoming evil. At the same time, the fate of Sigurd, who by his acts gained the (cursed) gold and brought about his own death, could be construed as containing a Christian moral – the possession of great wealth is in itself no guarantee of good fortune.

The part of *Vǫlsunga saga* in which Sigurd kills Fafnir – and the ensuing events – forms the subject of a remarkable carving on a rock-face at Ramsund, Södermanland, in Sweden [195]. Fafnir is there depicted as a snake (or serpent), forming a rune-inscribed band, with the text commemorating the construction of a 'bridge'. So as to be able to stab upwards into the beast's belly (the only vulnerable part of its body), Sigurd had to position himself in a pit and wait for Fafnir to pass over him. In order to convey this, the artist has placed Sigurd below the runic snake/band, within which the other scenes take place.

The overall composition has Sigurd's horse Grani at its centre, tethered to a tree in which is perched a pair of birds. A box-like object on Grani's back presumably contains the treasure. Sigurd is shown facing his horse, and the birds, with one hand holding Fafnir's heart on a spit over a double flame, but the other raised to suck his burnt thumb. It was thus that he tasted the serpent's blood, which gave him the power to understand the language of birds. Those in the tree warned him

195. The runic inscription (L 470 cm) carved on a rock-face at Ramsund, Södermanland, Sweden, is contained within the body of the serpent Fafnir, in the process of being stabbed by Sigurd (bottom right). The central scene (from left to right) consists of the headless figure of the smith Regin, Sigurd spit-roasting Fafnir's heart and Grani tethered to a tree containing a pair of birds.

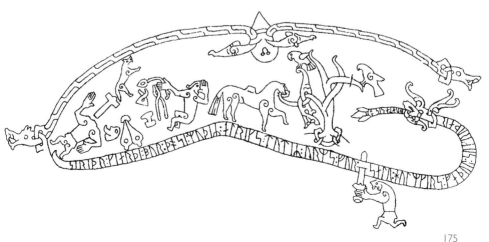

196. The Sigurd legend enjoyed widespread popularity during the Viking Age and later – one of its earliest depictions is to be found on the Manx cross-slab (detail shown here), from Kirk Andreas. At centre, Sigurd is shown spit-roasting slices of Fafnir's heart while raising his burnt fingers to his mouth.

that his companion, the dwarf Regin (who had forged his sword), was about to kill him in order to take the treasure for himself. The result is shown to the left: Regin's decapitated body, identified as that of a smith by the associated hammer, bellows, anvil and tongs. The sweeping composition of Ramsundberget is a remarkable achievement by a Swedish carver of runestones whose use of Ringerike-style tendrils dates his career to the early eleventh century.

The earliest known depictions of scenes from *Vǫlsunga saga* are to be found in the tenth-century series of Manx cross-slabs. Among these, a stone from Kirk Andreas displays the fullest sequence of events, reading upwards on the left-hand side of the cross-shaft [196]. At the bottom, Sigurd thrusts his sword into the serpent's under-belly; at the centre, Sigurd spit-roasts slices of heart over a fire of triple triangular flames, with his burnt hand raised to his mouth; at the top, Grani watches over

197. Two scenes from the Sigurd cycle carved on the late 12th-century portal from Hylestad stave-church, Aust-Agder, Norway. In Regin's smithy, the sword with which Sigurd will slay Fafnir is being forged (below), although the first blade breaks when tested on the anvil (above).

him. An incised bird's head, with open beak, is inserted between Grani's neck and Sigurd's back.

Sigurd's exploits continued to be celebrated in Scandinavian art well into the twelfth century, as can be seen on the Norwegian stave-church portal from Hylestad in Setesdal [197]. Here the scenes begin with Sigurd and Regin forging the sword, with which Fafnir will be slain, and end with the fate of Sigurd's own murderer, Gunnar, in the snake-pit – depicted with his hands bound behind him, endeavouring to charm the poisonous snakes by playing the harp with his toes. One of the four faces of the twelfth-century stone font from Norum church, in Bohuslän (then part of Norway), also depicts Gunnar in the snake-pit, with his feet likewise on what must be a musical instrument – the very detail that allows the scene to be properly identified, unlike those discussed above on the Oseberg wagon [53] and Klinte 'picture-stone' [194].

Supposing Fafnir represents the old religion, then his killing
symbolizes the end of the pagan tradition – the past enlisted
for the purposes of the Church during a period of transition.
Conversion would make new demands on the Viking Age artists
of Scandinavia, but there were new models to be utilized from
both West and East for cross and crucifixion, for saints and the
Epiphany. It was thus that the winged 'dragon' of European
Romanesque art made its first appearance in Scandinavia on
some of the eleventh-century runestones of Uppland, alongside
the indigenous 'serpent' exemplified by Fafnir.

Christianity and Viking Art

Archaeological evidence for the presence of Christians at
the town of Birka, in central Sweden, has been thoroughly
researched by Anne-Sofie Gräslund. It includes what is
considered to be the earliest known depiction of Christ from
Scandinavia [2], in the form of a small, silver-gilt, crucifix
pendant. The erect figure is clothed, wearing full-length
trousers and appears to be bound to the cross. This is Christ
cast in a northern heroic mould because a figure, clad only in
a loin-cloth, nailed to a cross and sagging in pain, was scarcely
a promising image for missionaries to project to the Northern
World. Christ had to be seen as strong and triumphant. On
the Jelling runestone, for example, the cross is only hinted at
by being treated as a tree-of-life [105], the branches of which
entwine the fully clothed figure of Christ, whose feet are even
placed on a slight rough projection from the face of the stone
(as if ground on which to stand).

The moustachioed Christ of the crucifix pendant from
Trondheim, with bound wrists, has already been noted [159].
This usage continued into the twelfth century, as seen on the
Danish processional cross from about 1100, in Veinge church,
Halland (southern Sweden), although now Christ's head and
arms have begun to sag in suffering [198]. In these details,
the figure is reminiscent of the crucified Christ on one side
of the Gåtebo reliquary cross, with its background in Byzantine
art [158].

There existed for some people and for some time a period
of overlap and/or transition. It is instructive to recall, albeit
from later written sources, the case of Helgi the Lean. Helgi
was an important settler of Iceland, towards 900, who called

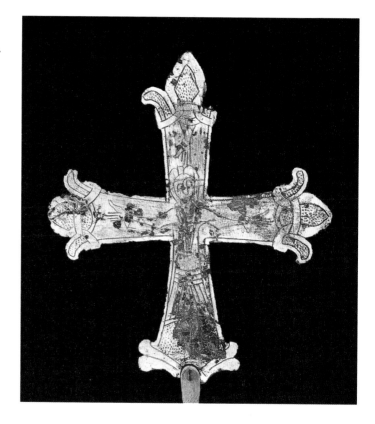

198. Danish processional cross (H 16.3 cm), from Veinge church, Halland (in southern Sweden), dating from about 1100, when the suffering of Christ during the crucifixion had begun to be depicted in Scandinavian art (cf. ill. 158).

his farm Kristnes ('Christ's headland') and is said to have believed in Christ, but to have invoked Thor before voyages and hard undertakings. The old tradition, with its numerous gods, could accommodate one more if need be during a period of transition, whereas the new religion could put to work familiar stories, as also old places of worship. The chieftain who had held religious ceremonies for his neighbourhood in his hall now needed to build an 'estate' church on his land – and undertake 'good works', such as the construction of 'bridges' (or causeways) to facilitate access in bad weather.

A clear example of syncretism in Christian Viking art is the use of Ragnarok, the downfall of the pagan gods, to demonstrate the necessity for conversion. The last great battle in pagan Norse mythology can be seen to anticipate the triumph of Christianity, which thus had a certain inevitability about it. The art of the Conversion period is exemplified by the iconography of a tenth-century cross-slab from Kirk Andreas, in the Isle of Man, and of the Gosforth cross in Cumbria.

199. Fragmentary cross-slab (H 35 cm) from Kirk Andreas, Isle of Man, raised by Thorwald, contrasting a scene from Ragnarok (Odin, with a raven on his shoulder, in the process of being devoured by the wolf Fenrir), with the triumph of Christianity (a priest with cross and book trampling on the snake of paganism, with the Christian symbol of a fish alongside). The cross-shaft is decorated with a Manx version of the Borre-style ring-chain.

One side of the Kirk Andreas stone [199] has the figure of a man carrying a cross in one hand and a rectangular object (a book?) in the other, accompanied by a fish (a Christian symbol) and two snakes with knotted bodies (representing evil). This scene suggests the coming of Christ, when contrasted with the scene on its other side, representing the end of the world in pagan terms. There another man, with a bird on one shoulder, is shown striking downwards with a spear at a fanged animal that has one of his feet in its mouth; there is a snake with knotted body to one side. From what we know of the events of Ragnarok, it is simple enough to identify the figure as Odin (with a raven) attempting in vain to avoid being devoured by the dread wolf Fenrir.

The iconography of the Gosforth cross is far more complex, incorporating a crucifixion attended in part by a valkyrie-like woman [200]. Above this scene is a staff/spear-bearing figure trying to resist his consumption by a serpent. Among the other events relating to Ragnarok, the god Heimdall can be identified, the gods' watchman and the herald of this final battle. He has his horn in one hand and a staff or spear in the other, with which he is endeavouring to hold back a pair of open-jawed serpents. At the bottom of the same main face, there is a complex scene, which seems to depict the bound figure of Loki and his kneeling wife. She is endeavouring to catch the poison dripping onto him from the venomous snake that the gods have suspended above him, in vengeance for his

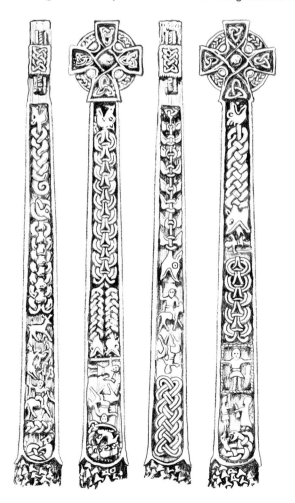

200. This drawing of the Gosforth cross, Cumbria, (see ill. 13) reveals that much of its shaft is occupied with animal-headed interlace with the crucifixion occupying just the lower part of one main face.

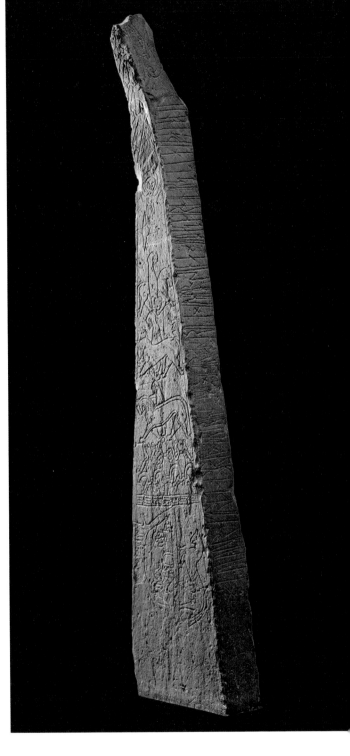

201. The Christian runestone (present H 275 cm) from Dynna, Oppland, Norway, depicts three figures on horseback below a star – the prelude to the scene of the 'Adoration of the Magi' (placed sideways-on in the bottom register), in which Mary, with the Christ child, is shown receiving the gifts brought by the kings.

part in the death of their beloved Baldr. It was believed that Loki would finally escape his torture to participate in Ragnarok when he would fight Heimdall to the death.

The Dynna stone, raised to commemorate Astrid 'the handiest maid in Hadeland', in southeastern Norway, is unique in Scandinavia for its depiction of the 'Adoration of the Magi' [201]. This stone, with eleventh-century Ringerike-style decoration, depicts the three kings on horseback following the star, on which the infant Jesus is standing. Sideways on, in the bottom register, there is a hog-backed hall in which Mary is shown receiving the kings' gifts, with a token horse tethered outside.

As we have seen (p. 148), during the eleventh century in Sweden a new type of churchyard monument was created – in the form of a box-shaped cist made up of four or five stones. Those with the tallest stones at either end are named after an example from Eskilstuna in Södermanland [202], although this type of monument was, in fact, most popular in Östergötland. The Eskilstuna cist was itself sculpted by Näsbjörn (as named in the runic inscription carved by Tove), who filled its headstone with Urnes-style ornament in a zoomorphic composition that

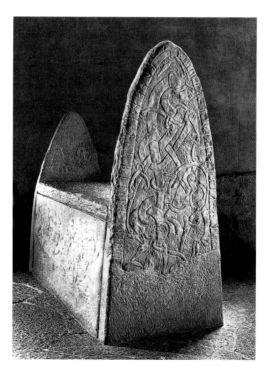

202. A fine example of an Eskilstuna-type stone 'sarcophagus' from Vreta Monastery, Östergötland, Sweden, with characteristic Urnes-style decoration.

203. The Norwegian stave-church at Borgund, in Sogn, is an exceptionally well-preserved example of this unique type of building, dating from the second half of the 12th century – the animal-heads projecting from the upper gables recall those of the 10th-century Cammin casket (ill. 126).

lacks any direct Christian symbolism. Smaller cists, likewise of late Viking Age date, are known in Gotland, as at Ardre [169], with an overseas example being that from St Paul's churchyard in London [145].

The first wooden churches in Scandinavia will have been simple structures, as now known from numerous excavated examples, including that at Hørning, which has been reconstructed at Moesgård, in Jutland [155]. The later 'stave-churches' could, however, be highly elaborate structures. Prominent animal heads project from the roof of Borgund church, at Sogn (in Norway), which is largely unaltered since it was built in the second half of the twelfth century [203]. These have clear Viking Age antecedents in the finials seen jutting from the roof/lid of the Cammin casket [126], as also those of the house on the Hedeby coins [59 bottom].

The earliest extant Scandinavian church decoration is generally agreed to be the fragmentary wooden panels from Flatatunga, in Iceland [142]. The row of haloed figures (the apostles or other saints), beneath a fine display of Ringerike-style foliage, is too incomplete for iconographic interpretation. On the other hand, it has already been noted (p. 142) that the surviving carved ornament from the eleventh-century Urnes church [161, 162] seems to be lacking in any overtly Christian content. This is in line with the general prominence of ornament (over narrative art) during the Viking Age, although a lack of new Christian iconographical models may have played a part during the eleventh century. At any rate, most of the eleventh-century memorial stones from Scandinavia, such as those illustrated from Uppland [163–67], contain only a cross among the animal motifs.

The use of birds in pagan Viking art was concerned with birds of prey, ravens and the noble pursuit of falconry. In the early Church (as in antiquity), the peacock was seen as a symbol of rebirth and resurrection. There can be little doubt that the Græsli bird [137], with its elaborate tail and crest, is one such example, but other Scandinavian bird brooches from the eleventh century are more dove-like in appearance, suggesting that they allude to the Holy Spirit, assuming they are likewise inspired by the Christian art of western Europe.

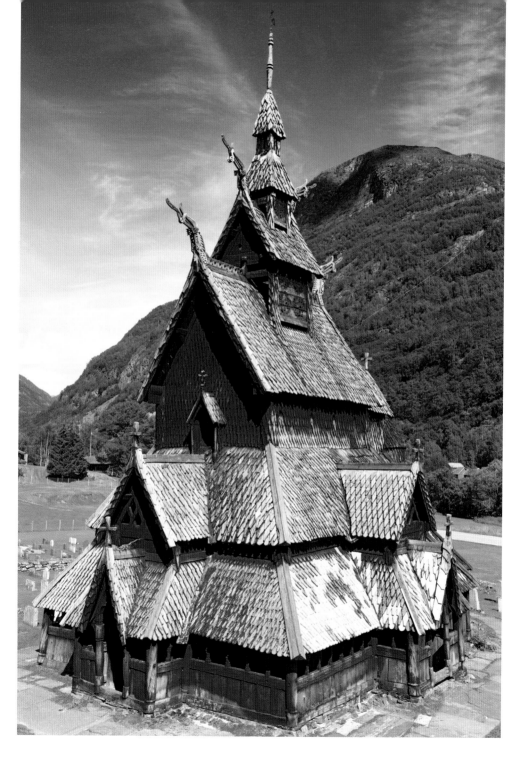

204. One of the 12th-century
wooden capitals in the stave-
church at Urnes, Sogn, Norway
(ill. 9), carved with a Romanesque
winged dragon, its body looping
in the manner of the Urnes-style
animals that decorated its Viking
Age predecessor (ills 161–62).

205. The polygonal stone font in
Vamlingbo church, Gotland, is
decorated with an architectural
arcade containing designs
belonging to the transitional
Urnes-Romanesque style of
Scandinavian art during the
12th century.

The Urnes-Romanesque Style

As noted in the previous chapter, the Urnes style did not simply fade away with the end of the Viking Age, to be replaced by Romanesque art and architecture. 'On the contrary', as Signe Horn Fuglesang has observed (1986), 'it formed a vital tradition which hybridized with the Romanesque and has left a number of distinguished monuments from all the Scandinavian countries of the first half of the twelfth century'.

The timber for the Romanesque stave-church at Urnes was felled between 1129 and 1131, according to dendrochronology. This building forms the basis of the present church [9] which contains a fine series of wooden capitals, with decoration in arcaded panels [204]. These, not altogether surprisingly, contain elements derived from the style of the earlier Viking Age carvings incorporated into its structure [161, 162]. Indeed, it is in such ecclesiastical contexts that the Urnes-Romanesque style is most visible today, including on some Norwegian stave-church portals (e.g. Hopperstad) and on stone fonts, such as that in Vamlingbo church on Gotland [205].

A fine example of the Urnes-Romanesque style-phase is provided by the decorated church bench from Kungsåra, Västmanland (in Sweden). In the same manner as the Urnes capitals, its ornamental motifs look back to the eleventh century, but the appearance of the winged dragons and the Romanesque scrolls place it firmly in the twelfth [206].

A silver disc brooch in a hoard from Alvedsjö, Öland, provides an exceptional example of a secular ornament in Urnes-Romanesque style from a dated context, its coins

206. The back of this carved wooden bench (L 194 cm) from Kungsåra church, Västmanland, Sweden, is finely decorated with elongated dragons and a plant scroll in the Urnes-Romanesque style.

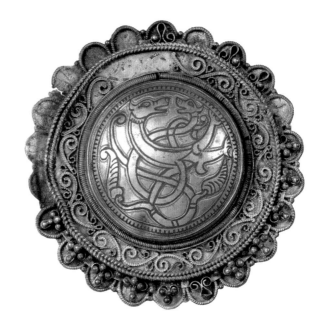

207. Silver disc brooch from a hoard found at Alvedsjö, in Öland, decorated with an animal/snake composition that has Urnes-style antecedents, providing an example of ornamental metalwork in the Urnes-Romanesque style better known in ecclesiastical art in Scandinavia.

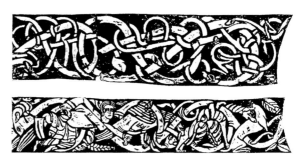

208, 209. (above and opposite) The magnificent Danish 'golden altar' (W 159.5 cm) from Lisbjerg church, Jutland, from the mid-12th century, incorporates an earlier crucifix (c. 1100–25). The numerous Romanesque figures, in their architectural settings, are framed by ornamental borders containing both zoomorphic designs related to those of the Urnes style (drawing above, top) and Romanesque motifs of men and animals in plant tendrils (drawing above).

consisting predominantly of those of Knut Eriksson (c. 1170–97). Its incised ornament consists of an animal intertwined with a snake, in an open-loop composition that is recognizably a continuation of the Urnes-style tradition, even if not of the highest quality [207].

The metal fittings decorating the magnificent Danish altar from Lisbjerg church, Jutland [209], form an appropriate conclusion to this brief appreciation of the final contribution of Viking art to that of Scandinavia during the medieval period. The figural style is purely Romanesque, but there is a border [208] deploying Urnes-style motifs utilized in the Urnes-style manner, with Romanesque motifs elsewhere on the monument also treated according to Urnes-style principles.

210. Anglo-Norman carved stone lintel (L 150 cm), in Southwell Minster, Nottinghamshire, with St Michael confronting a Romanesque dragon whose body is intertwined with foliate loops in a manner reminiscent of the English-Urnes style.

Outside Scandinavia, the importance of the Urnes-Romanesque transition has already been described for the development of Irish art during the twelfth century (in Chapter 4), whereas its impact in Anglo-Norman art seems to have been confined to a few details in occasional instances of architectural ornament, as on the Southwell stone in Nottinghamshire [210].

Survival and Revival

Motifs familiar from the work of Viking Age artists and craftsmen continued to enjoy some popularity in Scandinavia throughout the Middle Ages, as can be illustrated by a couple of pieces of decorated farm equipment from Norway.

A wooden wool-basket from Telemark, manufactured about 1800 in the medieval tradition, includes two versions of the Viking Age 'ring-chain' in its ornamental repertoire [211]. As a further example, there is nothing quite so remarkable as the wooden harness-bow from Lom, Oppland, with a medieval radiocarbon date, which displays a scrum of serpents, dragons and quadrupeds (lions?) in a Romanesque re-invention of the 'gripping-beast' patterns of ninth-century Norwegian art [212].

It was, however, in the nineteenth century that Viking art once again came to the fore in Scandinavia, as part of the European romantic interest in medieval revival, in particular in Norway where it took a nationalistic turn. The importance of ethnic identity was central to the struggle for political independence in Norway and archaeology played an important role, with the excavation of the Viking ship-graves at Gokstad (1880) and Oseberg (1904).

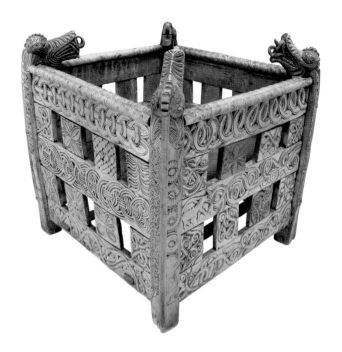

211. This Norwegian wooden wool-basket from Telemark (c. 1800), with animal-head corner-posts, provides an example of how the Viking Age 'ring-chain' motif survived in later Scandinavian folk-art.

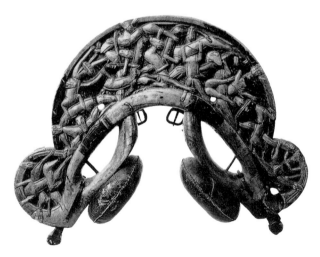

212. This wooden harness-bow (H 36 cm), from Lom in Gudbransdal, Norway, has a medieval radiocarbon date, yet its main ornament is a Romanesque re-invention of the 'gripping-beast' designs made popular in Viking art.

Indeed, the art and architecture of the Vikings attracted widespread interest across Europe during this period, with the latest finds being brought to the attention of the English-reading public in the general works of such scholars as the French-American anthropologist, Paul du Chaillu, whose two-volume work, *The Viking Age*, was published in 1889.

The 'Dragon Style'

'For those committed to the New Art', Paul Greenhalgh (2000) has written, 'history was a key tool for the creation of modernity.' In the case of the Nordic nations and the development of Art Nouveau, 'history at the service of modernity' meant turning back to Viking art, duly informed by the latest archaeological discoveries.

The imagery and interlace of Viking art provided 'a source for the creation of an independent modern style' in the late nineteenth century. For Nordic silversmiths, zoomorphic interlace and animal-head terminals, in particular, afforded a rich vocabulary with which to decorate tableware, such as silver jardinières in the form of 'dragon ships' [213]. Such was their reliance on Viking motifs that the work produced by such internationally acknowledged artists as Henrik Bull, Gerhard Munthe and Lars Kinsarvik [214] became known as *Dragestil* – the 'Dragon style'.

In wooden architecture, the 'Dragon style' found expression in grandiose log-buildings in Norway, as also in the Swedish 'Old Norse style'. The steep roof, big eaves and dragon-head finials of, for example, the Villa Balderslund, Balestrand (in Norway), from 1907, are a direct reflection of stave-church architecture.

That the 'Dragon style' reached its peak in Norway around 1900 is not surprising, in the context of its contribution to the international development of Art Nouveau, but less well known is its adoption in Germany, where it merged with the Jugend style. It was popularized by the emperor himself, for Kaiser Wilhelm II was strongly influenced by everything Nordic as a result of his annual Norwegian excursions during the 1890s.

Afterword

In 1904, when a monument was commissioned for Fécamp, in Normandy, to commemorate those who had lost their lives at sea, the result was an obelisk supported on the prows of four 'dragon ships'. This Viking homage anticipated the millennium of the foundation of Normandy, which was to be lavishly celebrated in 1911. Public addresses were received from Scandinavia and the anniversary marked by a variety of spectacles and cultural events, including an exhibition in Rouen [215].

213. (opposite above) Silver jardinière in the form of a Viking ship, with animal figureheads, by Thorolf Prytz for the workshop of Jacob Tostrup in Oslo (c. 1900). The excavation of the Gokstad and Oseberg ships, in 1880 and 1904, provided a source of inspiration for the creation of an independent modern art style in Norway.

214. (opposite below) Pair of armchairs in painted pine by the Norwegian artist, Lars Kinsarvik (c. 1900), one of the pioneers in the creation of the Nordic version of Art Nouveau that became known as the 'Dragon Style'.

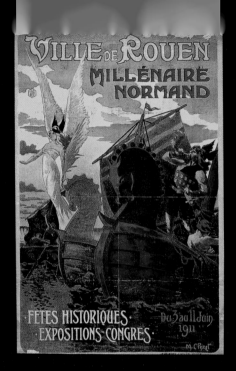

215. (above left) Poster with a romantic 'Viking' image advertising the celebrations on the occasion of the millennium of the foundation of Normandy in 911, when Rouen and its surrounding territory was granted by the Frankish king to a Viking leader called Rollo, to protect the Seine.

216. (above right) This colourful label from a Norwegian beer bottle employs 'Viking' motifs to market it as 'Viking øl'. The Viking ship itself is less fanciful than the earlier 'dragon ships' (as ills 213 and 215), but the accompanying animal ornament bears little resemblance to actual Viking art.

If exact dates are unknown for such celebratory purposes, they can always be imagined for heritage reasons – as in the Isle of Man where a millennium (of sorts) was celebrated in 1979. In the United States of America, in 1980, an annual 'Leif Erikson Day' was proclaimed by President Jimmy Carter, in commemoration of Leif's 'conquest' of the North Atlantic 'one thousand years ago', although it was in 2000 that a 'Viking Millennium' was celebrated in Canada.

Anniversaries such as these – often accompanied by the issue of commemorative postal stamps – help to keep alive public interest in the Vikings, especially among those with Scandinavian 'roots'. It is, however, very much the case that the Vikings (and especially their ships) are assured of a continuing 'artistic' existence through modern marketing. Imaginative 'period' scenes and Viking-inspired logos are used to sell anything and everything from Rover cars to Normandy cheese – and, less surprisingly, a wide variety of Scandinavian products, such as Swedish matches and Norwegian beer [216].

To end on a more serious note, the Swedish archaeologist Hans Hildebrand, Academician and State Antiquary,

217. Head of a helmeted Viking warrior (H 4.0 cm), carved in elk antler, from Sigtuna, Sweden. The careful depiction of his well-groomed hair, neat beard and braided moustache all contribute to make this a rare example of naturalistic Viking art.

commented in *The Industrial Arts of Scandinavia in the Pagan Time* (London, 1892):

> *The archaeologists of the north have been able to show that [the Vikings], who seemed to their victims to have only one interest – war, murder, rapine – really possessed also industrial arts of a kind so characteristically developed that even we, men of the era of engines and steam, have a great deal to learn from them.*

To demonstrate that this observation remains true for Viking art, in all its forms, after more than a hundred years of further 'progress', has been one intent of this survey.

The noble head of a helmeted warrior found in Sigtuna, carved from elk antler in the eleventh or twelfth century, displays both neatly dressed hair and an elegant moustache [**217**]. His gaze – regarding us across the intervening millennium – might even be supposed justifiably proud – in the memory of what Peter Foote and David Wilson (1970) so aptly entitled *The Viking Achievement*.

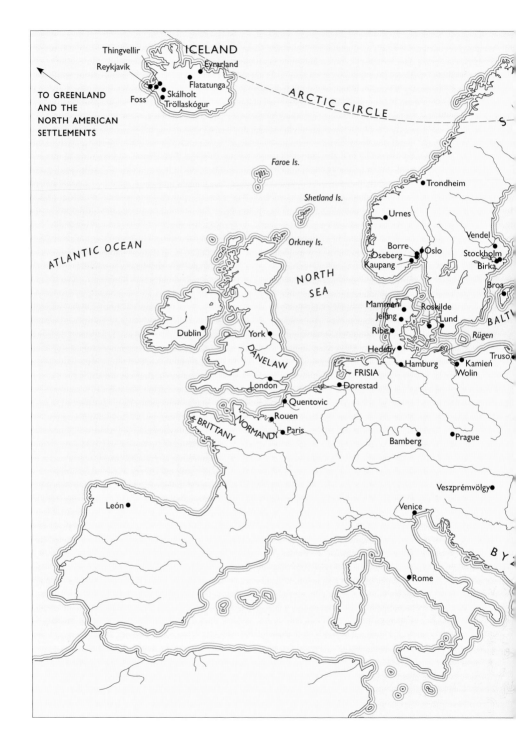

Thingvellir ICELAND
Reykjavík Eyrarland
Flatatunga
TO GREENLAND Skálholt
AND THE Foss Tröllaskógur
NORTH AMERICAN
SETTLEMENTS

ARCTIC CIRCLE

S

Faroe Is.

Shetland Is.

Trondheim

Urnes

Vendel

ATLANTIC OCEAN
Orkney Is.

Borre
Oseberg Oslo
Kaupang

Stockholm
Birka

NORTH
SEA

Broa

BALTI

Mammen
Jelling Roskilde
Dublin York Ribe Lund

Rügen

Hedeby Truso
DANELAW Hamburg Kamień
FRISIA Wolin
London Dorestad

Quentovic
BRITTANY Rouen
NORMANDY Paris

Bamberg Prague

Veszprémvölgy

León Venice

B Y Z

Rome

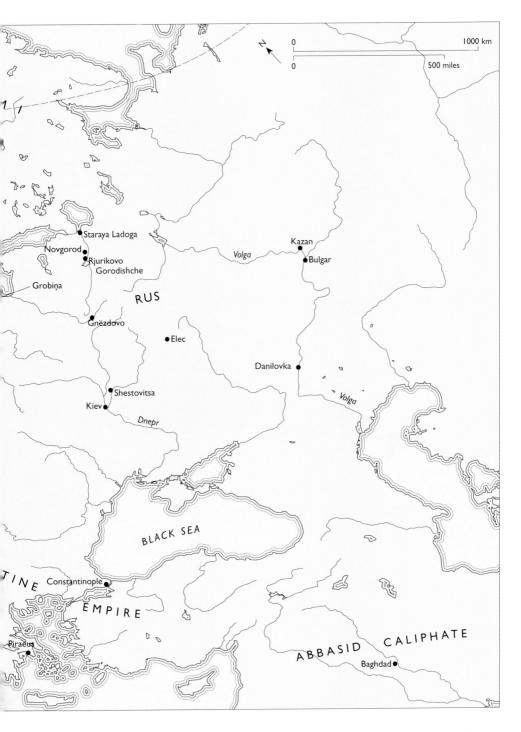

0 1000 km

0 500 miles

Staraya Ladoga

Novgorod

Rjurikovo
Gorodishche

Grobiņa

RUS

Gnëzdovo

Elec

Kazan

Volga

Bulgar

Danilovka

Volga

Shestovitsa

Kiev

Dnepr

BLACK SEA

TINE

Constantinople

EMPIRE

Piraeus

ABBASID CALIPHATE

Baghdad

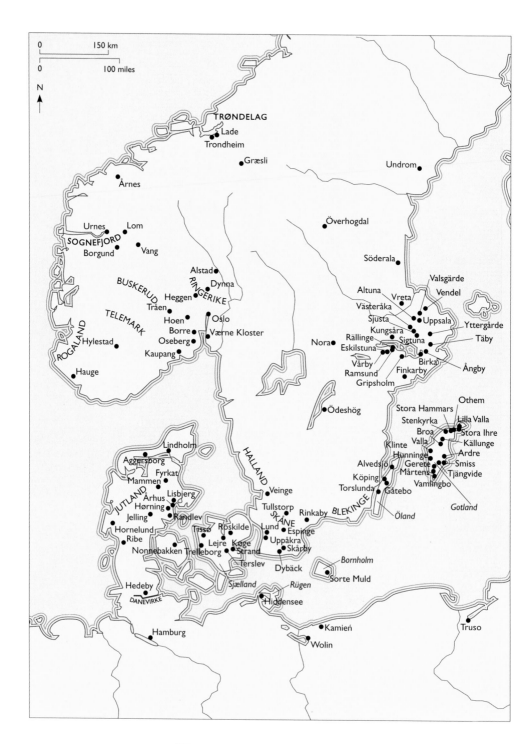

0 150 km

0 100 miles

N

TRØNDELAG
Lade
Trondheim
Græsli

Undrom

Årnes

Urnes Lom
SOGNEFJORD
Borgund Vang

Overhogdal

Söderala

Alstad
Dynna
BUSKERUD RINGERIKE
Heggen
Tråen
Hoen Oslo
Borre Værne Kloster
Oseberg
Kaupang

Valsgärde
Vendel
Altuna Vreta
Västeråka
Sjusta
Kungsåra Uppsala Yttergårde
Rällinge Sigtuna Täby
Nora Eskilstuna
Vårby Birka Ångby
Ramsund Finkarby
Gripsholm

TELEMARK
ROGALAND
Hylestad

Hauge

Ödeshög

Othem
Stora Hammars Lilla Valla
Stenkyrka
Broa Stora Ihre
Klinte Valla Källunge
Hunninge Ardre
Alvedsjö Gerete Smiss
Köping Mårtens Tjängvide
Torslunda Gåtebo Vamlingbo
Öland Gotland

Lindholm
Aggersborg
Fyrkat
Mammen
JUTLAND Lisbjerg
Århus
Hørning Randlev
Jelling
Hornelund Tissø Roskilde
Ribe Lejre Køge
Nonnebakken Trelleborg Strand
Terslev
Hedeby
DANEVIRKE

Veinge
Tullstorp
Rinkaby
SKÅNE
Lund Espinge
Uppåkra
Skårby
Dybäck
Sjælland Rügen

HALLAND
BLEKINGE

Bornholm
Sorte Muld
Hiddensee

Hamburg

Kamień
Wolin

Truso

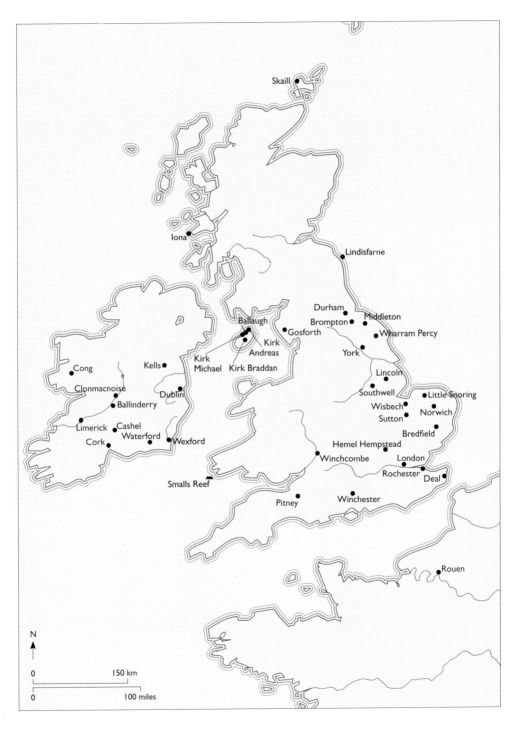

Skaill

Iona

Lindisfarne

Durham
Brompton
Middleton
Ballaugh
Gosforth
Wharram Percy
Kirk
Andreas
York
Kirk
Michael
Kirk Braddan

Cong
Kells
Lincoln

Clonmacnoise
Dublin
Southwell
Little Snoring

Ballinderry
Wisbech
Norwich
Sutton

Limerick
Cashel
Bredfield
Cork
Waterford
Wexford
Hemel Hempstead
London

Winchcombe
Rochester
Deal
Smalls Reef

Pitney
Winchester

Rouen

N

0 150 km

0 100 miles

Further Reading

THE VIKING AGE
Background
General introductions to the Viking Age include: Foote and Wilson 1970 (2nd edn 1980); Graham-Campbell 2001; Hall 2007; Jones 1984; Roesdahl 1998a; Sawyer 1982 and Sawyer (ed.) 1997. Brink with Price (eds) 2008 gathers together much recent research from across the Viking world, with contributions from a multi-disciplinary team of some seventy authors.

VIKING ART
General surveys
The standard survey of Viking art in English is Wilson and Klindt-Jensen (1966; 2nd edn 1980), but see also Fuglesang 1996 and Anker 1970. General modern surveys in Scandinavian languages include Fuglesang 1981a (in Norwegian) and Wilson 1995 (in Swedish). For short introductions in English, see Fuglesang 1992, 1993, 1996 and Wilson 2008a. For an introduction to the Gotlandic 'picture-stones', see Nylén and Lamm 1988, although the standard work remains Lindqvist 1941–42; recent studies include Wilson 1998, Imer 2004, Staecker 2006 and Snædal 2010. For Scandinavian rune-stones in general, see Moltke 1981 and Jansson 1987. Detailed descriptions of most of the illustrated objects, with additional references, are to be found in two major exhibition catalogues: Graham-Campbell 1980 and Roesdahl & Wilson (eds) 1992.

EARLY VIKING ART
Oseberg to Jellinge styles
Individual studies of early Viking art include Fuglesang 1982 and 2013, and Wilson 2001. For the Oseberg wood-carvings, see: Shetelig 1920; the Hoen hoard: Fuglesang & Wilson (eds) 2006, Fuglesang 2006; Hedeby coins: Malmer 2007; Terslev and Hiddensee hoards, etc.: Johansen 1912, Paulsen 1936, Duczko 1985, Eilbracht 1999, Armbruster 2002, 2004. For Borre and Jellinge western expansion, see: Wilson 1976, Bailey 1980, Fuglesang 1986b, Graham-Campbell 1995; in Ireland: Henry 1967, O'Meadhra 1979–87, Lang 1988; and in Isle of Man: Kermode 1907 (1994), Wilson 1983, 2008b.

LATE VIKING ART
Mammen to Urnes styles
Detailed studies of late Viking art include Fuglesang 1980, 1981c, 1991, 2001; see also contributions to Iversen (ed.) 1991 on Mammen. For the Skaill hoard, see: Graham-Campbell 1995; for Bamberg, Cammin and León: Muhl 1990, Fuglesang 1991, Roesdahl 1998b, 2010a, 2010b. For aspects of the art of the Swedish runestones: Fuglesang 1986a, 1998 and Gräslund 2005. For Isle of Man: Wilson 1983, 2008b; for England: Fuglesang 1986b, Owen 2001, Webster 2012; and for Ireland: Henry 1970, O'Meadhra 1979–87, Ó Floinn 1987, 2001, Lang 1988.

VIKING RELIGION
For an introduction to pagan Norse religion, see Page 1990 and contributions to Brink with Price (eds) 2008, 'Pre-Christian religion and belief' (212–73). Turville-Petre 1964 remains a standard work, but more recent studies include Orchard 1997 and Dubois 1999; see also Price 2002 and Andrén et al. (eds) 2006. For 'The coming of Christianity', see Brink with Price (eds) 2008, 621–44, and contributors to Carver (ed.) 2003. For aspects of pagan/Christian imagery: Fuglesang 1986a, 2007, Margeson 1980, Perkins 2001, Hedeager 2003, Gräslund 2005, 2006, Roesdahl 2013, Staecker 2006.

AFTERMATH
Romanesque to Art Nouveau
For the Urnes-Romanesque style, see: Blindheim 1965, Fuglesang 1981c, 1986b, Hohler 1999 and contributors to Roesdahl and Wilson (eds) 1992. For a general introduction to Art Nouveau, see: Duncan 1994 and Greenhalgh (ed.) 2000. For Normandy millennium celebrations (1911) and the 'Dragon style': Dragons et Drakkars. Le mythe Viking de la Scandinavie à la Normandie, XVIIIe–XXe siècles (exh. cat.; Musée de Normandie, Rouen, 1996).

SELECT BIBLIOGRAPHY
Andrén, A., K. Jennbert and C. Raudvere (eds), 2006. *Old Norse Religion in Long-Term Perspectives: Origins, Changes and Interactions.* (Vägar till Midgård 8.) Lund.

Anker, P., 1970. *The Art of Scandinavia.* Vol. 1. London and New York.

Armbruster, B. R., 2002. 'Goldschmeide in Haithabu – Ein Beitrag zum Frühmittelalterlichen Metallhandwerk.' *Berichte über die Ausgrabungen in Haithabu* 34: 85–205.

Armbruster, B., 2004. 'Goldsmiths' Tools at Hedeby' in J. Hines et al. (eds) *Land, Sea and Home.* Leeds. 109–23.

Bailey, R. N., 1980. *Viking Age Sculpture in Northern England.* London.

Blindheim, M., 1965. *Norwegian Romanesque Decorative Sculpture 1090–1210.* London.

Brink, S., with N. Price (eds), 2008. *The Viking World.* London and New York.

Carver, M. (ed.), 2003. *The Cross Goes North: Processes of Conversion in Northern Europe, AD 300–1300.* York and Rochester, NY.

Dubois, T. A., 1999. *Nordic Religions in the Viking Age.* Philadelphia.

Du Chaillu, P. B., 1889. *The Viking Age: The Early History, Manners, and Customs of the Ancestors of the English-Speaking Nations* (2 vols). London and New York.

Duczko, W., 1985. *The Filigree and Granulation Work of the Viking Period: An Analysis of the Material from Björkö.* (Birka V.) Stockholm.

Duncan, A., 1994. *Art Nouveau.* London and New York.

Eilbracht, H., 1999. *Filigran- und Granulationskunst im Wikingischen Norden.* Köln.

Fell, C., P. Foote, J. Graham-Campbell and R. Thomson (eds), 1983. *The Viking Age in the Isle of Man.* London.

Foote, P., and D. M. Wilson, 1970. *The Viking Achievement: The Society and Culture of Early Medieval Scandinavia.* London and New York. 2nd edn, 1980.

Fuglesang, S. Horn, 1980. *Some Aspects of the Ringerike Style.* Odense.

Fuglesang, S. H., 1981a. 'Vikingtidens Kunst' in K. Berg (ed.), *Norges Kunsthistorie.* Vol. 1: *Fra Oseberg til Borgund.* Oslo. 36–138.

Fuglesang, S. H., 1981b. 'Crucifixion Iconography in Viking Scandinavia' in H. Bekker-Nielsen et al. (eds), *Proceedings of the Eighth Viking Congress, 1977.* Odense. 73–94.

Fuglesang, S. H., 1981c. 'Stylistic Groups in Late Viking and Early Romanesque Art.' *Acta ad Archaeologiam et Artium Historiam Pertinentia* (Series altera in 8°) I: 79–125.

Fuglesang, S. H., 1982. 'Early Viking Art.' *Acta ad Archaeologiam et Artium Historiam Pertinentia* (Series altera in 8°) II: 125–73.

Fuglesang, S. H., 1986a. 'Ikonographie der Skandinavischen Runensteine

der Jüngeren Wikingerzeit' in H. Roth (ed.), *Zum Problem der Deutung Frühmittelalterlicher Bildinhalte.* Sigmaringen. 183–210.

Fuglesang, S. H., 1986b. 'The Relationship between Scandinavian and English Art from the late eighth to the mid-twelfth century', in P. E. Szarmach (ed.), *Sources of Anglo-Saxon Culture.* Kalamazoo. 203–41.

Fuglesang, S. H., 1991. 'The Axe-head from Mammen and the Mammen style' in Iversen (ed.), 83–108.

Fuglesang, S. H., 1992. 'Art' in Roesdahl and Wilson (eds), 176–83.

Fuglesang, S. H., 1993. 'Viking Art' in P. Pulsiano and K. Wolf (eds), *Medieval Scandinavia: An Encyclopedia.* New York and London. 694–700.

Fuglesang, S. H., 1996. 'Viking Art', in J. Turner (ed.), *The Grove Dictionary of Art.* Vol. 32. London and New York. 514–27, 531–32.

Fuglesang, S. H., 1998. 'Swedish Runestones of the Eleventh Century: Ornament and Dating' in K. Düwel (ed.), *Runeninschriften als Quellen interdisziplinärer Forschung.* Berlin. 197–218.

Fuglesang, S. H., 2001. 'Animal Ornament: The Late Viking Period' in Müller-Wille and Larsson (eds), 157–94.

Fuglesang, S. H., 2006. 'The Hoen hoard: Ornaments, Dating and Function' in G. Steinsland (ed.), *Transformasjoner i Vikingtid og Norrøn Middelalder.* Oslo. 7–25.

Fuglesang, S. H., 2007. 'Ekphrasis and Surviving Imagery in Viking Scandinavia', *Viking and Medieval Scandinavia* 3: 193–223.

Fuglesang, S. H., 2013. 'Copying and Creativity in Early Viking Ornament' in Reynolds and Webster (eds), 825–41.

Fuglesang, S. H., and D. M. Wilson (eds), 2006. *The Hoen Hoard: A Viking Gold Treasure of the Ninth Century = Acta ad Archaeologiam et Artium Historiam Pertinentia* (Series altera in 8°) 14. Oslo and Rome.

Graham-Campbell, J., 1980. *Viking Artefacts: A Select Catalogue.* London.

Graham-Campbell, J., 1987. 'From Scandinavia to the Irish Sea: Viking Art Reviewed' in M. Ryan (ed.), *Ireland and Insular Art A.D. 500–1200.* Dublin. 144–52.

Graham-Campbell, J., 1995. *The Viking Age Gold and Silver of Scotland (AD 850–1100).* Edinburgh.

Graham-Campbell, J., 2001. *The Viking World.* 3rd edn. London.

Graham-Campbell, J., 2004. 'Viking Art at the Millennium' in S. Lewis-Simpson (ed.), *Vinland Revisited: The Norse World at the Turn of the First Millennium.* St John's (NL). 219–26.

Gräslund, A.-S., 2005. 'The Watchful Dragon: Aspects of the Conversion of Scandinavia' in A. Mortensen and S. V. Arge (eds), *Viking and Norse in the North Atlantic.* Tórshavn. 412–21.

Gräslund, A.-S., 2006. 'Wolves, Serpents and Birds: Their Symbolic Meaning in Old Norse Belief', in Andrén et al. (eds), 124–29.

Greenhalgh, P. (ed.), 2000. *Art Nouveau 1890–1914.* London and Washington.

Hall, R., 2007. *Exploring the World of the Vikings.* London and New York.

Haywood, J., 2000. *Encyclopaedia of the Viking Age.* London and New York.

Hedeager, L., 2003. 'Beyond Mortality: Scandinavian Animal Styles AD 400–1200', in J. Downes and A. Ritchie (eds), *Sea Change: Orkney and Northern Europe in the Later Iron Age AD 300–800.* Balgavies. 127–36.

Henry, F., 1967. *Irish Art during the Viking Invasions (800–1020 AD).* London and Ithaca.

Henry, F., 1970. *Irish Art in the Romanesque Period (1020–1170 A.D.).* London and Ithaca, NY.

Hildebrand, H., 1892. *The Industrial Arts of Scandinavia in the Pagan Time.* 2nd edn. London.

Hohler, E. B., 1999. *Norwegian Stave Church Sculpture* (2 vols). Oslo and Boston.

Imer, L. M., 2004. 'Gotlandske Billedstenen – Dateringen af Lindqvist's Gruppe C og D.' *Aarbøger for Nordisk Oldkyndighed og Historie 2001:* 47–111 (English summary).

Iversen, M. (ed.), 1991. *Mammen: Grav, Kunst og Sammfund i Vikingetid.* (Jysk Arkæologisk Selskabs Skrifter, XXVIII.) Højbjerg.

Jansson, S. B. F., 1987. *The Runes of Sweden.* 2nd edn (trans. P. Foote). Stockholm.

Johansen, K. Friis., 1912. 'Sølvskatten fra Terslev.' *Aarbøger for Nordisk Oldkyndighed og Historie* xx: 189–216.

Jones, G., 1984. *A History of the Vikings.* 2nd edn. Oxford and New York.

Kermode, P. M. C., 1907. *Manx Crosses.* London.

Lang, J. T., 1988. *Viking-Age Decorated Wood: A Study of its Ornament and Style.* (Medieval Dublin Excavations 1962–81, Series B, vol. 1). Dublin.

Lindqvist, S., 1931. 'Yngre Vikingastilar', in Shetelig (ed.), 144–47.

Lindqvist, S., 1941–42. *Gotlands Bildsteine* (2 vols). Stockholm.

Malmer, B., 2007. 'South Scandinavian Coinage in the Ninth Century' in J. Graham-Campbell and G. Williams (eds), *Silver Economy in the Viking Age.* Walnut Creek, CA. 13–27.

Margeson, S., 1980. 'On the Iconography of the Manx Crosses' in Fell et al. (eds), 95–106.

Moltke, E., 1981. *Runes and their Origin: Denmark and Elsewhere* (trans. P. Foote). Copenhagen.

Muhl, A., 1990. 'Der Bamberger und der Camminer Schrein: Zwei im Mammenstil Verzierte Prunkkästchen der Wikingerzeit.' *Offa* 47: 241–420.

Müller, S., 1880. 'Dyreornamentiken i Norden.' *Aarbøger for Nordisk Oldkyndighed og Historie:* 185–405.

Müller-Wille, M., 2001. 'Tierstile des 8.–12. Jahrhunderts im Norden Europas. Dendrochronologie und kunsthistorische Einordnung' in Müller-Wille and Larsen (eds), 215–50.

Müller-Wille, M., and L. O. Larsen (eds), 2001. *Tiere – Menschen – Götter: Wikingerzeitliche Kunststile und ihre Neuzeitliche Rezeption.* Göttingen.

Nylén, E., and J. P. Lamm, 1988. *Stones, Ships and Symbols: The Picture Stones of Gotland from the Viking Age and Before.* Stockholm.

Ó Floinn, R., 1987. 'Schools of Metalworking in Eleventh- and Twelfth-century Ireland' in M. Ryan (ed.), *Ireland and Insular Art A.D. 500–1200.* Dublin. 179–87.

Ó Floinn, R., 2001. 'Irish and Scandinavian Art in the Early Medieval Period' in A. C. Larsen (ed.), *The Vikings in Ireland.* Roskilde. 87–97.

O'Meadhra, U., 1979–87. *Early Christian, Viking and Romanesque Art: Motif-Pieces from Ireland* (2 vols). Stockholm.

Orchard, A., 1997. *Dictionary of Norse Myth and Legend.* London.

Owen, O., 2001. 'The Strange Beast That is the English Urnes style' in J. Graham-Campbell et al. (eds), *Vikings and the Danelaw: Select Papers from the Proceedings of the Thirteenth Viking Congress.* Oxford. 203–22.

Page, R. I., 1990. *Norse Myths.* London and Austin, TX.

Paulsen, P., 1936. *Der Goldschatz von Hiddensee.* Leipzig.

Perkins, R., 2001. *Thor the Wind-Raiser and the Eyrarland Image.* London.

Price, N., 2002. *The Viking Way: Religion and War in Late Iron Age Scandinavia.* (Aun 31.) Uppsala.

Price, N., 2006. 'What's in a name?', in Andrén et al. (eds), 179–83.

Reynolds, A., and L. Webster (eds), 2013. *Early Medieval Art and*

Archaeology in the Northern World. Studies in Honour of James Graham-Campbell. Leiden and Boston.

Roesdahl, E., 1998a. The Vikings (trans. S. M. Margeson and K. Williams). 3rd edn. London and New York.

Roesdahl, E., 1998b. 'Cammin – Bamberg – Prague – León. Four Scandinavian objets d'art in Europe' in A. Wesse (ed.), Studien zur Archaeologie des Osteeraumes. Neumünster. 547–54.

Roesdahl, E., 2010a. 'Viking Art in European Churches (Cammin – Bamberg – Prague – León)' in I. S. Klæsøe (ed.), Viking Trade and Settlement in Continental Western Europe. Copenhagen. 149–64.

Roesdahl, E., 2010b. 'From Scandinavia to Spain: a Viking-age reliquary in León and its meaning', in Sheehan and Ó Corráin (eds), 353–60.

Roesdahl, E., 2013. 'King Harald's Rune-Stone in Jelling: Methods and Messages' in Reynolds and Webster (eds), 859–75.

Roesdahl, E., and D. M. Wilson (eds), 1992. From Viking to Crusader: Scandinavia and Europe 800–1200 (exh. cat.). Copenhagen and New York.

Salin, B., 1904. Die Altgermanische Thierornamentik. Stockholm.

Sawyer, P., 1982. Kings and Vikings: Scandinavia and Europe AD 700–1100. London and New York.

Sawyer, P. (ed.), 1997. The Oxford Illustrated History of the Vikings. Oxford and New York.

Sheehan, J., and D. Ó Corráin (eds), 2010. The Viking Age: Ireland and the West. Dublin and Portland, OR.

S[c]hetelig, H., 1920. Osebergfundet. Vol. III. Kristiania.

Shetelig, H. (ed.), 1931. Kunst. (Nordisk Kultur xvii.) Oslo.

Snædal, Th., 2010. 'Ailikn's Wagon and Óðinn's Warriors: The Pictures on the Gotlandic Ardre Monuments' in Sheehan and Ó Corráin (eds), 441–49.

Staecker, J., 2006. 'Heroes, Kings and Gods: Discovering Sagas on Gotlandic Picture-stones' in Andrén et al. (eds), 363–68.

Turville-Petre, G., 1964. Myth and Religion of the North: The Religion of Ancient Scandinavia. London and New York.

Webster, L., 1984. 'The Golden Age: Metalwork and Sculpture' in J. Backhouse et al. (eds), The Golden Age of Anglo-Saxon Art, 966–1066 (exh.

cat.). London and Bloomington, IN. 88, 103–4.

Webster, L., 2012. Anglo-Saxon Art: A New History. London and Ithaca, NY.

Wilson, D. M., 1976. 'The Borre style in the British Isles' in B. Vilhjámsson et al. (eds), Minjar og Menntir. Reykjavík. 502–9.

Wilson, D. M., 1983. 'The Art of the Manx Crosses of the Viking Age' in Fell et al. (eds), 175–87.

Wilson, D. M., 1995. Vikingatidens Konst. (Signums Svenska Konsthistoria 2.) Lund.

Wilson, D. M., 1998. 'The Gotland Picture-stones: A Chronological Re-assessment' in A. Wesse (ed.), Studien zur Archaeologie des Osteeraumes. Neumünster. 547–54.

Wilson, D. M., 2001. 'The Earliest Animal Styles of the Viking Age' in Müller-Wille and Larsson (eds), 131–56.

Wilson, D. M., 2008a. 'The Development of Viking Art' in Brink with Price (eds), 323–38.

Wilson, D. M., 2008b. The Vikings in the Isle of Man. Aarhus and Oakville.

Wilson, D. M., and O. Klindt-Jensen, 1966. Viking Art. London. 2nd edn, 1980. Minneapolis.

Acknowledgments

My greatest debt is to David M. Wilson whose teaching first aroused my interest in Viking art and whose continuing guidance has long sustained my involvement in Viking studies. His friendship has extended to reading a draft of this book which is all the better for this kindness, although this in no way commits him to any of the opinions expressed here. I also wish to acknowledge my gratitude to Signe Horn Fuglesang for numerous discussions on the subject of Viking art, arising out of her own research and her many publications on the subject to which frequent reference is made. My old friend and colleague, Else Roesdahl, is to be warmly thanked for her assistance with the provision of illustrations, so ably gathered together for me by Maria Ranauro. It is, finally, a pleasure to record my thanks for the friendly and efficient manner in which my editor, Alice Reid, has eased this book into existence, as also to the rest of the team at T&H involved in its design and production.

Sources of Illustrations

Numbers in **bold** refer to page numbers.
a = above; b = below; c = centre; l = left; r = right

Abbreviations
ATA: Antikvarisk-topografiska arkivet, Stockholm.
NMD: National Museum of Denmark, Copenhagen.
SHM: Statens Historiska Museum, Stockholm.
MCH: Museum of Cultural History, University of Oslo.
LL/BMP: Photo Lennart Larsen/British Museum Publications.
LL/FLP: Photo Lennart Larsen/Frances Lincoln Publishers.

2, **11a** SHM. LL/BMP. **11b** Drawing © Thames & Hudson Ltd, London. **12** SHM. **14** Photo Torkild Balslev. **15** NMD. **16l**, **16r** MCH. **17** Fotosearch/SuperStock. **18** ATA. **20** 19th-century engraving. **23** National Museum of Iceland, Reykjavík. **24** Photo James Graham-Campbell. **26** © Eva Wilson. **27al** Werner Forman Archive/SHM. **27ar** Gustavianum, Museum of Nordic Antiquities, Uppsala. LL/FLP. **27b** SHM. **28** ATA. **29a** © Eva Wilson. **29b** ATA. **30l** MCH. LL/BMP. **30r** From M. Müller-Wille (2001). **31a**, **31c** SHM. LL/BMP. **31b** Drawing B. Salin from D. M. Wilson and O. Klindt-Jensen, Viking Art (1966). **32** SHM. LL/BMP. **33** Drawing B. Salin from D. M.

Wilson and O. Klindt-Jensen (1966). **34** Drawings a: B. Salin
from D. M. Wilson and O. Klindt-Jensen (1966), b: © Eva
Wilson, c: after H. Shetelig, *Osebergfundet*, Vol. III (1920),
d: © Eva Wilson, e: from M. Müller-Wille (2001), f, g: © Eva
Wilson, h: after J. Graham-Campbell from S. H. Fuglesang
(1991). **35** Drawings a: B. Salin from D. M. Wilson and O.
Klindt-Jensen (1966), b: from M. Müller-Wille (2001), c: ©
Eva Wilson, d: M. Müller-Wille (2001), e: Jenny Smith from J.
Graham-Campbell (2001), f: from M. Müller-Wille (2001), g:
Jenny Smith from J. Graham-Campbell (2001). **36** Drawings a:
after Sue Bird in E. Roesdahl, *Viking Age Denmark* (1982), b, c,
d: © Eva Wilson, e: after John Fuller from J. Graham-Campbell
(ed.), *Cultural Atlas of the Viking World* (1994). **37** SHM. **38a**
Historisk Museum, Bergen. **38b** NMD. Photo Lennart Larsen.
39 SHM. **40** © Eva Wilson. **42** PhotoAlto/SuperStock. **43**
Photo Michael Jenner. **44** SHM. **45** SHM. **48** MCH. LL/
BMP. **49** After H. Shetelig (1920) from M. Müller-Wille
(2001). **51l** Viking Ship Museum, Bygdøy. **51r** © Eva Wilson.
52 After H. Shetelig, *Osebergfundet*, Vol. I (1917), from M.
Müller-Wille (2001). **53l** MCH. **53r** After H. Shetelig (1920)
from M. Müller-Wille (2001). **54a** Werner Forman Archive/
Viking Ship Museum, Bygdøy. **54b, 55, 56, 57b** Viking Ship
Museum, Bygdøy. **57a** Viking Ship Museum, Bygdøy. Photo
Bertil Almgren. **58a** Werner Forman Archive/Viking Ship
Museum, Bygdøy. **58-59** MCH. Illustration Mary Storm 1948.
Photo Eirik Irgens Johnsen. **60a** MCH. LL/BMP. **60b** MCH.
61 MCH. Photo Ove Holst. **63** Royal Coin Cabinet, SHM. LL/
FLP. **64** MCH. **65** From M. Müller-Wille (2001). **66** MCH. **67a**
Museum of Natural History and Archaeology, NTNU (Norges
teknisk-naturvitenskapelige universitet), Trondheim. LL/FLP.
67b Moesgård Museum, Department of Photo and Media. **68**
SHM. LL/FLP. **69a** British Museum, London. **69bl** MCH. LL/
FLP. **69br** State Hermitage Museum, St. Petersburg. **71a** SHM.
LL/BMP. **71b** MCH. **72a** Kulturhistorisches Museum Stralsund.
72b, 74 Archäologisches Landesmuseum, Schleswig. **75**
Sigtuna Museum. **76al, ac, ar** Collection of James Graham-
Campbell. **76bl** Drawing Monika Szymczak. Courtesy
Mieczyslaw Jusza, Institute of Archaeology and Ethnology,
Warsaw. **76br** Blazej Stanislawski, Institute of Archaeology
and Ethnology at the Polish Academy of Sciences in Wolin.
77 National Museum of Ireland, Dublin. **78** Manx National
Heritage, Douglas, Isle of Man. **79** From J. C. Cumming, *The
Runic and other Monumental Remains of the Isle of Man* (1857).
80 Richard A. Hall. **81a** English Heritage. **81b** British Museum,
London. **83a** © Eva Wilson. **83b** NMD. **84l** © Eva Wilson.
84-85 NMD. Photo John Lee. **85b** Drawing Orla Svendsen
from M. Iveson (1991). **86** NMD. Photo John Lee. **87** MCH.
LL/FLP. **88l** © Eva Wilson. **88r** MCH. Photo Ove Holst. **89a**
SHM. **89bl** Drawing Orla Svendsen from M. Iveson (1991).
89br Roberto Fortuna/Kira Ursem/NMD. **90al, br** SHM. LL/
BMP. **90ar, bl** Drawing Jenny Smith from J. Graham-Campbell
(2001). **91** SHM. **92a** From D. Waterman, "Late Saxon,
Viking, and Early Medieval Finds from York", *Archaeologia*, vol.
97 (1959). **92b** National Monuments Record, Swindon. **93,
94** York Archaeological Trust. **95** British Museum, London.
96 Photo Else Roesdahl 2009. **97** Photo Else Roesdahl 2007.
98l Photo Else Roesdahl. **98r** Photo Else Roesdahl 2009. **99**
Photo E. Malkie. **101, 102a** NMD. Photo Kit Weiss. **102b**
NMD. Photo Roberto Fortuna/Kira Ursem. **103** From M.
Müller-Wille (2001). **104** NMD. LL/FLP. **105** © Eva Wilson.
106l Drawing after J. Graham-Campbell from S. H. Fuglesang
(1991). **106r** National Museum of Scotland, Edinburgh. **107a**
NMD. Photo John Lee. **107b** Moesgård Museum. **108a**
Museum of Natural History and Archaeology, NTNU (Norges

teknisk-naturvitenskapelige universitet), Trondheim. **108ac**
Drawing Jeremy Ford from J. Graham-Campbell and D. Kidd,
The Vikings (1980). **108bc, b** Sigtuna Museum. **109** Drawing
Gyulia Laszlo. **110** British Museum, London. **112** Bayerisches
Nationalmuseum, Munich. **113a** Destroyed (formerly in the
Szcecin Museum, Poland). Photo collection of D. M. Wilson.
113b akg-images/Interfoto. **114l** Léon Cathedral Treasury.
14r Drawing Louise Himar after E. Roesdahl (2010b). **118**
MCH. Photo Leif Pedersen. **119** © Eva Wilson. **120** Photo
Bokforlaget Signum. **121a** SHM. Photo © D. M. Wilson. **121bl**
SHM. **121br** NMD. LL/BMP. **122a** NMD. Photo John Lee.
122c SHM. LL/BMP. **122b** Museum of Natural History and
Archaeology, NTNU (Norges teknisk-naturvitenskapelige
universitet), Trondheim. LL/BMP. **124** Gotlands Fornsal,
Visby. **125** MCH. LL/BMP. **126** SHM. **127** Laczkó Dezső
Museum, Veszprém, Hungary. **128l, c** National Museum of
Iceland, Reykjavík. **128r** State Historical Museum, Moscow.
129 SHM. LL/BMP. **130** Museum of London. **131a** From D.
Williams, Late Saxon Stirrup-Strap Mounts (1997). **131b** ©
Eva Wilson. **132l** Cambridge University Library, Ms Ff.1.23, f.
37v. **132r** Norwich Castle Museum & Art Gallery. **133** ATA.
134al Aalborg Historical Museum. **134ar** National Museum
of Iceland, Reykjavík. Ancient Art and Architecture Collection
Ltd./Bridgeman Art Library. **134b** Kulturen, Lund. **135** British
Museum, London. **136** Photo Else Roesdahl. **137a** NMD.
LL/FLP. **137b** National Museum of Iceland, Reykjavík. **138l**
SHM. LL/BMP. **138r, 139** Museum of Natural History and
Archaeology, NTNU (Norges teknisk-naturvitenskapelige
universitet), Trondheim. LL/FLP. **140** © Eva Wilson. **141**
Werner Forman Archive. **144, 145** Photo Sten-M. Rosenlund.
146l, 146r ATA. **147** © Eva Wilson. **148** ATA. **149** SHM.
150 British Museum, London. **151** The Collection: Art and
Archaeology in Lincolnshire. **152l** Durham Cathedral. **152r,
154l** © Eva Wilson. **154r, 155** National Museum of Ireland,
Dublin/Boltin Picture Library/Bridgeman Art Library. **156a**
National Museum of Ireland, Dublin. **156c** Amgueddfa Cymru/
National Museum Wales, Cardiff. **156b** imagebroker.net/
SuperStock. **158-159** Jamtli Bildbyrå, Östersund, Sweden.
161, 162 SHM. **163** NMD. Photo Roberto Fortuna/Kira
Ursem. **164** akg-images/Interfoto. **165** Gosforth Church,
Cumbria. **166** SHM. **167** National Museum of Iceland,
Reykjavík. **168** Drawing Veronika Murasheva. **169** SHM. LL/
FLP. **171** Ole Malling, Roskilde Museum. **172** SHM. **173** Lunds
Universitets Historiska Museum. Photo Bengt Almgren.
174 Gotlands Fornsal, Visby. **175** Drawing Lesley Collett ©
Thames & Hudson Ltd, London. **176** Richard A. Hall. **177**
MCH. **179** SHM. **180** Manx National Heritage, Douglas, Isle
of Man. **181** Drawing © Thames & Hudson Ltd, London. **182**
MCH. Photo Eirik Irgens Johnsen. **183** ATA. **185** © Astrid
Lindhjem/imagebroker/Corbis. **186a** Historisk Museum,
Bergen. **186b** ATA. **187, 188a** SHM. **188b** From P. Nørlund,
Gyldne Altre (1926). **189** NMD. **190** Southwell Minster,
Cathedral of Nottinghamshire. Photo Finnur Sjalfsad Hannard.
191a Telemark Museum, Skien, Norway. Photo R. Nyblin.
191b Nordiska Museet Stockholm. **193a** Atelier Teigen,
Oslo. **193b** The Art Archive/Victoria and Albert Museum
London/V&A Images. **194l** Richard A. Hall. **194r** Viking Øl,
Rogaland. **195** SHM.

Index